FACES OF THE CIVIL WAR

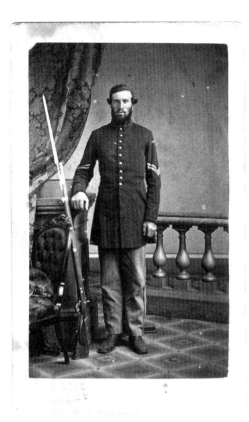

This *carte de visite* showing an unidentified
soldier is printed at actual size. The photographs
in this collection have been enlarged.

An Album of Union Soldiers and Their Stories

Faces of the Civil War

RONALD S. CODDINGTON

WITH A FOREWORD BY MICHAEL FELLMAN

THE JOHNS HOPKINS UNIVERSITY PRESS BALTIMORE AND LONDON

9 8 7 6 5 4 3 2 1

Some of the profiles, in slightly different form, were published in
Civil War News between April 2001 and June 2003. An earlier version
of the profile of James M. Cooper was published in the September–
October 2001 issue of *Military Images* magazine.

The Johns Hopkins University Press

2715 North Charles Street

Baltimore, Maryland 21218-4363

www.press.jhu.edu

LIBRARY OF CONGRESS CATALOGING-IN-PUBLICATION DATA

Coddington, Ron, 1963–
 Faces of the Civil War : an album of Union soldiers and their stories / Ronald S.
Coddington ; with a foreword by Michael Fellman.
 p. cm.
Includes bibliographical references (p.) and index.
 ISBN 0-8018-7876-4 (alk. paper)
 1. United States — History — Civil War, 1861–1865 — Biography. 2. United
States — History — Civil War, 1861–1865 — Portraits. 3. United States. Army —
Officers — Biography. 4. United States. Army — Officers — Portraits. 5. Soldiers —
United States — Biography. 6. Soldiers — United States — Portraits. I. Title.
 E467.C63 2004
 973.7'41'0922 — dc22 2003018305

A catalog record for this book is available from the British Library.

*The frontispiece photograph was taken by James Presley Ball (1825–1904) between
1861 and 1863. The unidentified corporal's firearm is an Austrian Lorenz musket.*

This volume is dedicated to all Americans as a memorial to our countrymen who volunteered in the armed forces of the United States during our greatest national crisis.

CONTENTS

FOREWORD

Michael Fellman

As Northern men rushed into the Union army after the bombardment of Fort Sumter in April 1861, the American correspondent to an English periodical noted, "For the few days in which the military are being enrolled, . . . the photographic galleries are thriving: the wise soldier makes his will, and seeks the photograph as possibly the last token of affection for the dear ones at home." And so it was off into the vast, unknown conflict, to possible maiming or death, with the image of the proud and probably fearful new soldier, uniformed and posed in the photographer's studio, left behind. This magical representation, at once of the civilian he had been and the soldier he had become, remained with the home folks as they held their breath awaiting news of injury, death, or disappearance.

Into this unusual and moving volume Ron Coddington has gathered the portraits of dozens of ordinary soldiers—junior officers and enlisted men rather than the famous generals—giving us a portrait gallery of Union soldiers on the brink of a war that would change their lives forever, whatever their physical fate. More than that, he has tracked down the life histories of these men and tells us about their wartime and postwar experiences, their stories often ending in death by battle and disease or from postwar wounds, or continuing in more ordinary ways until death in bed, years or decades later. Although many of these men returned home after the war, others stayed restless, wandering the United States in search of greater opportunities, sometimes with a modicum of success, sometimes without. Although Coddington does not speculate on the psychology of these later lives, it does seem clear from their stories that for many soldiers the wounds of war were by no means all visible.

But the images were. They stemmed from a very common experience, that visit to the photographer's studio. By coincidence, just in time for the Civil War, technological and business change made possible the ready supply of cheap graven images that matched the soldiers' great demand for some form of symbolic immortality. Democratic portraiture filled the great hunger for self-representation of a democratic and individualist soldiery.

Photography was only twenty-two years old when the war started, but it had rapidly developed from an expensive and difficult technique to one readily attuned to the mass production of inexpensive prints. In January 1839, Louis Jacques Mandé Daguerre announced the discovery that bore his name. By March, the American portrait painter and inventor, Samuel F. B. Morse, who was in Europe to secure patents for his telegraph, had met Daguerre, learned the process, purchased a camera, and brought the process back home to America, where it immediately spread as a quick method of portraiture. Daguerreotypes were unique pictures, the light being impressed directly on a plate that was the picture itself, and so the price remained relatively high—around $5 at first. By 1850 there were 938 daguerreotypists distributed among the cities and many of the towns of the United States, and the price had dropped to about $2.50—still dear, but clearly low enough to feed a rapidly growing demand.

Photography took a great leap forward in the early 1850s, when collodion technology developed, again mainly in France. The photographer now exposed his camera lens on chemically treated glass plate negatives, with the images then transferred onto ordinary, treated paper, making positive prints. This made possible the reproducibility of inexpensive photographs. And then, in 1854, Adolphe-Eugene Disdéri, the court photographer to Napoleon III, developed a movable plate holder, allowing eight to twelve poses to be imprinted on one negative plate. A single print from this negative could thus produce many images, and reproductions were made even cheaper by the fact that unskilled laborers could

handle the printing processes. In 1857, according to legend and possibly in reality, the Duke of Parma gave Disdéri one of his business cards and asked that his photograph be glued onto the reverse side. As such cards were of a uniform four by two and one-half inches throughout Europe and America, this small portrait, known as the *carte de visite,* became the standard form of cheap photographic portraits.

Technological and artistic transfer from imperial France to the democratic United States (sometimes via Britain) continued its swift pace. Such trade long had been true of many products, notably Parisian women's clothing fashions. Then as now, Paris was the hub. Not only did wealthy Americans buy directly at Parisian salons, artists from *Godey's Lady's Book,* the leading American fashion magazine, attended the French showings, and within months French haute couture knock-offs appeared on the streets of Cedar Rapids, Iowa. Now the collodion process and the *carte de visite* photographic reproduction form also spread like lightning, to England, and then across the Atlantic. First advertised in January 1860 by a Broadway photographer as "The London Style Your Photograph on a Card," *carte de visite* pictures cost only $1.00 for 25, and competition soon increased the quantity the customer's dollar would buy. What was, even at the time, called "cardomania" spread like the flu in the Spring of 1860, by which time 3,154 Americans earned their living as photographers, eighty-three in New York alone, and at least one in nearly every city and town.

Within a year the newspapers were advertising another new product—photograph albums; between 1860 and 1865, fifteen styles were patented. Most versions featured recessed pockets with slots for inserting the pictures. Some albums were ornate, costing up to $40, some priced as low as $1.50. Photographers mass-produced landscapes and pictures of famous people in the *carte de visite* format, which fit in nicely amid pictures of family and friends. (Indeed celebrities soon charged for sitting; the celebrated

actress Lily Langtry, for example, charged $5,000, but her photographer made a small fortune by selling copies at $5.) Photo albums frequently became the second adornment of log cabins as well as front parlors, set on a table next to the family Bible. Many of the same families also bought stereographic prints and viewers, which created the illusion of three dimensions, but the *carte de visite* craze was even greater. Some regiments had their own photographers, and whenever armies went to winter encampments, artistic sutlers soon set up shop nearby; approximately 300 served the Army of the Potomac alone. These enterprising photographers also recorded the scenes of battlefields, after the event, their cameras being too slow for action shots during battle (when, in any event, smoke covered the field). Put on public exhibition, these scenes of vast numbers of the mangled dead soon brought the war home to civilians in a visceral way, undoubtedly contributing to the unpopularity of the war by 1864.

Mathew Brady, the most noted battlefield photographer, made his bread and butter at $1 per sitting during the war, along with scores of other picture takers, including the three brothers Bergstresser from Pennsylvania, who traveled to the front and took up to 160 portraits per day during lulls in battle. As one Boston photographer observed in May 1863, "the card photograph has for the past two years . . . been in universal demand, almost to the complete exclusion of every other style of photographic portraiture, and has in fact produced a revolution in the photographic business."

Democratic, cheap, and popular, the *carte de visite* had aesthetic limits — most soldiers were shot full figure in a very small frame — and so a larger product, the four by six and one-half inch "cabinet card," came into fashion after 1866. Cabinet cards could pay more attention to detail and to the character of the sitter. Soon, photo albums accommodating this format became all the rage and *cartes de visite* lost fashion. The cabinet card held sway until the late 1880s, when celluloid reel-to-reel film, hand-held

cameras, and the photo-finishing business once more transformed and further democratized photography, in the form that lasted until the current digital craze.

Throughout the war the home folks could gaze on the likenesses of their endangered soldier boys, and the unlucky ones possessed at least a representational reminder of the promising men who had marched off to war only to offer the ultimate sacrifice. Not without reason did Oliver Wendell Holmes call *cartes de visite*, "the social currency, the sentimental 'green-backs' of civilization." Often the soldiers carried pictures of their loved ones in their packs as well, as their end of a ritualized exchange of prewar memories on paper. Stiff though the picture poses might be, set not in nature but in airless studios beside photographers' props, the *cartes de visite* were nevertheless powerful reminders of love for men plunged into hateful circumstances.

The full meanings of soldiers' lives could never be indicated by these still and solitary photographic compositions, however much they meant to the soldiers and their families as *aides-mémoire*. Military experience meant not just the unspeakable terrors of combat but a nearly total transformation of everyday life. Men from dissimilar and often conflicting social and ethnic backgrounds were thrown together pell-mell in interdependent, large-scale collectives entirely new to them. As most of the soldiers depicted here served in the eastern theater, fewer of them were farmers and more came from towns and cities than would have been the case in the Confederate army, or for that matter Union armies in the West. They were more likely to be clerks, tradesmen, and professionals than was true in other units, and more were immigrants. Canadian, English, French, Czech, and especially Irish troops are well-represented here, though Coddington found no pictures of the numerous German immigrants in the army, nor any images of the African Americans who comprised 12 percent of the Union force by 1865.

This diversity of young manhood was thrown into an extensive,

diverse, and increasingly bureaucratized Union war effort—an improvised yet rigorous and authoritarian institutional construction completely new to this generation of Americans. They were mobilized, equipped, and deployed in impersonal masses, often to lethal ends, that bewildered and angered them, though they also took pride in their new collective prowess and their ability to face the enemy in ruthless battle. Many were wounded permanently in psychological as well as physical ways while far from home, living and dying in a manner far beyond the comprehension of the home folks or of the peaceful citizen selves they once had been. It is little wonder that so many later took to drink and to wandering through life, paths Coddington describes quite vividly. For many, perhaps most, war brought more enduring pain than glory. In that sense, these stylized pictures of composed and confident young men deny the inner experiences of the war.

By placing these still images within the context of brief, turmoil-filled biographies, Ron Coddington has given us an original memoir of the impact of the Civil War on ordinary American young men and their families. They ventured forth at great risk, often becoming sacrifices to political ends that to them and their families were abstractions. Pride and potential loss is reflected in their pictures and their stories. No other book has rendered as well the sheer poignancy of the impact of war; with continuing immediacy these anticipatory portraits stare out at us much as they did in 1861. Coddington's stories drive home the image of the resilience and fragility of all soldiers everywhere, and during the American Civil War in particular.

Bibliographical Note

For discussions of the *carte de visite* craze set within the context of the history of nineteenth-century American photography see the following four books, noted in chronological order: Robert Taft, *Photography and the American Scene, A Social History, 1839–1889* (1938; reprinted, Mineola, N.Y.: Dover Books, 1964); Beau-

mont Newhall, *The History of Photography: From 1839 to the Present Day*, rev. ed. (New York: Museum of Modern Art, 1964); Alan Trachtenberg, *Reading American Photographs: Images as History, Mathew Brady to Walker Evans* (New York: Hill & Wang, 1989); Martha A. Sandweiss, ed., *Photography in Nineteenth-Century America* (New York: Henry N. Abrams, with the Amon Carter Museum, Fort Worth, Tex., 1991).

PREFACE

EVERY SOLDIER HAS a story to tell. Countless volumes of narrative could be filled with the tragedies and triumphs of Union volunteers who enlisted to fight between 1861 and 1865. More than two million Northern men — one in every five, half of the males of prime fighting age[1] — took up arms against the states in rebellion. Over forty-eight months, 360,000 perished, an average of 250 soldiers per day, whether from wounds, from disease, or from exposure to life in prison camps. If a Civil War memorial wall for Union volunteers were constructed on the model of the 500-foot-long Vietnam memorial, it would stretch over a half-mile — without counting the Southern dead. The death toll is only part of the tragedy. Hundreds of thousands of survivors suffered permanent physical and mental disabilities. A significant and irreplaceable portion of a generation was destroyed.

One century and four decades have passed since the conclusion of the Civil War. The vast armies of soldiers who fought and died have been largely forgotten, reduced to little more than numbers and names on a memorial plaque or statue.

The Union men who enlisted and served have never been part of our collective consciousness as unique individuals. Rather, they are memorialized en masse, perhaps a fitting tribute to the solidarity and sacrifice of a generation compelled to come together and defeat an enemy that threatened the very existence of the Republic. The stories of individual soldiers, originally the domain of family reunions and local legend, have faded into obscurity, victims of the march of time and the inevitable passing of generations.

But time has also been a friend to the old soldiers. New generations of Americans are moved to go beyond the memorial marker — they want to learn more about the common men who fought.

This volume offers a different perspective on the Civil War experience by chronicling the stories of a select group of unique individuals, each illustrated with an original portrait photograph. The faces of most of these men have never been included in a book before, and they represent a visual record of the common soldier. These images were originally produced during the war, when photography was only twenty years old—too old to be a novelty, but young enough still to inspire awe and excitement.

The soldiers pictured in this book were wealthy and poor, educated and unschooled, American-born and immigrant, city slicker and country boy. All put their civilian lives on hold and shared the commonality of military life. Yet their personal stories reveal a great diversity in war experience, for each man was confronted by the mental and physical rigors of life in camp and on the battlefield. Each man reacted in his own way, and accounts of their actions are scattered throughout the country's private holdings and public institutions in the form of journals, letters, books, newspaper articles, and government files. The text for this volume was produced from these resources, and the stories of many of the soldiers on the following pages are published here for the first time.

These profiles tell of men who lived during an era of intense political turmoil and social reform. They are also part of a larger body of Civil War history and help us understand the role of the common soldier.

About This Volume

Sitting at a workstation in the large, dimly lit research room on the fourth floor of the flat-topped National Archives building in downtown Washington, D.C., I pause and listen to the familiar chickety-chick-shhh of dozens of microfilm machines in use by historians, genealogists, and others from all over the country. It's music to my ears, and the rhythmic sound reminds me of a visit to the great repository one spring afternoon three years ago, when I pored over the records of a young Civil War captain. His tragic

story intensified my lifelong interest in the War Between the States and inspired a quest that grew into a column, and now this book.

I have been fascinated by the Civil War almost as long as I can remember. I still have a grammar school notebook filled with drawings of Union soldiers, battle scenes, and gunboats firing flaming broadsides. My favorite boyhood relic is a family photograph taken in Gettysburg, Pennsylvania. My parents and two brothers, exhausted from marching around the battlefield in the scorching summer sun, look like they are ready to surrender. I am standing with them, next to a cannon, wearing a blue felt kepi and a smile as long as Cemetery Ridge.

Drawing was also an important part of my childhood. In my teen years I became preoccupied with capturing the human face on paper. I copied, in pencil, portraits of every Civil War general and statesman that caught my eye in my schoolbooks, and, after I'd exhausted that resource, sketched from library books and volumes at home. When I was fourteen, I discovered a new source for reference — antique photographs.

My parents had caught the flea market bug the summer before, and they passed it to their three sons. Some of my most pleasant memories stem from weekend outings spent "antiquing"; we were particularly fond of the market not far from home in Neshanic Station, New Jersey. It was set up along the banks of the Neshanic River, near a vintage railroad station converted into an antique gun shop. We could be found there most Sunday afternoons, plowing through row after row of tables topped with mountains of old stuff. In one of these piles I saw my first antique photograph, and the thought came to me that I could use it to learn more about drawing portraits. But it was at another flea market several weeks later, in May 1977, that I first handed over a couple dollars of my hard-earned newspaper boy money and walked away with a photograph of a Civil War soldier. During the following week, I added his likeness to my sketchbook; the following Sunday, I bought another image to draw. I filled my sketchbook with their faces,

and, as a bonus, developed a collection of old photographs, which I kept in an aging cigar box.

Visitors to the Coddington home during my high school years would likely find me upstairs, tucked away in one corner of my bedroom, hunched over a small desk with pencil in hand, struggling to master the art of portraiture. After much practice and many failures, I learned how to draw a face. My need for antique photographs for reference faded, but my passion for collecting did not. These old paper images captivated me. I was most affected by the faces of the formally posed subjects gazing at the camera, each lacking smiles or frowns, yet deeply expressive. I added to my collection even after I no longer needed them for drawing and, in the fall after my senior year, packed up my cigar box full of photographic treasures as I headed off to college.

With equal zeal, I collected Civil War photographs and pursued my degree in fine arts, motivated in part by classes in art history and American history. My collecting venues diversified after I discovered dealers who sold images through mail-order catalogs and after I attended my first Civil War antiques show, where I interacted with dealers and fellow collectors while poring over tables of relics.

I continued to accumulate old photographs after graduation and as marriage, a career in graphic arts and journalism, and other major life events enriched and shaped my life. In 2000, a need for change led to a decision that had a direct impact on my interest in Civil War *cartes de visite.* For some time I had aspired to become involved in a project beyond the scope of the fast-paced, daily deadline assignments I thrived upon in my professional life. In the spring of that year, I turned to my collection with the idea of assembling a book of Civil War *cartes de visite* of enlisted men and officers and writing a brief caption for each picture that would include the soldier's name, rank, regiment, and dates of military service. I learned that this information could be obtained from the National Archives, just a short trip from my home in Arlington, Virginia.

On an unseasonably cool April morning, I set out for the subway ride to Washington, D.C., and the National Archives. Upon my arrival I was directed to the fourth floor research room. Here I was told that every soldier had a military service file that includes monthly muster reports, prisoner of war and casualty records, requests for furloughs, and other documents. I was also made aware that many veterans and their widows had filed for pensions and that those records, which include applications, affidavits, and other testimonials, were also available. Intrigued, I filled out the request forms for a Massachusetts captain, Edward Washburn, of the state's Fifty-third Infantry, and patiently waited for the staff to retrieve the files.

Two faded manila envelopes were delivered a couple hours later, and I reviewed with great interest the basic facts about the severe leg wound he received in battle and then was fascinated to read through a collection of letters written by his regimental surgeon which described the minute details of his successful surgery and slow but steady rehabilitation. I was pleased to read that he had left the army with a prognosis for a full recovery, albeit on crutches.

A few days later, I discovered a Web site about the Fifty-third Massachusetts, maintained by Walter Blenderman, who responded promptly after I sent him an e-mail request for information about Capt. Washburn. My heart sank as I scanned the profile of Washburn that appeared in the regimental history. He had been anxious to get back into the war, but his leg would not heal properly. The wound broke open about a year later, blood poisoning set in, and he died after ten days of great suffering. A large circle of family and friends mourned his loss, and I was devastated.

This man's story moved me as no other Civil War narrative had. I wanted to read more about these volunteers, to gain a better understanding and appreciation of their war experience and how it impacted their lives. I scrapped my original plan to compose brief captions for the pictures and dedicated myself to researching and writing the stories of these citizen soldiers.

Over the next nine months, I developed my research skills, honed my writing abilities, and gained confidence with each new profile. In early 2001, I sent a package of samples to Kathryn Jorgensen, managing editor of the *Civil War News,* with the hope that these stories might become a regular feature. Her response was positive, and *Faces of War* made its debut in the April issue. Supportive e-mails and telephone calls from readers encouraged me to continue my quest. Some of the profiles printed here also appeared in the column, and many of these stories have been expanded to include details not available when each was originally published.

The transition from column to book presents several organizational challenges. Perhaps most important is the arrangement of the stories, which are grouped in chronological order by the date of the central war event of the soldier's story.

The captions cite the subject's *final* unit assignment and rank. This may be a source of confusion, as many soldiers served in more than one regiment, and the regiment listed may have received only a mention in the profile. The rank may not match that designated on the subject's uniform, as the image may have been made earlier in the war, when the soldier had a lesser rank. Brevets, or honorary ranks usually awarded to officers for gallant conduct or meritorious service, have been omitted from the captions but are included in some of the profiles.

The names and home cities of the photographers, if imprinted on the original *carte de visite,* are also included in the captions. This information typically appears on the back of the photograph's mount but is sometimes printed on its front. Life dates are from the database of the George Eastman House in Rochester, New York.

Only volunteer soldiers who ranked below colonel at the end of the war have been selected for inclusion in this volume, because much has already been written about general officers. However,

the endnotes include brief biographies of colonels and generals mentioned in the text.

Descriptions of campaigns, battles, skirmishes, and other movements have been included only when essential to the soldier's story. Extended explanations and summaries of military actions have been abandoned in favor of details about the situation and circumstances encountered by the soldier on the ground.

There are certain drawbacks in assembling a volume of profiles based on a private collection of Civil War *cartes de visite*. I have lived in the northeast and mid-Atlantic region for most of my life, and the majority of the images in my collection have been accumulated from dealers and other sources in these areas. As a result, eastern regiments are better represented than their brother units in the West. A large percentage of the identified images in my collection are lieutenants and captains, and they are the subjects in many *cartes de visite* on the market. The reason for this imbalance may be that their photographs were simply in greater demand by the rank and file, in addition to fellow staff officers and friends and family. Lieutenants and captains were likely to be formal and informal leaders in the towns and villages from which their regiments were formed and were closely acquainted with the privates and noncommissioned officers who served in their companies. Another explanation may be that officers were of a higher social and economic class, and card photographs may have been more important to this group of Americans.

That Confederate *cartes de visite* are scarce is probably due to the South's war-torn economy and difficulties procuring photographic supplies as a result of the Union blockade. Identified images of African American soldiers are exceedingly rare, which may suggest that the democratization of photography following the popularization of the *carte de visite* may not have extended much further than the dominant Eurocentric culture. Approximately four hundred women are believed to have served in uniform on

both sides during the Civil War, but images showing them thus are seldom seen.

At a Civil War round table where I had been invited to talk about *Faces of War,* a member asked me, "What came first, the photos or the stories?" I answered by explaining how I believed I had approached this book in reverse, by selecting the images first. The genesis for most Civil War volumes based on personal accounts is textual: journals, letters, articles, and other writings. These books can be difficult to illustrate, as portraits of the soldiers described in the text have usually been lost, or lie undiscovered in a private or public collection. The point of origin for this book is the *cartes de visite* created by thousands of hometown photographers who operated during the war years. Starting with the images has made this a memoir that connects a face with a name, a name with an event, and an event with the context of a lifetime.

The stories in this volume leave no doubt that the Civil War had a profound impact on the lives of many volunteers and their families. But they also reveal that, for some, the war was little more than a minor interruption. One fact is certain: the Union was falling apart, and the men of this generation in Union states came together to fight for freedom and liberty. The cost in deaths in battle and by disease to preserve and protect these values was high, and of those who survived, many endured a life of pain and suffering. This generation, despite its loss in men and materials, went on to play a vital role in rebuilding the country and contributing to a period of unprecedented economic growth in the latter half of the nineteenth century, in the same way that their descendants and others would do so during the post–World War II era. Their stories are an enduring part of the American legacy, for they illustrate the commitment and sacrifice of individuals who left their homes and farms en masse to answer their nation's call to arms. The images of these men are a singular visual record, and it is important that they be preserved and handed down with their stories to future generations.

CARTES DE VISITE

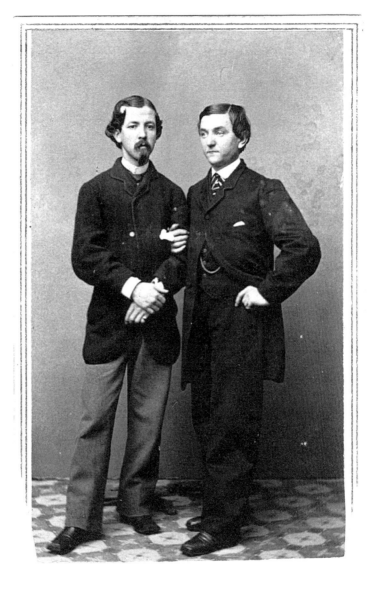

Bugler William Dowling Gourley, Company B, First Massachusetts Cavalry (*left*) and friend

Carte de visite by John Goldin (b. 1827) & Co. of Washington, D.C., about 1864

One of the War's First Casualties

On April 16, 1861, four days after the Civil War started, Pvt. William Gourley and his militia company were assigned to the Sixth Massachusetts Infantry and left Boston for Washington, D.C., where President Abraham Lincoln, serving his first month in office, had issued a call for all available units to defend the capital. Three days later, they faced a mob of Southern sympathizers in Baltimore, where, reported the regiment's colonel, "they were furiously attacked by a shower of missiles, which came faster as they advanced. They increased their steps to double-quick, which seemed to infuriate the mob."[2] The crowd "fired into the ranks, and one soldier fell dead. The order 'Fire' was given, and it was executed."[3] Several of the mob fell. The regiment hastily left the city and counted its casualties—four men killed and at least thirty-nine wounded, including Gourley. He had been hit on the left heel by a thrown cobblestone and spent two weeks in a hospital.

Gourley served the remainder of his three-month enlistment with the Sixth and then joined Company B of the First Massachusetts Cavalry as its bugler. In 1862, he was appointed to the staff of Col. Robert Williams[4] as an aide-de-camp. The colonel resigned a month later to join the Adjutant General's Office of the War Department. Gourley followed him there in early 1863 and was put in charge of the printing office. After the war, he transferred to the headquarters of the Department of the East in New York City.

There he met Anna Hillgrove, a printer ten years his junior and the daughter of a Civil War veteran. They became engaged, but they did not marry for twenty years. Anna had a mother to support who was "too proud to live on a son-in-law."[5] They married in 1906 after the mother died, but by then he was sixty-five and in failing health. Five years later, he died of heart disease.

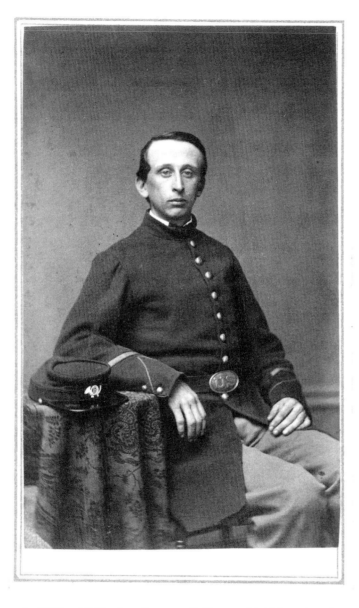

1st Lt. William W. Dutcher, Company B, Twenty-third Massachusetts
Infantry

Carte de visite by Wires (life dates unknown) of Milford, Massachusetts, about 1865

In Annapolis, Maryland, news of war from Fort Sumter, South Carolina, raised deep concern from its loyal citizenry for the safety of a national icon, the USS *Constitution*, which was moored at the nearby U.S. Naval Academy. Distress calls went out, and the response came from an unlikely source — the Eighth Massachusetts Infantry.

The Eighth had been formed within days of the start of the war and consisted of men from the greater Boston area. From the suburb of Marblehead, eighteen-year-old shoemaker William Dutcher enlisted and was assigned to Company B. He barely had time to say goodbye to his pregnant wife and daughter before orders came to leave for Washington, D.C. In Baltimore, pro-Confederate rioters had attacked its brother regiment, the Sixth Massachusetts Infantry, so the Eighth came by chartered steamboat, disembarking at Annapolis, to avoid the mobs.

Brig. Gen. Benjamin Butler,[6] commanding the Eighth and other Union forces, entered Annapolis and sized up the situation. "Appreciating at once the necessity of having the ship to cover our connections, as well as a strong desire to keep Old Ironsides out of the hands of those who would be but too happy to raise their Confederate flag upon the *Constitution* as the first ship of their hoped-for navy, I at once came alongside, and giving the assistance of my whole command as well to guard the ship as to hoist out her guns, I was happy to see her afloat outside the bar ready to do good service."[7]

The Eighth left for Washington after securing the famed frigate, and guarded the capital until they were mustered out in August 1861. Dutcher reenlisted, as sergeant in the Twenty-third Massa-

chusetts Infantry, and worked his way to first lieutenant in four years of service in North Carolina and Virginia.

After the war, Dutcher went home to Marblehead, where he returned to shoemaking and raised a family that grew to include eight children. He died in 1907 at age sixty-three.

Wounded and Captured at Bull Run

ON OCTOBER 23, 1893, in a hotel room near the World's Columbian Exposition in Chicago, Marcus Conant writhed in agony, unable to speak. He soon slipped into unconsciousness, but before doing so he used his hands to communicate to a doctor that he was experiencing excruciating pain in his head, behind the right ear. Ten hours later, he was dead of a cerebral hemorrhage, a day shy of his fifty-first birthday. He had traveled to Chicago a week earlier from his home outside Jacksonville, Florida, to visit the World's Fair and also to seek treatment for impaired hearing and vertigo, both conditions resulting from a head wound received thirty-two years earlier at the First Battle of Bull Run.

In July 1861, Pvt. Conant and his regiment, the Eleventh Massachusetts Infantry, had been in reserve near Manassas, Virginia. But on the 21st, after its brigade battery had been crippled by enemy fire, the Eleventh marched in with the Fifth Massachusetts Infantry to get the guns out. According to brigade commander Col. William Franklin,[8] the regiments "were slightly exposed to the fire of the enemy's battery on the left, and were consequently thrown into some confusion. This was shown by the difficulty of forming the Eleventh Regiment, and by wild firing made by both regiments."[9] After three failed attempts to save the cannon, Franklin reported, the regiments "retired in confusion, and no efforts of myself or staff were successful in rallying them."[10] During the attempt to reclaim the guns, Conant went down with a gunshot wound in the head, possibly caused by wild firing of the Massachusetts troops, and was captured. He spent a year in rebel prisons at Columbia, South Carolina, and Salisbury, North Carolina, then received a parole and rejoined the army as a private in the Third

1st Lt. Marcus Conant, Company B, Third Massachusetts Heavy Artillery

Carte de visite by Mathew B. Brady (b. ca. 1823, d. 1896) of New York City and Washington, D.C., about 1865

Massachusetts Heavy Artillery, where he ended his military service in late 1865 as a first lieutenant.

His head wound healed, leaving a scar four inches long, a half-inch wide, and, in places, as much as a half-inch deep, extending from the top of his right ear back to the occipital lobe at the base of the skull. Partial deafness and vertigo were his constant companions. He and his wife, Ellen, were married in 1867 in New Jersey and settled in Florida in 1876. They were parents of two children. The younger, Marcus Jr., was eleven at the time of his father's death.

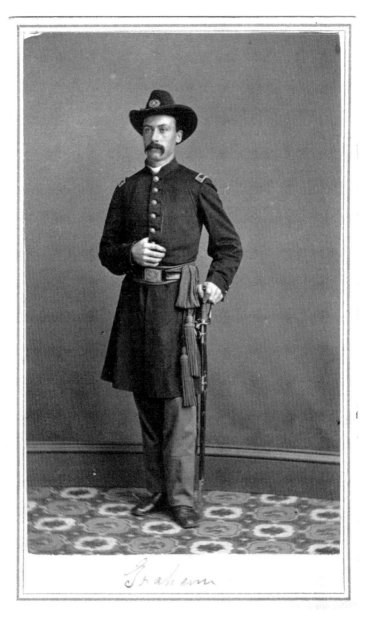

1st Lt. Henry Robert Graham, Company D, Eighth New York State Militia

Carte de visite by J. Taylor (life dates unknown), about 1862–1863

Wild About Harry

Everyone liked Harry Graham — it was next to impossible to find anyone who would say a word against the affable, easygoing carpenter from New York City, and he made a great impression on his new friends in the state's Eighth Militia Infantry when he joined them as a sergeant in 1861.

Activated for a three-month enlistment after the bombardment of Fort Sumter, the Eighth fought at the First Battle of Bull Run. Graham mustered out with the regiment in August 1861, then enlisted in the National Guard. He was called up two more times during the Civil War: in 1862, by then a first lieutenant, he traveled to Washington, D.C., for duty in the city's defenses, and in June 1863 he left New York to defend Harrisburg, Pennsylvania, against the Confederate invasion that ended in July at the Battle of Gettysburg.

Prior to his second term of enlistment, in 1862, Graham met Julia Clark. The couple married three years later and settled in Julia's hometown of Albany, New York, where he joined his father-in-law in selling stoves. Their partnership dissolved after two years in part because her father thought Graham's ideas for the business were too extravagant for Albany. Graham then struck out on his own and lost his shirt — not to mention money invested by his wife's family. She would later write that he was "weak financially."[11]

Their marriage was weak, too. Rumor had it that the Grahams did not get on well together. He left to find work in New York City and landed a bookkeeping job, while she stayed in Albany and taught school. Three years later, she moved to New York City and he promptly stopped working and lived off her earnings. Arguments about money and responsibility became frequent. In the

summer of 1876, telling his family that he was leaving because his wife was having an affair, he borrowed money from his buddies in the regiment and disappeared.

After an unsuccessful fifteen-year search, Julia assumed her husband was dead and filed for a war widow's pension. She was surprised to learn that her application was rejected because Graham was alive — the government disclosed that he was drawing a disability pension in California. She tried to contact him but he did not respond. She reapplied in 1904 and learned that he had died a year earlier of syphilis. Julia lived until 1938.

"My Goodness, Man, Don't Go Over There"

JOHN PIERSON OF the Seventh Iowa Infantry was captured at the Battle of Belmont, Missouri, on November 7, 1861, and interred in a prison camp in Memphis, Tennessee. He escaped four months later but was caught and taken to Jackson, Tennessee. On April 6, 1862, with the sounds of battle from nearby Shiloh distinctly audible, Pierson and other inmates were moved south to a more secure location in Corinth, Mississippi, and locked up in a small wood building.

Pierson described the events that followed: "The guards off duty had lain down and were asleep; all was quiet except the patter of rain. Just at this time Gen. Prentice[12] and seven hundred men who had been captured at Shiloh, were marched in front of the building. The guards, anxious to see the Yanks, rushed to the door."[13] Pierson and another soldier slipped out a back door. "We were soon halted by a guard and advanced to give the countersign, seized the end of his gun and hit him over the head, then ran out of the way."[14] Over the next three days, the escapees traveled only at night, slowly sneaking past the defeated Confederate army retreating from Shiloh. On the morning of the fourth day, they encountered a woman in the doorway of her house. "I asked the nearest road to the Confederate camp. She stepped to the end of the porch, pointed down the road and said it was a half mile to where they were guarding a bridge. Just at this time we heard drums beating to our left. On inquiring where they were, she said: 'My goodness, man, don't go over there, or the Yankees will get you.'"[15] When out of sight of the house, they started toward the sound of the Union drums. Some time later, they saw a soldier. "We asked him what army he belonged to. In a kind of positive way he said: 'The Union army, of course.' I asked him what regi-

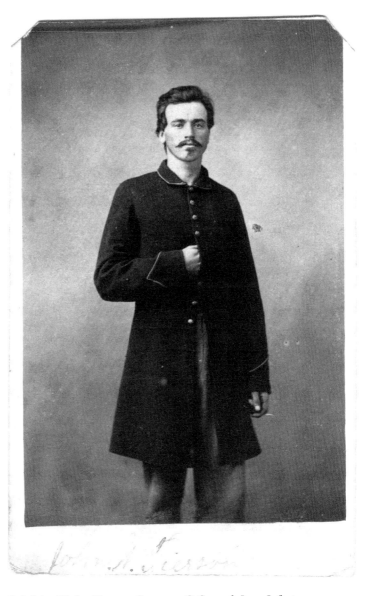

Cpl. John Wesley Pierson, Company C, Seventh Iowa Infantry

Carte de visite by Howard (life dates unknown) & Hall (life dates unknown) of Corinth, Mississippi, about 1862–1864

ment he belonged to. He said 'the 57th Illinois.' I asked him his colonel's name and his division commander, which names were familiar to me. Satisfying ourselves that he was a Union man, we told him we wanted to go to his camp, which he allowed we were joking, but seemed willing to go, leading off, and we following, and in three minutes we were inside of the lines."

"We went to a hospital and told the doctor that we were very near starved. He gave us a drink of wine, examined our pulse, and pronounced us in critical condition. He ordered us some potato soup and hardtack, and watched to keep us from eating too much, he requested us to stay all night, which we did. Next morning we ate breakfast and started out to inquire for our regiment. In a short time we found it, where we were met with a 'Hurrah.' After a short stay with the company the colonel took me to [Maj. Gen. U.S.] Grant's[16] headquarters, where I stayed some time, and then returned to my regiment, but was not able for duty for several weeks."[17]

Pierson mustered out when his term of enlistment expired in 1864. He married and settled in Mokane, Missouri, where he lived with his wife and five children until his death in January 1906. He was sixty-two.

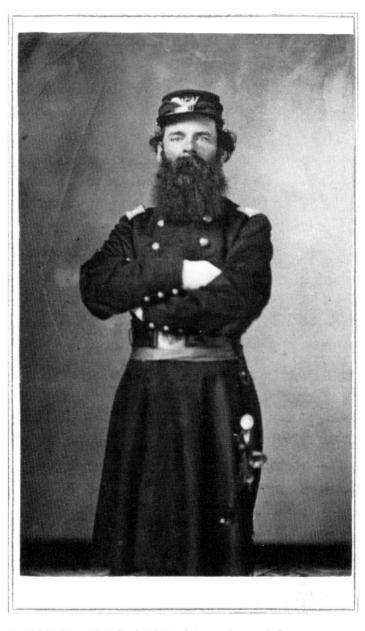

Lt. Col. William W. Bullock, Thirtieth Massachusetts Infantry

Carte de visite by unidentified photographer, about 1862–1864

Political War

THE FATES OF THE officers of the Thirtieth Massachusetts Infantry were at stake in a political war between Governor John Andrew[18] and Benjamin Butler, the U.S. congressman turned general who recruited the regiment. Andrew questioned Butler's authority to raise troops in the state, and battles were waged in the newspapers and the statehouse. When the dust settled in early 1862, the Thirtieth was mustered in without its officers. One soldier confided in his diary, "Governor Andrew has gained the day over General Butler and he is sending out officers to take the place of Butler's appointments. It seems hard, after the old officers have recruited and drilled their men."[19] The same soldier wrote home, "It is astonishing to see the wire-pulling for commissions; nearly all who succeed do so through influence only, no matter whether they are dummies or not. . . . It causes hard feelings, I assure you."[20]

The new lieutenant colonel was William Bullock of Cambridge. His resumé was impressive. A member of the Massachusetts militia since 1849, he had made brigadier general in 1858.[21] His service in the Thirtieth did not live up to expectations, and he lasted only a year-and-a-half in the regiment. Speculation had it that Bullock left because of a personal conflict with a fellow Governor Andrew appointee,[22] but his official resignation noted that he was departing "on account of age."[23] This explanation only served to fuel the rumors, as he was forty-three and in generally good health.

Bullock returned to Massachusetts and found a job as a clerk in the Adjutant General's Office in Boston. In 1868, he became a pensioner after complications from an infection contracted during the war impaired his sight — by 1874, his right eye was blind. His last appearance on the pension rolls was 1878, when he was sixty.

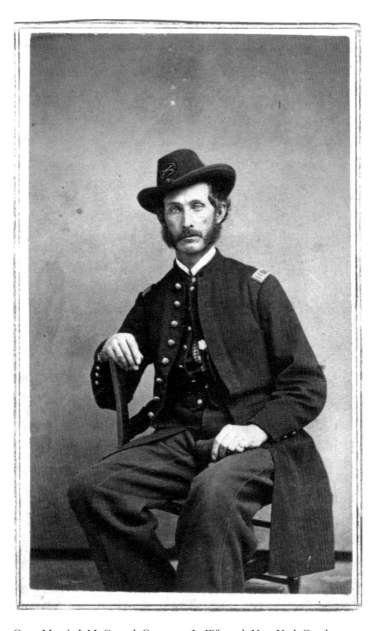

Capt. Morris J. McCornal, Company L, Fifteenth New York Cavalry

Carte de visite by Edwin Baird (1817–1920) & Jessup (life dates unknown) of Middletown, New York, about 1863–1864

Pursuit of His Dream Interrupted

MORRIS MCCORNAL dreamed of being a fine art painter. He pursued his passion in Middletown, New York, a small but thriving community where he resided after leaving his home state of New Jersey in the 1850s. When the Civil War started, the blue-eyed six-footer, a "genial and pleasant man,"[24] put aside his ambitions, helped raise Company C of the First New York Mounted Rifles, and was elected its captain. He and his company were ordered to Virginia in December 1861.

McCornal lasted only a few months with the regiment. He suffered ill health, possibly from exposure incurred on frequent patrols during the winter months, and resigned in the spring of 1862. In late 1863, he enlisted again, this time as first lieutenant in the Fifteenth New York Cavalry. Various illnesses debilitated him once more, but he managed to recover and lead his company on assignments in Virginia. Promoted to captain in 1864, he commanded his company at Appomattox Court House, Virginia, when Gen. Robert E. Lee[25] surrendered his army.

After the war, he returned to Middletown and resumed the pursuit of his dream, but success eluded him. He sank into a state of chronic depression as early as 1867, and his condition worsened after the death of his wife ten years later. One friend said of McCornal: "I know him to be a man of artistic talent in painting and that he is making from time to time an effort in his lifelong pursuit, but fails at every instance to continue in his efforts on account of his extreme weakness and nervous disability."[26] Each new failure would often result in a relapse more severe than the previous bout of depression. He managed to earn a living as a sign painter in business with his son Robert, but he never fulfilled his true ambition. He died in 1900 at age seventy-eight and was survived by six children.

After His Return from the Front

SITTING FOR A photograph was one of the first items of business on young Ned Clark's short list after mustering out of the army. He stepped into Frank Rowell's popular studio in downtown Providence, Rhode Island, with an armful of accoutrements and had his *carte de visite* made. He gave away the finished prints. He or a friend or family member wrote on the back of one of them, "Edward Clark / Ned after his return from the front." In fact, during his enlistment he was miles from the main Union lines.

Clark and his regiment, the First Rhode Island National Guard, were called up for emergency service in May 1862 after 20,000 rebels led by Gen. Thomas J. "Stonewall" Jackson[27] launched a hard-hitting, fast-marching raid up Virginia's Shenandoah Valley, and threatened Washington, D.C., where President Abraham Lincoln issued an urgent appeal for troops on May 25. Within four days, the Rhode Islanders gathered, mustered in as the state's Tenth Infantry, and arrived in the federal capital. But during its trip to Washington, Jackson's force had retreated down the valley — its mission of spreading alarm and preventing a concentration of Union forces in front of Richmond accomplished. The threat to the capital subsided, and the Tenth was left without an assignment.

The regiment remained in Washington, and its companies were divided and dispatched to garrison duty in the defensive perimeter of forts and batteries circling the capital. Clark's Company D spent its three-month term of service in the squalid conditions of hastily constructed Fort DeRussy, guarding the western approach to the city. In summing up the regiment's contribution in a report to the state governor, its commander, Col. James Shaw,[28] said, "We were permitted to perform but an humble part in the great strug-

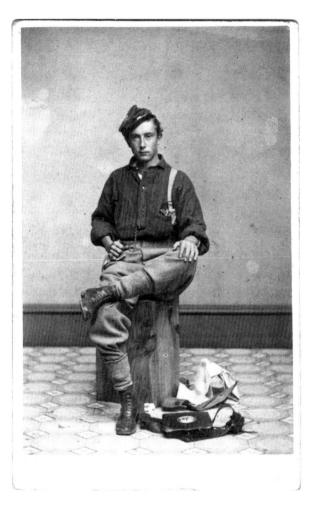

Pvt. Edward Colton Clark, Company D, Tenth Rhode Island
Infantry

Carte de visite by Frank Rowell (1832–1900) of Providence, Rhode
Island, September 1862

gle for all that we hold most dear, but I hope that this part was well
done."[29]

 Unlike many of his fellow soldiers, Clark did not reenlist after
his term expired, choosing to return to his job in Providence. He
died in 1874 at age thirty-two and was survived by his wife, Ann.

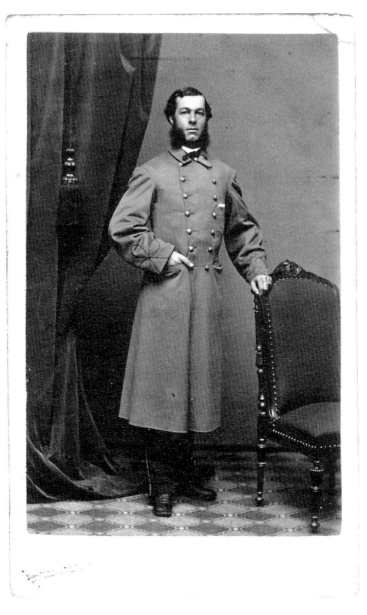

Capt. Hibbert Moin Bochner Masters, Fifty-fifth New York Infantry

Carte de visite by Daniel A. Clifford (1826–1887) & Thomas W. Shapleigh (life dates unknown) of Boston, Massachusetts, about 1862

In the Wrong Place at the Wrong Time

BRIG. GEN. JEB STUART[30] and 1,200 Confederate cavalrymen were finishing up a wild 150-mile reconnaissance-turned-raid run around the Union's Army of the Potomac. On June 13, 1862, the rebel horsemen hit a federal train near Tunstall's Station, only five miles outside the landing along the Pamunkey River at White House, a major Union supply base. The cars were packed with sick, wounded, and other military personnel, including Capt. Hibbert Masters, who, with many others, was taken prisoner and shipped south.

Masters, a twenty-two-year-old native of Canada, had been living in New York City when the war started. In October 1861, he accepted a first lieutenant's commission and joined the state's Fifty-fifth Infantry, a unit nicknamed the "Garde de Lafayette" for its large number of French immigrants. Led by poet-author Philippe Regis de Trobriand,[31] it joined the army outside Richmond, Virginia, in March 1862, and fought in the Peninsular Campaign, a failed Union effort to take the Confederate capital. On May 31, it lost more than one hundred men in the battle at Fair Oaks, Virginia; the casualties were sent to White House. Masters, then the regiment's assistant quartermaster, may have accompanied the unit's injured from the battlefield, or he may have been at the base on commissary business. He was incarcerated in Richmond's Libby Prison four days later and remained there for two months before being exchanged for a Confederate naval commander.

Masters returned to the Fifty-fifth in August, was subsequently promoted to captain, and departed the regiment with an honorable discharge in December 1862. He settled in Brooklyn, married in 1863, and became a merchant. His name last appeared in the city directory in 1890.

"He Was Wounded Bad"

JUNE 27, 1862, the third day of the Seven Days battles, was supposed to be a day of rest for the Fifth Pennsylvania Reserve Infantry. The regiment and its division, part of the Union army's fighting Fifth Corps, had been attacked the previous day at Mechanicsville, Virginia, only six miles from the Confederate capital. The division had fought hard at Mechanicsville, and Fifth Corps commander Brig. Gen. Fitz-John Porter[32] had planned to hold it in reserve on the 27th, but devastating rebel assaults upset his plans.

By 2 P.M., with the Union front caving in at nearby Gaines Mill, Virginia, Porter ordered in his reserves. According to Lt. Col. Joseph Fisher[33] of the Fifth, the regiment took its assigned position and held it "for nearly four hours under a heavy fire of the enemy, our officers and men behaving with great coolness and courage. We were kept under fire until our ammunition was exhausted, when our right flank was attacked by a brigade of the enemy and we were forced to retire, which we did in good order."[34] The regiment withdrew at sundown, less fifty-six casualties, including twenty-seven-year-old 2nd Lt. D. Hayes McMicken of Company A, who was wounded, left on the battlefield, and captured.

The third of seven children of Eleanor and David McMicken,[35] he joined the Fifth from Lycoming County, Pennsylvania, about seventy miles north of Harrisburg. James Miles Smith,[36] a private in his company, wrote home about McMicken, "He was wounded bad but I don't think dangerous. He was struck in the breast with a piece of shell."[37] Confederate guards escorted him with other prisoners to Richmond, Virginia, where surgeons found him to be in deteriorating health, gave him a parole, and sent him north.

On August 27, 1862, the U.S. Army reported that he had been

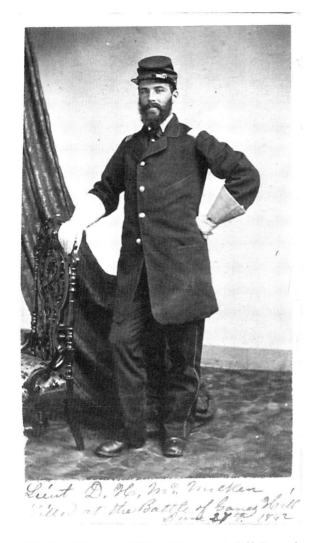

Lieut D. H, Mc Micken
Killed at the Battle of Ganes Hill
June 27 1862

2nd Lt. David Hayes McMicken, Company A, Fifth Pennsyl-
vania Reserve Infantry (Thirty-fourth Pennsylvania Infantry)

Carte de visite by Robert W. Addis (d. 1874) of McClees Gallery in
Washington, D.C., 1861

exchanged for a rebel officer, fulfilling the terms of his parole.
Chances are he never knew of the transaction, having succumbed
to his injury on July 31 in a hospital in Baltimore.

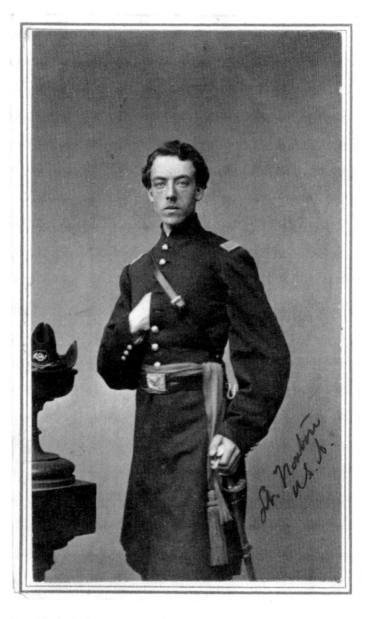

Capt. Motier Lafayette Norton, Company I, First Veteran Reserve Corps

Carte de visite by Richard A. Lewis (1820–1891) of New York City, about 1861–1862

"An Unusual Amount of Patriotism"

According to an old friend, Motier Norton was "embodied with an unusual amount of patriotism having a great love for liberty and our country."[38] Norton was quick to enlist after the Civil War started, joining Company B of the Eighteenth New York Infantry as second lieutenant. Here he discovered a fact that must have caused him great pain: he did not have the physical stamina to endure the rigors of military life.

A few days after he fought in the Battle of Malvern Hill, Virginia, in July 1862, Norton fell ill with typhoid fever and diarrhea. A month later, his health unimproved, doctors sent him to a military hospital in New York, where he remained nearly two months. After his release, he found himself "in such a condition that renders me totally unable to perform the duties of an Officer, or endure the fatigues of a Campaign."[39] He decided to resign for the good of the country. "By remaining longer in the army I feel I am occupying a position that should be filled by a man capable of doing the active duties of an officer and soldier, which I am not."[40]

Norton returned to his wife and children in Greenbush, a village outside Albany, New York. A year later, he found another way to serve his country—as an officer in the newly formed Invalid Corps, later renamed the Veteran Reserve Corps. The VRC was created in April 1863 for those unfit for combat duty but able to serve in a limited capacity. He performed quartermaster duties in two New York military hospitals and mustered out as captain in the summer of 1866.

After the war, he became a salesman and settled with his family in Ordway, Dakota Territory. Because he was still plagued with

diarrhea, his wife and friends urged him to file for a disability pension, but he "felt delicate about asking aid from the government."[41] He changed his mind and reapplied in 1883 after being diagnosed with rectal cancer, but died before the pension was approved. He was fifty-seven.

"Daring and Courage"

ON AN AUTUMN DAY in 1866, more than a year after the end of the Civil War, a steward sat at a table in a Washington, D.C., hospital, dipped his pen into an ink well, and prepared to take notes. Across from him sat the focus of his attention, 1st Lt. Dennis Moore, who described how his life had been forever changed when he was critically wounded in battle four years earlier.

Moore, formerly captain of the Sixty-first New York Infantry's Company B, told the steward of the tough predicament his command had been in at Nelson's Farm, near Malvern Hill, Virginia, on June 30, 1862: Late that summer afternoon, after having been under fire all day in support of Union batteries, the New Yorkers formed along a fence on the border of a field, fixed bayonets, and charged enemy positions across the open ground. Darkness and thick smoke clouded what happened next, but Col. Francis Barlow,[42] commander of the Sixty-first, reported that the Confederates "fell back hastily at our approach. . . . As we approached the woods on the other side of the field the enemy asked from within what regiment we were. My men answering 'Sixty first New York,' the enemy shouted, 'Throw down your arms, or you are all dead men.' We at once opened fire upon them. They were posted just in the edge of the woods. We were very close to them, and their fire severe and fatal."[43]

The rebels pounded the regiment with infantry and artillery fire. One shell smashed into Moore's right calf, shattering his bones and nearly tearing his leg off. He made his way to the yard of the Nelson farmhouse, now a makeshift hospital, where, an hour later, a surgeon amputated his leg four inches below the knee. He lay there for the next four days, without food or medical attention, while both sides continued the fight for control of the battlefield.

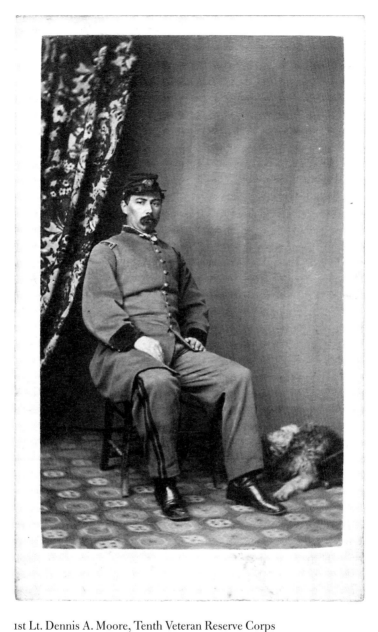

1st Lt. Dennis A. Moore, Tenth Veteran Reserve Corps

Carte de visite by Van Doorn (life dates unknown) of Brooklyn, New York, about 1863–1864

When it was all over, the Confederates held the ground — Moore and all the other wounded were captured and sent to Libby Prison in Richmond. On July 19, almost three weeks after his amputation, he was paroled, sent North, and furloughed to his family home in New York City to recuperate. In his year with the Sixty-first, he "won the esteem of his fellows by his daring and courage,"[44] and secured a reputation of honor, discretion, and reliability.

Back in New York, a prominent family friend who had donated funds for Moore to recruit Company B helped him back on his feet.[45] He fitted him with a top-quality, custom-made artificial leg, then secured him a commission in the Tenth Veteran Reserve Corps, which he joined and was rated by the command's colonel as "one of the most efficient line officers we have."[46] He served in New York's Park Barracks and in the Kalorama Hospital in Washington, D.C., where he worked in proximity to a smallpox ward.

In September 1865, he married Francis Gardner. They lived in Washington until his discharge the following year, then moved to Columbia, South Carolina, her hometown, where he found work as an army sutler. In 1870, they left the South for Newport, Rhode Island, where he served as postmaster. He died in 1875 at age forty.

He Stayed at His Post

ACCORDING TO A family friend, Dr. Albert Robinson was "the most domestic man I ever saw."[47] A graduate in the University of Buffalo class of 1857, he settled in Holden, Massachusetts, a hamlet near Worcester, established a practice, and married in 1859. After the Civil War started, he left the comforts of home for the rigors of army life.

In the summer of 1862, he was commissioned as assistant surgeon of the Tenth Massachusetts Infantry. The following April, he took ill in camp at Falmouth, Virginia. "I was prostrated by Malaria Neuralgia,"[48] a nervous disorder that caused excruciating pain along the nerves in his head and back. "I was sick and confined to my tent a week or ten days before I went to the hospital,"[49] he reported. His boss, Surgeon Cyrus Chamberlain,[50] stated that his illness was the result of exposure to "camp life and service in the field."[51] Chamberlain recalled, "I treated him for his neuralgia with an injection of morphine. I remember that in particular, because of its complete success in so readily relieving him of his pain."[52] His relief was temporary, as his condition became chronic. But he stayed at his post and advanced to surgeon after Chamberlain was promoted and left the Tenth. Chamberlain saw Robinson several times after and found "his general appearance . . . rather haggard — as though the Service did not agree with him."[53]

Robinson mustered out with the Tenth in 1864. He and his wife moved to Boston the following year, hoping city living would decrease his neuralgia attacks by limiting his outdoor exposure. But he still suffered four to five episodes each year. A typical attack lasted from one to four weeks, "rendering me totally unable to attend to my professional duties, thereby losing time, business and patients."[54] In the 1880s, in his mid-forties, he used a cane to sup-

Surgeon Albert Brown Robinson, Tenth Massachusetts Infantry

Carte de visite by Mathew B. Brady (b. ca. 1823, d. 1896) of New York City
and Washington, D.C., about 1863–1864

port his weakened body. A patient remembered how Robinson
would "pull himself up by hitching his cane on to the top of a
door."[55] But it was heart disease that killed him, at age seventy-
three in 1908.

ON JULY 8, 1862, the U.S. War Department issued General Order 75, which made provisions for the appointment of regimental recruiting officers. Each officer would hold the rank of second lieutenant and would be expected to make recruiting quotas on a time frame designated by each state's governor. In August 1863, four officers of the Eleventh Kansas Cavalry signed a nomination letter recommending Pvt. Thomas Barber "as a suitable and qualified person"[56] for the position. Barber, a twenty-six-year-old farmer from Emporia, Kansas, was a five-foot-five, blue-eyed English immigrant described by one friend as a man who "was not physically powerful."[57] He may not have been a strong man, but he impressed the Eleventh Cavalry's officer corps, who recommended him for two staff positions before the war's end.

First, as a second lieutenant, he was appointed recruiting officer, and in December 1863 he reported to Fort Leavenworth, Kansas. Six months later he returned to the Eleventh Cavalry, after his appointment and commission expired. Thanks to another nomination letter signed by officers from the regiment, he assumed the duties of staff veterinary surgeon with the rank of sergeant major. He served in this capacity until the end of the war.

After he mustered out, Barber returned to farming in Emporia and married Emma Rose Swingley in 1869. They were parents of two children—a son who died young and a daughter who lived to maturity. About 1877, the Barbers moved to neighboring Morris County, Kansas, and lived in Council Grove for a few years before settling permanently in nearby Dunlap. In 1919, suffering from rheumatism and nearly blind and deaf, he was admitted to the western branch of the National Home for Disabled Volunteer

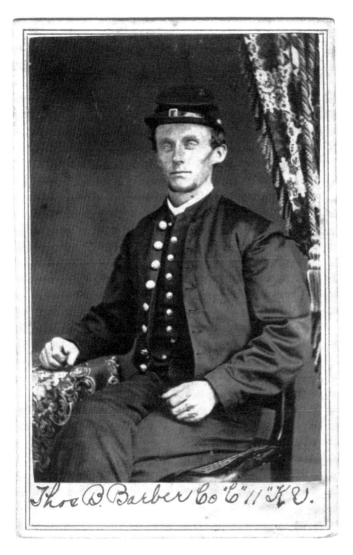

Thos B. Barber Co "C" 11 "K.V.

Veterinary Surgeon Thomas B. Barber, Eleventh Kansas Cavalry

Carte de visite by unidentified photographer, about 1862–1863

Soldiers, in Leavenworth. He returned to his home in 1922 and, thanks in part to the care and attention of his wife and a full-time nurse, lived for five more years.

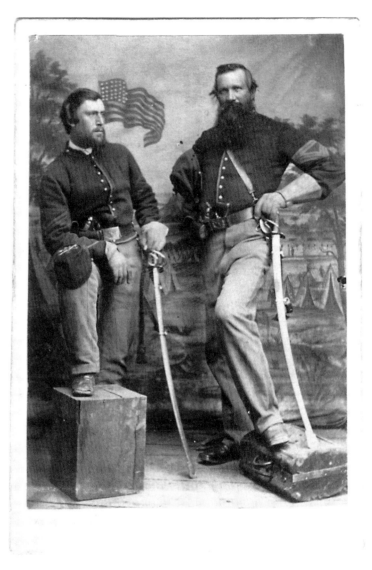

Quartermaster Sgt. Henry Augustus Blanchard, Company I, Thirteenth
New York Cavalry (*right*) and friend

Carte de visite by unidentified photographer, about 1863–1864

GUS BLANCHARD, delirious from typhoid fever, tossed and turned in his bed at a tent hospital in Winchester, Virginia. "About half the time I did not know whether I was dead or alive, did not expect to live,"[58] he recalled. He was in no condition to be moved, but after news of an imminent rebel raid swept through the federal-occupied town in the summer of 1862, Union commanders ordered an immediate evacuation. He and other sick men were hastily loaded onto a train bound for Harpers Ferry, Virginia. "They put me into a box car without straw or any thing but a blanket to lie on,"[59] he remembered. He hoped simply to avoid capture and survive the trip.

Blanchard, a "big, stout, square-built fellow,"[60] was a mountain of a man at 200 pounds and over six feet tall. He had grown up around New York's Catskill Mountains, where he enjoyed a reputation as "a most attractive and interesting gentleman in conversation."[61] An avid reader, "his mind was well stored from many of the best authors, and he could entertain for hours with recitations."[62] According to his brother, he "had no time to waste with those who had no aspirations,"[63] and preferred to surround himself with those who challenged his intellect. He followed two of his heroes, Daniel Webster and Henry Clay, into the Whig Party, and became an ardent supporter of the Republican Party after it formed in 1854. Passionate about agriculture, he proved an efficient manager of his family's large farm, where he increased crop production, improved the buildings, and planted various species of fruit and ornamental trees.

In the fall of 1861, at age thirty-seven, he joined the Fifth New York Cavalry as a sergeant in Company M. He traveled with his regiment to Maryland and, in May 1862, moved on to Virginia's

Shenandoah Valley. There he fell ill with typhoid fever. He survived the evacuation to Harpers Ferry, but on September 12, a week shy of the battle at nearby Sharpsburg, Confederates captured Blanchard and other patients at a Frederick, Maryland, hospital where he was recuperating from a relapse of typhoid and the onset of rheumatism. He was "a prisoner there under the rebels about ten days."[64] Shortly before Christmas, he received a parole and returned to his regiment, but his health was broken. He remained on the regiment's rolls until July 1863, when, no longer able to endure the rigors of campaigning, he resigned. He returned to the army two months later with the Thirteenth New York Cavalry as a quartermaster sergeant, a position requiring light work and little exposure, and served until the end of the war.

Blanchard's health prevented him from returning to the farming life he loved, and he drifted from job to job. In 1876, he became overseer of his brother's Delaware farm, but the work proved too taxing. He suffered spells that left him in a semicomatose state — on several occasions, workers found him lying in a field or along a roadside "in a perfectly helpless and prostrate condition."[65] In 1881, he gave up farming altogether, moved to Washington, D.C., and became a watchman at the U.S. Navy Department.

He suffered a paralyzing stroke in early 1896 and died the following year at age seventy-three. A confirmed bachelor, he left behind no family. The fruit and ornamental trees he planted in New York years earlier outlived him, providing shade and beauty along streets and inside a park surrounding a school and church which were carved out of the land that was once his family farm.

FIVE MILES SOUTH and west of Culpeper, Virginia, Cedar Mountain rises above a hilly landscape checkered with farms. On August 9, 1862, Union and Confederate armies tore into each other in the fields and woods just beyond the base of the mountain in the first engagement of the Second Bull Run campaign. The next day, Union Gen. George Gordon[66] surveyed the battlefield where he had lost 466 of the 1,500 men in his brigade. "On our left the cornfield was only sprinkled with dead, but on the wheat-field, and in the woods into which our regiments charged and by the fence where my brigade fought in line of battle, there were ghastly piles of dead."[67] Gordon came upon the grisly scene where his old regiment, the Second Massachusetts Infantry, had been overwhelmed on the front, flank, and rear. The corpses of five officers, including one of the regiment's most popular captains, thirty-one-year-old Blackstone Williams,[68] were surrounded by many of their fifty-two troops killed in action.

Williams opposed the Republican Party. His minister described him as "staunch in the conviction that the success of that party, following the long agitation at the North of the disrupting question of slavery, had precipitated the Rebellion."[69] But after the war began, the Boston bachelor put politics aside, left his father's home in Jamaica Plain, and raised recruits for the Second Infantry. He brought a wealth of experience — and privilege — to his command. Born into a family of means, he studied drawing and mathematics under private teachers and became an engineer. In 1850, he accompanied a team of engineers to Mexico to survey a rail route across the Isthmus of Tehuantepec.[70] The venture was abandoned a year later, but Williams continued working in the booming railroad business and prospered from lucrative construc-

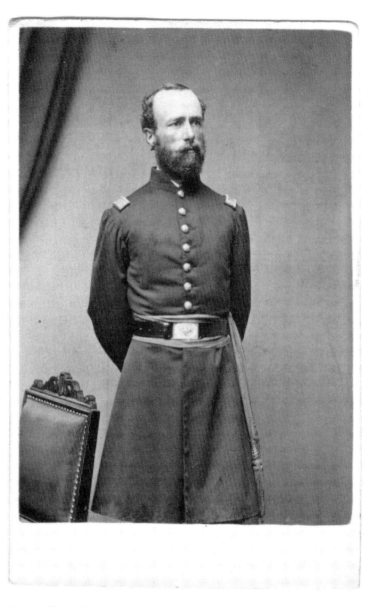

Capt. William Blackstone Williams, Company E, Second Massachusetts Infantry

Carte de visite by John Adams Whipple (1822–1891) of Boston, Massachusetts, about 1861

tion contracts in the Midwest. In 1858, he toured Europe, returning just before the war started. Williams's accomplishments sat with an easy grace upon him and, combined with a gentle and easy manner of speaking, earned him the respect of the enlisted men and his fellow officers. Friends remembered him as "generous and upright, cool, reflective, sagacious, resolute in purpose, courageous."[71]

His body was sent home, and a memorial service held at the Unitarian Church in Jamaica Plain was attended by a large group of mourners. The pastor said of Williams, "My friends, his best eulogy cannot be spoken. It is the silent homage to his worth, of which this immense concourse of friends is the expression; it is the unbounded confidence, respect, and love of his companions in arms. . . . it is the eternal debt which the American Nation owes to his memory, and the enrolment of his name in the grand historical obituary of the peerless defenders of her institutions, her liberties, and her life."[72]

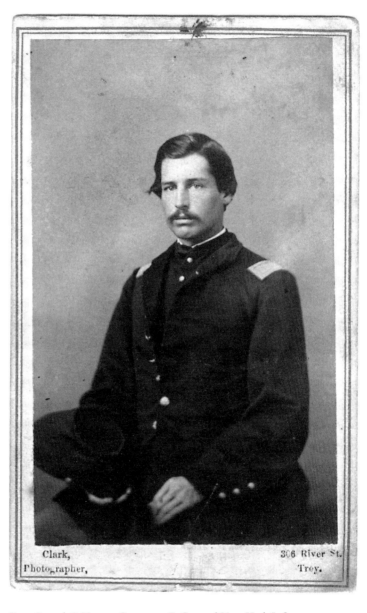

Capt. Joseph J. Hagen, Company B, Second New York Infantry

Carte de visite by Clark (life dates unknown) of Troy, New York, about 1861–1863

Distinguished Conduct

JOSEPH HAGEN would have been on any recruiting officer's short list. The twenty-one-year-old civil engineer, a native of Troy, New York, was intelligent, well educated, and ready to fight. A week after the war began, he signed up for a two-year enlistment with the state's Second Infantry, and within six months he had risen through a rapid series of promotions from first sergeant to captain and command of Company B. His engineering background caught the attention of brigade commanders, and they tapped him for special duty on more than one occasion. But Hagen made his most notable contribution in August 1862 at Bristoe Station, Virginia, one in a series of tactical battles in the Second Bull Run campaign.

That summer, Union Army of Virginia commander Maj. Gen. John Pope,[73] stymied by enemy maneuvers, reacted by concentrating his army around Manassas to guard his communications and protect the federal capital. Pope's confusion was understandable. In an unconventional move, Confederate forces had divided into two wings and were aggressively probing the sluggish Union lines for weakness. On August 27, as troops from Maj. Gen. "Stonewall" Jackson's wing marched to envelop a federal flank, a rebel division posted at nearby Bristoe Station as a lookout spotted the Second New York, which was the skirmish line for its brigade. At half past two that afternoon, brigade commander Col. Joseph Carr[74] reported, "My skirmishers engaged those of the enemy. I formed line of battle with the Second New York Volunteers and the Fifth and Eighth New Jersey Volunteers and advanced through a dense wood, when the enemy made a stand."[75] The Union regiments moved forward and "charged the enemy, driving him about 200 yards into a thick woods, where they again made a

stand and gave battle."[76] The fight lasted more than an hour before the enemy withdrew and joined the Confederate wing. Each side lost about three hundred men. Col. Carr praised Capt. Hagen and other officers, who "particularly distinguished themselves on this occasion."[77] The campaign ended in a complete Union defeat a few days later, however, at the Second Battle of Bull Run.

Hagen mustered out with the Second in May 1863 and returned to Troy. In 1869, he married Sara Reed. Their first child, Joseph Jr., was born the following year but died at age two. They had two more sons, both of whom lived to maturity, and two daughters, who died young. Sara passed away in 1902 and Hagen in 1915. He was seventy-six.

Wounded at Bristoe Station

IN SUMMER 1899, Col. James W. Powell Jr. was ordered to the Philippines with the Seventeenth U.S. Infantry to quash the insurrection against U.S. rule, which had been implemented after the United States annexed the country at the end of the Spanish-American War in 1898. Powell went on the sick list soon after his arrival, plagued by malaria and dysentery contracted earlier that year in Cuba.[78] Resting in his quarters, waiting for a leave of absence to be approved, he might have cast his mind back to the Civil War and Bristoe Station, Virginia, where he had been wounded thirty-seven years earlier.

Back in 1862, twenty-one-year-old Powell had served as a lieutenant and adjutant with the Seventy-first New York Infantry. He and his father, Dr. James Powell Sr., had joined the regiment a year earlier. His father enlisted as the regimental quartermaster and later became a staff surgeon. At the Battle of Bristoe Station on August 27, a musket ball slammed into young Powell's right thigh. In surgery, a fragment of a knife blade and a piece of clothing were removed from the wound. He returned to duty in December as assistant adjutant of his brigade. However, his injury continued to trouble him, and he underwent another surgery, to relieve abscesses on his thigh. He began to heal properly, but recovery was slow and Powell resigned. After a couple of months off, he enrolled in the Tenth Veteran Reserve Corps and served in an administrative capacity until 1866, when he joined the regular army. Over the next thirty years, he played a leadership role in several infantry regiments and rose to the rank of colonel. After war broke out with Spain in 1898, Powell and the Seventeenth Infantry were dispatched to Cuba and on to the Philippines.

When Col. Powell's leave of absence from the Seventeenth Infantry was denied, he resigned, retired, and went home to Denver, Colorado. He died of cancer in 1907, survived by his wife, Angeline, and four children.

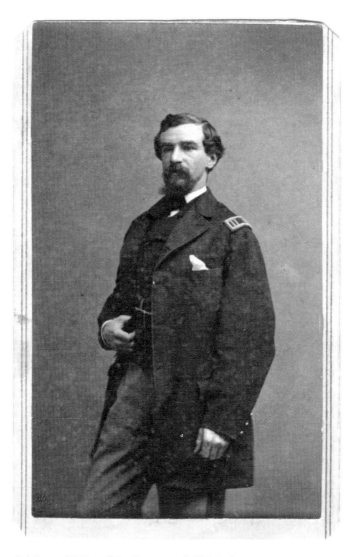

Col. James W. Powell Jr., Seventeenth U.S. Infantry
Carte de visite by unidentified photographer, about 1863–1864

"I Was Carried from the Field Utterly Helpless"

IN THE LATE AFTERNOON of September 17, 1862, at Sharpsburg, Maryland, a rebel artillery shell hissed as it rocketed through the air over the battle-scarred landscape near the Stone Bridge, a focal point of the day's horrific battle. Seconds later, it slammed into the ground near the edge of a field and exploded a few yards from Capt. Sam Oliver, who was standing with the remnants of his regiment, the Thirty-fifth Massachusetts Infantry, which had just lost more than two hundred men and officers in bloody fighting.

According to Oliver, "At or about six p.m. or it may have been a little earlier in the day, when nearly and safely through that terrible day, by the explosion of a shell, a fragment of which cut a piece from my hat, another fragment nearly severing my badge of rank from my left shoulder, I was thrown violently backwards against a stone wall or batch of large rocks, rendering me for a while insensible. I was carried from the field utterly helpless. From a hospital I was placed, in a day or two, in the railroad train and with a legion of others wounded was sent to Washington and there ordered home. My limbs were entirely useless, but with the help of crutches and two soldiers I reached my home at Salem."[79] His spine was injured and his legs paralyzed.

A few months before his injury, he had resigned under pressure from his first unit, the Fourteenth Massachusetts Infantry,[80] which he had joined a year earlier with a lieutenant colonel's commission. The Fourteenth's colonel, William Greene,[81] found Oliver "of no use" to the regiment, believing: "that he has not (and never has had) the least idea of the duties of his position, that the Regiment can get along better without him than with him, and that it would be for the interest of the service if he should be honorably discharged at the earliest convenient moment."[82] Oliver resigned

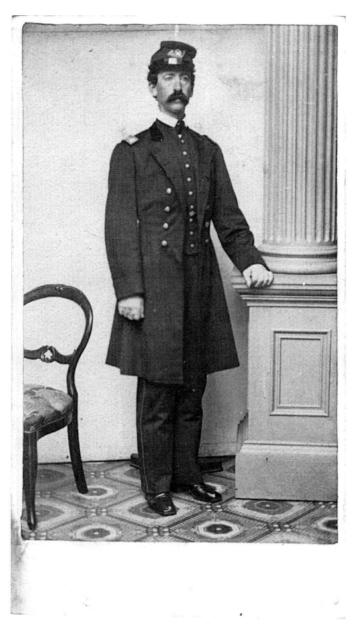

Lt. Col. Samuel C. Oliver, Second Massachusetts Heavy Artillery

Carte de visite by unidentified photographer, about 1862

in March 1862 and reenlisted as captain in the newly formed Thirty-fifth Infantry in August. He made a positive impression on his new colonel, Edward Wild,[83] who wrote, "I had such entire confidence in him, that I twice offered him the Colonelcy of a Colored regiment. At that time we were still hoping for his complete recovery. But he felt obliged to decline the offer, or to postpone the acceptance of it."

Oliver never accepted the offer, but, encouraged by the return of movement to his legs, he shed his crutches for a cane and joined the Second Massachusetts Heavy Artillery as its major. In January 1865, he applied for a commission in the Veteran Reserve Corps, but an examination board turned him down after a routine evaluation found him deficient in military knowledge and ability. He served his term of enlistment in the Second Massachusetts in North Carolina and ended the war in command of a battalion station at Fort Fisher.

He left the army at the end of 1865 with a colonel's brevet for gallant and meritorious service and returned to his family and the carpentry business. He never regained the full use of his legs, despite a multitude of treatments over a twenty-year period, including specially designed braces and electric shock therapy. He died of bronchitis in 1888 at age sixty-one.

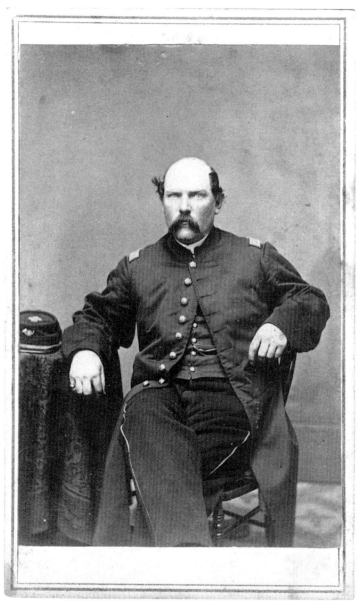

Capt. George Pierce Jr., Company G, Tenth Massachusetts Infantry

Carte de visite by D. B. Taylor (life dates unknown) of Greenfield, Massachusetts, about 1862–1864

Reinstated

In September 1862, Capt. George Pierce joined ten line officers from his regiment, the Tenth Massachusetts Infantry, and resigned his commission to protest the appointment of Maj. Dexter Parker,[84] a man "no more fitted for the position of major in a military point of view, than is a child three years old."[85] They were promptly arrested and sent before a court-martial. Two months later, the regimental correspondent reported: "Their case has been settled at last; all have been discharged but our Captain [Pierce]. How thankful we shall be if he is permitted to take command of us. If we should see him at the head of the company today, we should all consider it a Merry Christmas indeed."[86] He was not dismissed, due to a technicality — his file was lost in military bureaucracy. When it was found a few weeks later, he was cashiered.

His colonel, Henry Eustis,[87] came to the rescue. He petitioned President Abraham Lincoln to reinstate him. Lincoln agreed, and Pierce returned to his regiment in August 1863.

George Pierce was wounded in three Virginia battles: at Malvern Hill in July 1862 he was shot in the right arm, at Spotsylvania Court House in May 1864 he received a slight head injury, and at Winchester in September 1864 a gunshot in the right shoulder ended his war service. Just before Winchester, he escaped being fatally wounded when a musket ball that struck him in the chest was stopped by a notebook and papers in his breast pocket.

After his wounding at Winchester, he left the army with a medical discharge and went home to his family in Greenfield, Massachusetts, where he returned to his business as a shopkeeper, became involved in local politics, and joined the community's Grand Army of the Republic chapter. Townspeople called him "Cap" in

honor of his rank during the war. He loved plants and was active in numerous organizations, including the Massachusetts Society for the Prevention of Cruelty to Animals. Later in life, he enjoyed an occasional game of billiards and a cigar at the home of a cousin, and would often be seen with "Boney," his terrier and close companion. Pierce lived to the age of eighty-five, dying of heart disease in 1915.

Making a Scene

OLD ZACHARIAH MEDLER was drunk as a lord when he entered the doctor's office one day in January 1903. He managed to hand over the paper ordering him to appear for his pension exam and took a seat with the three or four patients ahead of him. But he was too tight to wait, and staggered into the examination room to get his paper back. When the doctors and patients tried to reason with him, he exploded in a stream of profanity and obscene language then stumbled out of the office and disappeared. He had a history of problems, and his checkered past extended back to his days as a soldier in the War Between the States.

Medler, a twenty-three-year-old boatman in Sullivan County, New York, joined the state's 143rd Infantry in the summer of 1862. October 8 was enrollment day for the volunteers, but not for Medler — he missed the muster due to illness. He joined the regiment after he recovered but was not formally enlisted until December. The delay caused his name not to be included on payroll records, and he went without salary until a clerk corrected the error some months later.

He started out as a corporal in Company E and made sergeant in early 1863, but he was busted to private for undisclosed reasons soon thereafter. In August he regained his original rank, corporal, and served as such for the remaining two years of his enlistment, marching and fighting from Alabama and Tennessee through Georgia to the sea, and into the Carolinas by the war's end.

Medler made sergeant a second time in January 1865. He mustered out with the regiment when the war ended. After returning to New York he married Elvina Hazen, and they started a family that grew to include three sons and two daughters. He supported

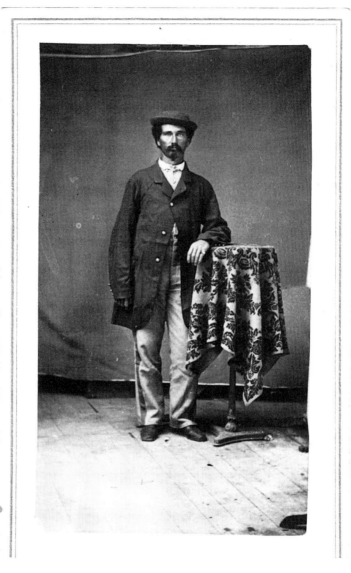

Sgt. Zachariah Medler, Company E, 143rd New York Infantry

Carte de visite by unidentified photographer, about 1862–1864

his family as a ship's carpenter, and his wages kept them afloat just above the poverty line.

He turned to alcohol at some point in his life, and it eventually consumed him, his scant earnings, and the dollars from his veteran's pension. In the 1890s, his oldest child, Bertha, intervened with a letter to the government's pension office. She wrote, "I think it would be an act of kindness to stop my father's pension for he don't use any of it in the family. It all goes for drink." She explained that he abused her mother and added, "I cannot help complaining for it don't do us any good and he is so ugly to us."[88]

Medler drowned in the Erie Canal at Amsterdam, New York, in 1912. Authorities ruled his death an accident. He was seventy-two.

Hell's Half Acre

ALONG STONES RIVER, Tennessee, on the last day of 1862, the break of dawn revealed masses of Confederate troops in motion against the Union Army of the Cumberland. The rebels swept into and crushed the federal right wing, and the stunned Union army fell back and scrambled to establish a defensive line, the strategic key of which was a four-acre grove of trees called "Round Forest," dubbed "Hell's Half Acre" after the battle. Near this point the Sixth Ohio Infantry received orders to launch an assault to protect the new line. In Company C, Cpl. Aloise Kalin worked with his line officers to prepare his men for the attack.

The Sixth and another regiment advanced and saw Union troops "flying in wild disorder, and hotly pursued by the enemy."[89] Col. Nicholas Anderson[90] formed the 383 men of the Sixth into a line of battle. Anderson recalled, "In a few minutes a terrible fire was opened on us, scarce one hundred yards distant, from a rebel line apparently four deep."[91] The Sixth fought desperately for forty minutes. Anderson ordered his men to "fix bayonets!"[92] then abruptly changed the command to retreat after the rebels flanked the regiment on both sides. "A score of gory corpses—brave men but half an hour before—marked the line where the Sixth had fought, and five score more were suffering there, or wending their painful way toward the rear in search of the surgeon."[93] The assault bought time for the rest of the brigade to prepare for the oncoming rebels, who were ultimately repelled. A half-hour later, the Sixth was sent in again—this time to support troops fighting on Hell's Half Acre. "The regiment was under almost constant fire, and many more brave men were there killed or wounded." The Sixth suffered almost fifty percent casualties, including Kalin, who was desperately wounded.

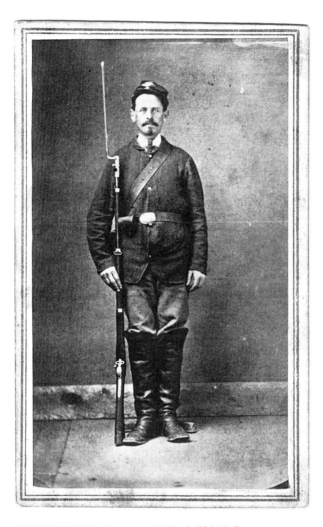

Cpl. Aloise Kalin, Company C, Sixth Ohio Infantry

Carte de visite by John Henry Reinhold (life dates unknown) of Cincinnati, Ohio, August or September 1862

Kalin was probably an immigrant from Eastern Europe.[94] He made his way to a hospital in nearby Murfreesboro, but succumbed to his wound two days later, as Union troops repulsed the last attacks in the battle and won a strategic victory that secured central Tennessee for the Union.

Latitude 29° 20', Longitude 75° 30'

POWERFUL WAVES formed by the turbulent, storm-swept waters of the Atlantic Ocean tossed the little transport steamer *Continental* back and forth as it chugged south some four hundred miles off the coast of Florida in the middle of January 1863. Onboard, many of the men of the Fifty-third Massachusetts Infantry were seasick. When Marcus Hagar of Company I was seized with a sudden attack, some may have assumed him another victim of the rough voyage. But the twenty-one-year-old first sergeant suffered from heart disease, and this episode proved fatal.

Hagar, an intelligent young man of promise from Westminster, Massachusetts, taught school and painted in his hometown when the war started. In the autumn of 1862, he enlisted as a private in Company I of the state's Fifty-third Infantry and was soon promoted to first sergeant. Two weeks after he shipped out with his regiment for New Orleans he suffered his fatal attack. His fellow soldiers buried him at sea. It was "a solemn event, which left a deep impression upon all who witnessed it."[95]

"It was at sunset, and while most of the men were too sick to come on deck, a few comrades of Company I came to attend the brief but solemn service. The steamer was slowed up, the colors hoisted at half-mast and the body of poor Hagar, which had been sewed up in a blanket with weights at his feet, was tenderly brought and placed on a plank, projecting over the vessel's side. The chaplain read the Episcopal form of service for the dead, while the little company of officers and privates stood reverently by with bowed heads. At the words 'we therefore commit his body to the deep,' the plank was lifted, and the corpse plunged beneath the waves; a brief prayer and all was over."[96]

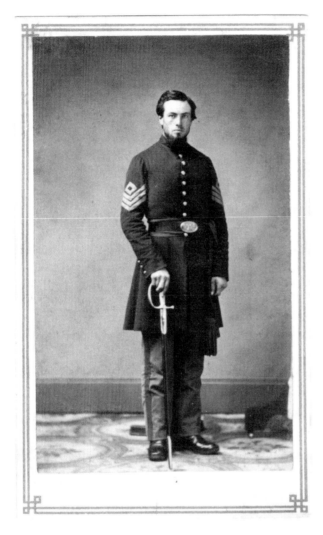

1st Sgt. Marcus Jones Hagar, Company I, Fifty-third Massachusetts
Infantry

Carte de visite by unidentified photographer, about 1862

He was buried at latitude 29°20', longitude 75°30'. Hagar's per-
sonal effects, including $1.90 cash, a diary, a pocket Bible, and a
silver watch, were sent home to his father.[97]

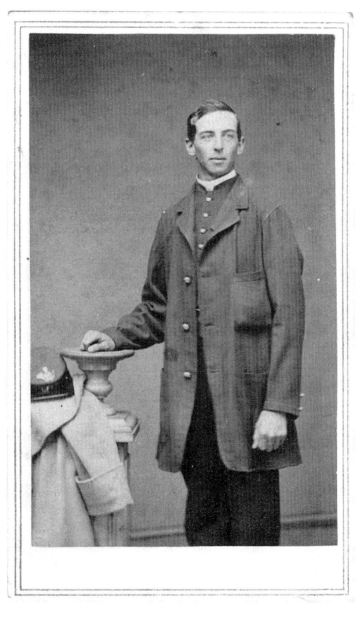

Pvt. Silas F. Havens, Company G, Fiftieth Massachusetts Infantry

Carte de visite by Abraham Bogardus (1822–1908) of New York City, about 1862

A Pension for the Old Man

SILAS HAVENS FELT angry and hurt. In the summer of 1896, he was abruptly dismissed from his job as deputy collector of taxes for New York's Second District. Desperate for income, the fifty-nine-year-old salesman-turned-bureaucrat hoped to land an important government contract—his disability pension. During the Civil War, he had served with the Fiftieth Massachusetts Infantry, a regiment organized in the autumn of 1862.

Havens was ill on September 19, 1862, the day he mustered in as a private (the nature of his illness was not recorded), and he was sent to a New York hospital, where he recuperated over the next three months. In December 1862, he joined his comrades in Company G and sailed for New Orleans, where the Fiftieth saw limited combat. At Port Hudson, Louisiana, the regiment's lone battle, it played a supporting role for heavy artillery units. Without losing any men to enemy fire, the Fiftieth mustered out in August 1863, having completed its nine-month term of enlistment. Havens found work in New York City, married in 1868, and settled across the Hudson River in Passaic, New Jersey.

In his 1896 pension application, Havens claimed he suffered with rheumatism and varicose veins contracted in the army. His claim could not be proven, and the government denied his request. He began a futile letter-writing campaign to protest his rejection. In a letter to the U.S. Secretary of the Interior, he vented his frustration at losing his state job, "for *no other reason* only that I was a *Republican.* I think the least the Government can do is to pension the old men until they are called to their long home, which is fast drawing to a close."[98] The following year, he reapplied, this time alleging, in addition to his other infirmities, total deafness in his right ear. A medical board disagreed—they found

his hearing was only diminished—and he was rejected again. He was finally granted a pension in 1907, after an elevator accident in the cellar of an office building in New York's financial district crushed his left hand, causing the loss of two fingers. He enjoyed his stipend for barely a year, when, in February 1908, he suffered a fatal heart attack at age seventy. He left behind his wife, Charlotte, who filed an application for, and was promptly awarded, a widow's pension until her death in 1920.

Another Farmer Turned Artilleryman

IN 1917, NINETEEN-YEAR-OLD Byron Lisk left his home in rural Hankinson, North Dakota, and enrolled in the Twentieth U.S. Engineers, who were about to play a major support role for the American Expeditionary Force entering World War I. He soon shipped out for France, where he spent the next fourteen months building roads, improving railroads, and constructing port facilities. He mustered out in 1919, and joined his father in the ranks of American military veterans.

Byron's dad was Cassius Lisk, a Seneca County, New York, farmer who joined the Twenty-sixth Independent Battery, New York Light Artillery in September 1862, three weeks after his eighteenth birthday. The recruiting officer was not convinced that he was of legal age, but Byron's grandfather, Levi, certified the enlistment paper.

In early December, Pvt. Lisk and his regiment shipped out to New Orleans, Louisiana. Rough seas damaged their ship twice en route, but the battery arrived intact in late January 1863. It spent the Civil War in Louisiana and Alabama and saw little combat. No men were lost to enemy fire but thirty-three died of disease. Lisk suffered an accidental injury in camp one day when he split open the second toe of his right foot with an ax.

He remained a private his entire enlistment and mustered out with the battery in September 1865. He spent the next year at home in New York before moving to Decatur, Michigan, then, six years later, to South Bend, Indiana, where he took up wagon making. On Christmas Day 1872, Lisk, then twenty-seven, married nineteen-year-old Julia Johnson of Prairie Ronde, Michigan. They raised three daughters and two sons, settling in Hankinson in 1880.

In 1896, Lisk was diagnosed with chronic nephritis, or Bright's disease, a kidney ailment. Around the turn of the century, the Lisks retired to Yakima, Washington, where he died in July 1923 after suffering a heart attack. He had lived to be seventy-eight.

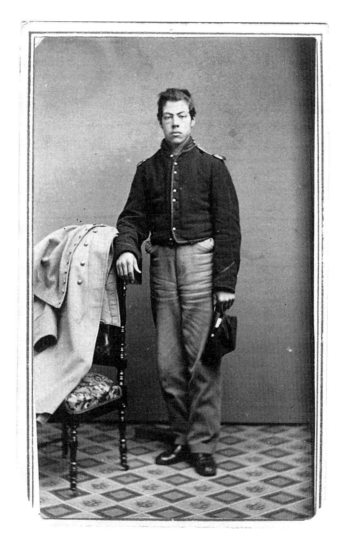

Pvt. Cassius Lisk, Twenty-sixth Independent Battery, New York Light Artillery

Carte de visite by unidentified photographer, about 1862

"He Was Generally Broke Down"

EDWARD MCATEE remembered his military service with pride, and his Civil War experience was one of the last things he spoke about before he died. During the evening of November 16, 1871, suffering intense pain from injuries sustained after he was thrown from his buggy while delivering mail nine days earlier, he sat in his rocking chair and reminisced about the war with a neighbor and fellow veteran. McAtee may have repeated lines from a letter he had written earlier that year, in which he declared, "I did not stand back when Uncle Sam wanted men," and "I gave my best days to the Government through two wars, in Mexico and the late war."[99]

In 1846, McAtee, a Jefferson County, Illinois, blacksmith, signed up as a private in the state's Third Infantry. He saw limited action with the regiment during the Mexican War. After the Third's one-year term expired in 1847, he went home and married. At the start of the Civil War, McAtee was a fifty-one-year-old father of five with a blacksmith shop and small farm. In late 1861, motivated by patriotism or perhaps by a desire to recapture his youth, he enlisted as a private in the Sixtieth Illinois Infantry with boys thirty years his junior. He remained in the ranks only a short time, for he was soon detailed as a hospital steward, serving in that capacity until Christmas 1862, when Company B elected him to be its new first lieutenant. His tenure with the company lasted less than one month.

On January 15, 1863, McAtee became ill after a fatiguing march through rain and snow from Nashville to Shoal Creek, Tennessee. Exposure to the elements aggravated his rheumatism, and diarrhea weakened him to the point where he "was not able to perform the duties of his rank properly."[100] He was sent back to the

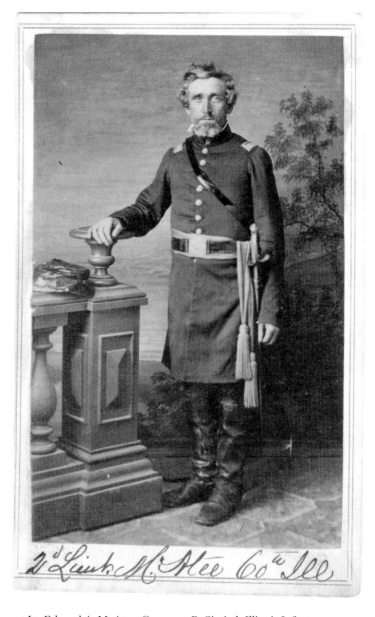

1st Lt. Edward A. McAtee, Company B, Sixtieth Illinois Infantry

Carte de visite by Theodore M. Schleier (life dates unknown) of Nashville, Tennessee, about 1864

regimental hospital—this time as a patient. Eventually ordered to the Officer's General Hospital on Lookout Mountain, Tennessee, he resigned his commission from there in December 1864.

He returned home in feeble condition—his wife described him as being "generally broke down." His poor health prevented him from blacksmithing, so he found less strenuous work as a mail carrier. He deteriorated quickly during the week following his buggy accident in 1871. McAtee's friend helped him to bed after they finished reminiscing, and the neighbor left for his adjoining farm. He "had been at home but a short time when I heard his folks holler, and in a short time I went over and he was dead."[101]

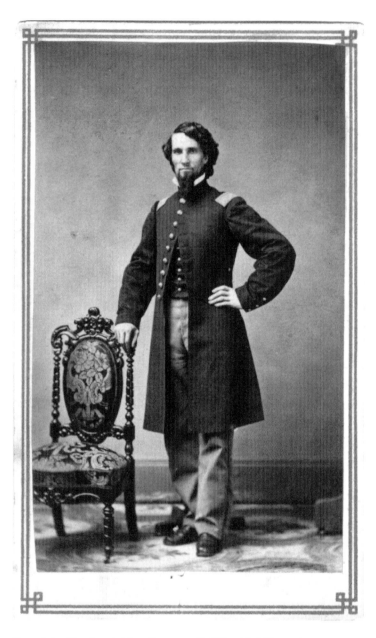

Capt. John Fletcher Ashley, Company G, Fifty-third Massachusetts
Infantry

Carte de visite by unidentified photographer, about 1862

On January 30, 1863, the Union transport steamer *Continental* chugged into the port of New Orleans, battered but intact, three weeks after it had departed from New York City. The ship and its cargo, the Fifty-third Massachusetts Infantry, had run into stormy weather and been bombarded by rough seas. To celebrate its safe passage, the officers of the Fifty-third arranged a special breakfast and nominated Capt. John Ashley to write and read a set of resolutions, "which embodied the sentiments of all, respecting the untiring and sleepless vigilance of the captain of the steamer and the efficiency of his subordinates."[102]

Ashley was a natural choice to deliver words of thanks and praise to the captain and crew of the *Continental,* because the thirty-four-year-old combat officer was an ordained Baptist preacher. The Nova Scotia, Canada, native had been schooled at seminaries in Rhode Island and Massachusetts in the mid-1850s. At the start of the Civil War, he ministered to congregations in Gardner, Massachusetts, and nearby villages, with the help of his wife, Maria. When the Fifty-third began forming for nine months' service in the summer of 1862, he heard the call and enlisted as captain of Company G. He had been more effective as a minister than he was as a fighting man.

After its harrowing voyage, the regiment spent the next seven months in Louisiana and Mississippi. Ashley contracted malaria within weeks of his arrival and was hospitalized. He rejoined his company a month later but the next day turned over command to a lieutenant and returned to the hospital, where he remained until the Fifty-third left for home.

Ashley mustered out with the regiment in September and re-

turned to Gardner, where he slowly regained his health. Soon after, he left his congregation for a Connecticut seminary, where he taught for many years. In the 1880s, suffering from heart disease, he returned to Gardner. His health fell into a steady decline after 1888, and he died in 1893 at age sixty-four.

In the Valley of the Shadow of Death

A VIRULENT EPIDEMIC of several diseases swept the Eleventh Kansas Cavalry during the early months of 1863. The regiment was infected with measles, smallpox, and other sicknesses at its camp on the lowlands along Cane Creek, about thirty miles south of Springfield, Missouri — the soldiers named the area the Valley of the Shadow of Death. In mid-February, the Eleventh relocated to a new camp west of Springfield, and the regimental surgeon ordered all men not previously vaccinated to be inoculated for smallpox, but Pvt. John Thomas and four other cavalrymen were on detached duty and missed the summons. They returned to camp soon after and were injected with the vaccine, but it was impure, and all were poisoned by the tainted batch. One man died, and the other four, including Thomas, suffered severe side effects that lasted their lifetimes.

A rash of blue pimples covered his body, and, Thomas wrote, "sores broke out all over me and formed abscesses at places which were long in healing."[103] He was sent to the hospital, and his arm remained sore and partially paralyzed for six months. "My whole body seems to be poisoned and my general health is growing rapidly worse," he recalled. "I have at frequent intervals a breaking out on my body, much like a rash, at other times large abscesses form and give me great suffering and pain lasting through several weeks before they break and run. My left side and arm are affected so that my arm is numb and nearly useless for labor."[104] After his release from the hospital, Thomas returned to the regiment, where he went on and off the sick list numerous times over the remaining two-and-a-half years of his enlistment.

After mustering out of the army in the summer of 1865, Tho-

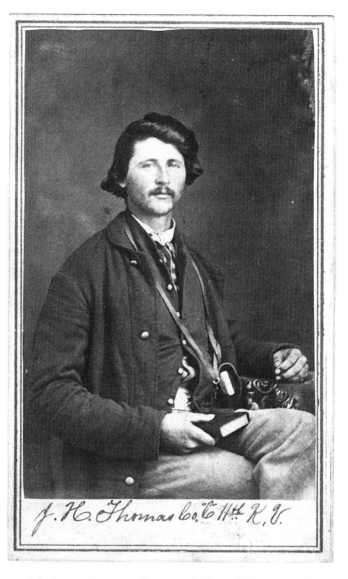

Pvt. John Harvey Thomas, Company C, Eleventh Kansas Cavalry

Carte de visite by unidentified photographer, about 1862–1863

mas returned to his farm in Emporia, Kansas, where he continued to be plagued by consequences of the contaminated vaccine. He explained, "I frequently break out with sores over my body — principally on left arm & left side. I feel weak & debilitated all the time — am occasionally confined to my bed and frequently to the house."[105] His condition slowed him down, but it did not prevent him from marrying in 1869 or raising three daughters and two sons. Thomas lived until 1911, dying of heart disease at age seventy.

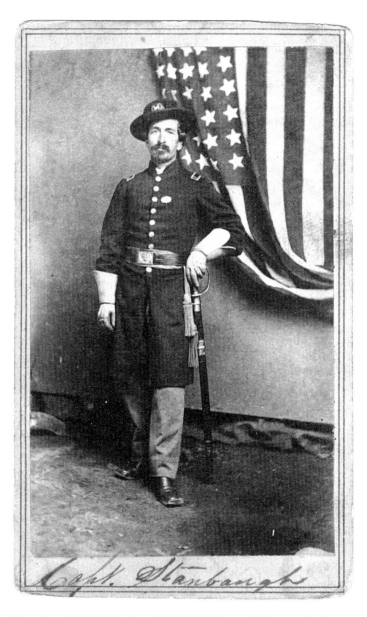

Capt. Joseph W. R. Stambaugh, First U.S. Veteran Volunteer Engineers

Carte de visite by I. H. Bonsall (life dates unknown) of Cincinnati, Ohio, about 1862

JOSEPH STAMBAUGH worked hard and played hard. According to friends and associates in his hometown of Sterling, Illinois, the North Carolina native "would take a social glass once in awhile. He would get out with the boys and get a little hilarious."[106] He was "a jovial fellow, and he drank a little too much at times."[107] But he was also a "man of action, mind and body,"[108] who operated a successful home decoration store that sold paints, wallpaper, and window shades, and cleaned carpets. He ran the store with his wife, daughter, and son-in-law from a two-story building they owned in town. The store occupied the first floor, and the Knights of Pythias, a fraternal order, rented the second floor. In his spare time, Stambaugh practiced taxidermy and "organized our militia company here and drilled it for pleasure."[109] Three years of service in the Civil War helped him to run the local company of volunteers.

Stambaugh mustered into the Seventy-fifth Illinois Infantry as a first lieutenant in September 1862, and, a month later, fought in his first battle, at Perryville, Kentucky, where he was slightly wounded in the side. In February 1863 he accepted a promotion to captain and company command. A month later, at Murfreesboro, Tennessee, he left his company, with orders to report to the Pioneer Brigade, where he supervised soldiers detailed to clear trees and brush, build roads, and satisfy other infrastructure needs for the Army of the Cumberland. He continued on detached duty until November 1864, when he joined the First Veteran Volunteer Engineers and finished out his army career at Chattanooga and Nashville, Tennessee.

After the war ended, he returned to his family in Illinois. Later in life, he suffered kidney and bladder disease and other ailments

that caused "paroxysms of pain in which he would spin around like a top until he became sick."[110] He worried that he was being poisoned by wallpaper paste and took a trip to Hot Springs, Arkansas, to relieve his pain, but the treatment failed. A fall from his horse while on a picnic in July 1889 marked the beginning of a serious decline in his health, and he died six months later at age fifty-eight.

Walt Whitman's Boss

On a clear spring day in March 1863, from a fifth-floor office window of the Corcoran Building in Washington, D.C., poet Walt Whitman was appreciating the view of the Potomac River, the National Mall, and other sites as he sat at his desk writing to two comrades. "I finish my letter in the office of Major Hapgood, a paymaster, and a friend of mine,"[111] he wrote, referring to Lyman Hapgood, a man as passionate about freedom and liberty as Whitman was compassionate about the wounded and ill patients he nursed.

Hapgood, a native of Maine and a banker in Boston, Massachusetts, was driven to achieve "my most earnest desire for the complete and triumphant success of universal liberty to all men without regard to race, color or condition."[112] He dedicated himself as a "true and efficient laborer in the early antislavery cause,"[113] first as a member of the abolitionist-led Liberty Party, then in 1848, after it joined forces with antislavery Whigs and Democrats to form the Free-Soilers. When the Republicans emerged in 1854, Hapgood became one of the party's Boston organizers. In its early days, "he was active, constant, valuable," recounted W. E. Webster, a close friend in Boston, "a man of sterling moral and political principles; he can be relied on everywhere and at all times."[114] After the Civil War began, U.S. senators Charles Sumner and Henry Wilson—both Massachusetts Republicans—secured a paymaster's appointment for the thirty-eight-year-old banker. He was ordered to Washington, reported to the Department of the Interior, and was assigned a spacious office in the Corcoran Building, which he shared with his clerk, Charles Eldridge, a Boston publisher who, in 1860, had managed the third edition printing of Whitman's *Leaves of Grass.*

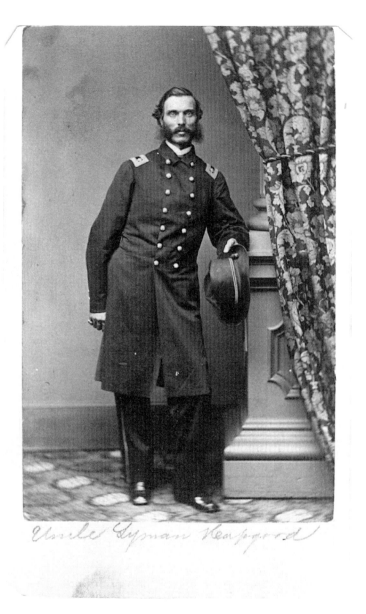

Uncle Lyman Hapgood

Maj. Lyman Sawin Hapgood, Paymaster, U.S. Volunteers

Carte de visite by Chandler or Charles Seaver Jr. (life dates unknown), of Boston, Massachusetts, about 1862–1864

"The Good Gray Poet"[115] came to Washington in December 1862 from Fredericksburg, Virginia, where he had visited his brother George, who had been injured in the recent battle there. Walking the streets and touring hospitals in the capital city, Whitman became overwhelmed by the pain and suffering of thousands of wounded and sick soldiers, and he enlisted himself to serve in behalf of the stricken. To fund his activities, he looked to Eldridge for help. Eldridge turned to his boss, Maj. Hapgood, and the latter provided Whitman with a comfortable base from which he could minister to his soldier "boys."[116] The major gave the poet a desk, put him to work as a copyist and clerk, and took him along on several trips to pay soldiers in the field. In late 1863, Whitman left Hapgood's office, although he continued to use Hapgood's mailbox for his correspondence.

By the war's end, Hapgood's reputation as a paymaster equaled the one he had gained for his political achievements. One admirer recalled, "his accounts have always been remarkably correct and . . . he is considered at the department one of the most valuable officers."[117] Hapgood lobbied to convert his volunteer appointment into a regular army commission, but his efforts failed. He returned to his wife, Elizabeth, and home in Boston. He remained a widower after her death in 1868 and, after taking sick during an unseasonably cold spell in March 1896, succumbed to pneumonia after a short illness. He was seventy-three.

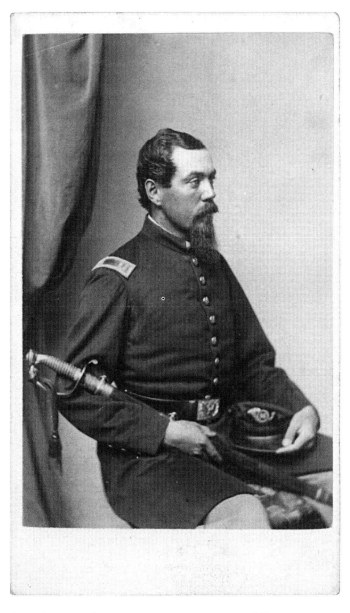

Capt. George Parkman Denny, Company A, Forty-fifth Massachusetts Infantry

Carte de visite by Frederic L. Lay (life dates unknown) of Boston, Massachusetts, about 1862–1863

"Charge, Double Quick!"

ON APRIL 28, 1863, the Forty-fifth Massachusetts Infantry deployed in line of battle near the junction of the Atlantic and North Carolina Railroad and Dover Road, a crossroads about one day's march from its base at New Bern, North Carolina. Behind them stood the Seventeenth Massachusetts Infantry. In front lay the railway, blocked by rebel earthworks. At the center of the line, Capt. George Denny's Company A formed the color guard and waited while Col. Charles Codman[118] assessed the situation.

Denny, a thirty-six-year-old merchant from Boston, was a founder of the regiment. Before the war, he had been a private in the Boston Cadet Company, a militia unit formed in 1741 to act as bodyguards for the royal governor. In 1765, the company had helped quell riots waged by irate Bostonians against the Stamp Act. By the time of the American Revolution, relations with the governor had become strained, and the company disbanded. It had reorganized against Britain soon thereafter. In 1862, the U.S. government had activated the Cadets for six weeks and ordered them to Fort Warren, in Boston Harbor, to guard Confederate prisoners. After that stint, four cadets, including Denny, then a first lieutenant, and Col. Codman, had opened a recruiting office in Boston and organized the Cadet Regiment, which had mustered as the Forty-fifth Infantry after the war began. It had been ordered to North Carolina, where it had helped slow Confederate plans to protect supply lines and gather materials for Gen. Robert E. Lee's Army of Northern Virginia.

By mid-April 1863, rebel forces were in check, and a small force of enemy infantry guarded the railroad junction near Dover. As Col. Codman deliberated, the Confederates opened fire. Codman called on Denny's company, divided into two platoons, to

spearhead the attack. Codman barked, "'Platoons into line'; then 'first platoon, Ready, Aim, Fire, lie down,' repeating these orders to the second platoon; then 'Rise up, first platoon, fix bayonets, forward, double-quick march!'" Next, he ordered the entire line to "'Charge, Double Quick!' Company A and the color guards rushed forward along the railroad, over loose sleepers [supporting timbers in the track bed], burnt crooked rails, etc., Captain Denny reaching the works among the first, the colonel and guard close up. The color bearer, Corporal Keating,[119] waved the colors from the highest point, then planted the staff in the earth."[120] The attack was over — the Forty-fifth had gained the earthworks at a cost of one killed and two wounded. In July 1863, the regiment's nine-month term expired and it mustered out. Denny returned to Boston, where he lived until his death in 1885.

The Fatal Forlorn Hope

ON MAY 21, 1863, Union Maj. Gen. Christopher Augur[121] observed the Forty-eighth Massachusetts Infantry in its first enemy action; he called two of its officers to his headquarters for a review the next day. Lt. Col. James O'Brien and Capt. Eben Stanwood[122] had had a tough time in the fight at Plains Store, along the road to Port Hudson, Louisiana. The Forty-eighth had been placed in the wrong position and poorly supported. A rebel attack had caught it off guard, and O'Brien had ordered everyone to fall back. In the confusion, Stanwood, not hearing the order, had rallied his company and established a new advance position. Augur complimented Stanwood, kindly criticized O'Brien for lacking aggression, and made both men aware that "the regiment would feel chagrined at the outcome of their first battle, but no doubt an early opportunity would be given them to retrieve themselves."[123] Augur had a specific opportunity in mind: Four days later, he called for volunteers to join the "Forlorn Hope," a 200-man storming party, to lead a massive Union assault against Port Hudson's defenses. More than the required number stepped forward, and ninety-two men from the Forty-eighth were chosen, including O'Brien, who was given the command.

O'Brien had labored under adversity since emigrating from Ireland's County Tipperary in 1850. He and his wife settled in Charlestown, Massachusetts, a hot bed of anti-Irish and anti-Catholic sentiment outside Boston.[124] Despite racial and religious animosity, he became one of Charlestown's leading citizens and won a seat on the town council in 1861. The following year, he began to organize an all-Irish regiment, but his plans were dashed after the U.S. War Department combined the six companies he had raised with four non-Irish companies to become the Forty-eighth

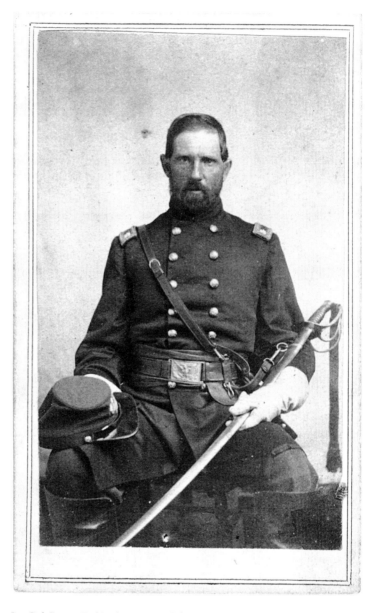

Lt. Col. James F. O'Brien, Forty-eighth Massachusetts Infantry

Carte de visite by William D. McPherson (d. 1867) & Oliver (life dates unknown) of
Baton Rouge, Louisiana, 1863

Infantry. In October 1862, the regiment mustered for nine months' service and left for Louisiana.

On May 27, 1863, under Augur's watchful eye, Lt. Col. O'Brien said to his command, "Come on boys; we'll wash in the Mississippi to-night,"[125] and the Forlorn Hope battled through an almost impenetrable landscape of felled trees, slashed branches, and sharply-pointed *chevaux de frise*.[126] It charged up to the rebel works and was devastated by intense enemy fire — the assault was a bloody failure. O'Brien was found, dead, in the most advanced line, and "when his clothes were opened the bullet which penetrated his body fell out, it having passed entirely through him and flattened up against a steel vest which he wore into the battle."[127] After a brief interment in New Orleans, his body was sent home to Charlestown, where it lay in state in the City Hall. American and Irish flags decorated an archway over the casket, and an Irish harp bearing the words "The Fatal Forlorn Hope" was displayed nearby. O'Brien's funeral was well attended by local officials and the public, who honored him as a hero. He left behind a widow and six children.

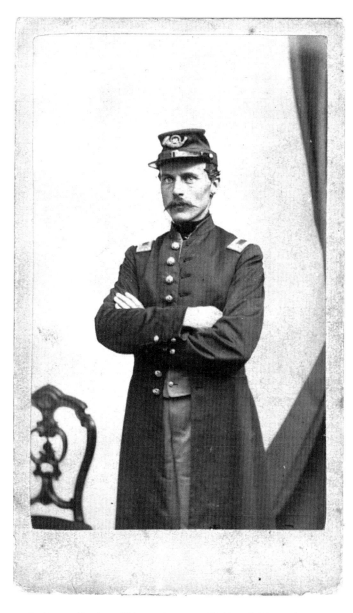

1st Lt. James Gardner Abbott, Company H, Fourth Massachusetts Infantry

Carte de visite by James Wallace Black (1825–1896) of Boston, Massachusetts, about 1862

The Second Storming of Port Hudson

JAMES ABBOTT LED by example. After word came down from Union army headquarters asking for officers and men to join a storming party to attack Port Hudson, Louisiana, the twenty-seven-year-old first lieutenant from the Fourth Massachusetts Infantry signed up. Volunteering for this assault—the second against Port Hudson's formidable defenses — required courage.

A sixth-generation descendant of Massachusetts colonists, Abbott had grown up in Lawrence, a small town twenty-five miles north of Boston. At the start of the Civil War, he was married, had an infant son, and worked as an express messenger. In the summer of 1862, he enlisted as a private in the Forty-eighth Massachusetts Infantry, but left to accept a first lieutenant's commission in the Fourth Infantry. He joined the staff of Company H, where his selfless conduct earned him the respect of his men. One private recalled, "he was a faithful officer neglecting himself for the good of his company."[128] In early 1863, the regiment departed for Louisiana, where it participated in the campaign to capture Port Hudson, which, along with Vicksburg, Mississippi, was the last Confederate bastion protecting the Mississippi River.

Maj. Gen. Nathaniel Banks,[129] commanding U.S. forces in front of Port Hudson, repeatedly threw his troops headlong against the Confederates' elaborate fortifications. The first assault, on May 27, 1863, was spearheaded by two hundred men and ended in a bloody failure. Banks ordered another attack two weeks later. On June 14, a storming party consisting of two hundred and fifty men, including Abbott, led the assault. It failed, and casualties were high. Abbott survived but did not participate in the third, also failed, attack. He was, however, present when the enemy garrison was finally compelled to surrender, after Vicksburg fell on July 4.

He mustered out with his regiment after its nine months of service were completed.

Abbott returned to Lawrence and his family, which eventually grew to three daughters in addition to his son. He became a U.S. Customs Service inspector and, in 1871, received a Medal of Honor from the Massachusetts Humane Society for saving two people from drowning. He became active in local politics in the mid-1870s, serving as councilman, alderman, and later justice of the peace. He died of a cerebral hemorrhage in 1907 at age seventy-one.

Model Soldier and Citizen

FIRST LT. JOSIAH VOSE fell heavily to the ground after a musket ball ripped into his chest during the Union assault at Port Hudson, Louisiana, on June 14, 1863. The men in his company went on without him, inspired in part by his courage under fire. They left behind a fine officer, deeply respected by his men and brother officers in the Fifty-third Massachusetts Infantry.

He had earned the esteem of his regiment before they left his hometown of Clinton, Massachusetts, through hard work, dedication, and perseverance. Orphaned as a child, he was raised by an uncle, who provided him with a rudimentary education that did not satisfy his studious, industrious mind. Vose supplemented his limited schooling "with much reading and investigation of subjects of practical and literary interest,"[130] and later studied mechanics and machinery. A persuasive public speaker, he delivered occasional lectures "upon matters of current interest which received most favorable comment."[131] A commitment to public education motivated him to become administrator of the local schools, but he had no political ambitions—he refused a nomination for state representative and never held elective office. He worked as a mill superintendent at the start of the Civil War and left his job, wife, and daughter to help raise Company I of the Fifty-third. In January 1863, outfitted with a sword and other equipment presented to him by his fellow Masons, he departed for Louisiana to join in the effort to secure the Mississippi River for the Union.

After falling in the unsuccessful assault against Port Hudson, Vose lay for hours in an exposed position before being carried to a field hospital, where surgeons decided to send him to nearby Springfield Landing for evacuation by steamer to a hospital in New Orleans. But the trip was too much for him, and he died en

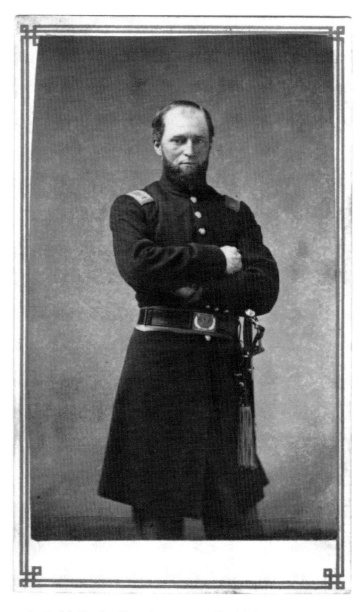

1st Lt. Josiah Hayden Vose, Company I, Fifty-third Massachusetts
Infantry

Carte de visite by unidentified photographer, about 1862

route. Vose was thirty-three. The Fifty-third mourned him as "an excellent officer, a good disciplinarian, cool and fearless in battle, beloved by his men, and respected by his brother officers in the Regiment."[132] The citizens of Clinton were profoundly shaken by their loss. In the words of the regimental historian, "It may truly be said that his strong character and personality made a marked, beneficial and lasting imprint upon the community in which he lived, and upon his contemporaries, who still remember the good he accomplished, and do not cease to regret that the promise of his life was not permitted to be fulfilled."[133]

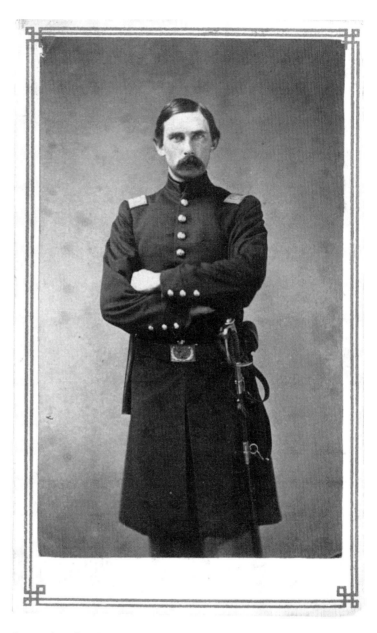

Capt. Edward Richmond Washburn, Company I, Fifty-third
Massachusetts Infantry

Carte de visite by unidentified photographer, about 1862

Determined to Get Back into the War

BODIES OF DEAD and wounded Union soldiers littered the ground near the top of a little knoll that lay in the path of the June 14, 1863, assault on Port Hudson, Louisiana. Brig. Gen. Halbert Paine,[134] a division commander, lay on the hillside, his leg hopelessly mangled by a rebel musket blast. Nearby lay Capt. Edward Washburn of the Fifty-third Massachusetts Infantry, who was dangerously wounded in his right thigh. Both became trapped after the federal attack was repulsed; they were pinned down by intense enemy fire for hours. Attempts to rescue them failed. The two men lay close enough together to talk as they waited for cover of darkness, and the young captain shared his canteen of water with the thirsty general. According to the regimental historian, Washburn "was able cautiously to smoke a single cigar he had brought with him, and thought if he had taken along a half-dozen he would have got through the day very well."[135] The two men were returned safely inside the Union line that night. Gen. Paine's leg was amputated, and he returned to active duty. The Fifty-third's term of enlistment expired while Washburn was recuperating, but he planned to rejoin the army after his convalescence was complete.

The musket ball that slammed into Washburn's thigh fractured the upper third of his femur. At the regimental hospital, an assistant surgeon removed a bone fragment and piece of lead from the wound and concluded that the captain's injury would result in a shortened leg. To prevent extreme shortening, he ordered Washburn to undergo extension treatment, by which weight was added to his leg using a pulley system, starting with a half-pound and ending with eighteen pounds. His body acted as the counterweight. The result was favorable, "with shortening of only half an inch."[136]

Washburn returned to his home in Lancaster, Massachusetts; in the fall of 1863, the twenty-seven-year-old bachelor went back to his job as a secretary with the Bay State Insurance Company. He was determined to get back into the war as soon as his health was fully regained, but his leg continued to trouble him. In August 1864, the wound broke open, blood poisoning set in, and he died after ten days of intense suffering. His death "was a great grief to a large circle of relatives and acquaintances,"[137] and Washburn was mourned as an officer "dignified in bearing, courteous to all, and secured in the love and respect of his men, while he held them in strict discipline."[138]

ANNA RHOADS FOUND herself short on cash and stranded in Nashville, Tennessee. She was traveling home to Williamsport, Pennsylvania, on a grim errand—bringing back the body of her husband, 1st Lt. Amos Rhoads, who had been killed a month earlier at Shelbyville, Tennessee.

On June 27, 1863, Rhoads and his regiment, the Seventh Pennsylvania Cavalry, had received orders to attack entrenchments in front of Shelbyville. A Confederate private witnessed the action and gave this account: "On either side of the highway, in columns of fours, they advanced at a steady gallop, until they passed into the opening in the line of earth works, through which the main road led, some two or three hundred yards in our advance. As soon as they reached this point inside the works, still on the full run, they deployed from columns of fours into line of battle, like the opening of a huge fan."[139] The troopers came on, "with sabers high in air, made no sound whatever, beyond the rumbling tattoo which their horses' hoofs played upon the ground."[140] At fifty yards the rebels opened fire, then fled. A detachment of 225 men from the Seventh Pennsylvania, including Rhoads, received orders to pursue the retreating rebels into Shelbyville, where a thousand Confederates, with four cannon, had massed. The Seventh, supported by two infantry regiments that attacked along side streets, blasted into town and forced most of the rebels to surrender or retreat. But a pocket of determined enemy troops remained holed up in the railway station and an adjacent structure. Rhoads and his company attacked the station from behind to force them out. In the ensuing melee, four enlisted men and two officers were shot down and killed, including Rhoads; but the assault was a success, and the commander of the Seventh, Col. William Sipes,[141] praised

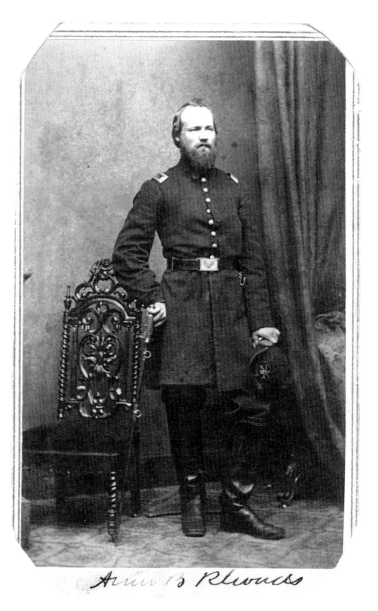

Auu B Rhoads

1st Lt. Amos B. Rhoads, Company B, Seventh Pennsylvania Cavalry

Carte de visite by Mathew B. Brady (b. ca. 1823, d. 1896) of New York City and Washington, D.C., about 1862–1863

the men who had "yielded up their lives as gallantly as ever soldiers fell in a cause."[142]

In Nashville, Brig. Gen. Walter Whitaker[143] heard about Mrs. Rhoads's predicament and arranged for her to have free transportation home, where she laid her husband to rest.[144] Two years later, she married a veteran. She died in 1935 at age ninety-three and was buried beside her second husband in Arlington National Cemetery.

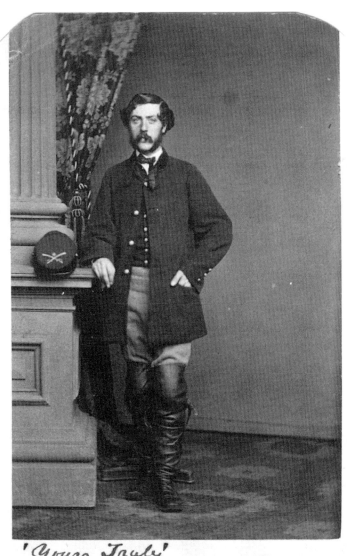

'Yours Truly'
'Edward M Ramsden'

Pvt. Edward M. Ramsden, Dana Troop, Pennsylvania Militia Emergency Service

Carte de visite by Oliver H. Willard (d. 1875) of Philadelphia, Pennsylvania, about 1862

Homeland Security

IN EARLY JUNE 1863, as word of a Confederate invasion into Pennsylvania spread, the mid-Atlantic region mobilized its homeland defense. In Washington, D.C., President Abraham Lincoln called for 50,000 militiamen from Pennsylvania, and 50,000 more from Maryland, West Virginia, and Ohio. From Harrisburg, the Keystone State capital, Gov. Andrew Curtin[145] made a personal plea for a strong and sustained public resistance. All eyes turned to Philadelphia, the expected target of the rebel incursion. Philadelphians launched an immediate and intense recruiting effort that included newspaper ads, broadsides, and other encouragements for able-bodied recruits to sign up for emergency service.[146] From his home in the city, Edward Ramsden responded to the call. He wanted to get back into the war; his first army experience had ended prematurely.

Ramsden, a twenty-four-year-old clerk from London, England, had joined the Fifteenth Pennsylvania Cavalry in August 1862. He went on the sick list soon after, suffering from a persistent cough and other respiratory ailments. Despite his illness, he traveled with the regiment to Nashville, Tennessee, for duty with the Army of the Cumberland. His health took an alarming turn during the winter, when he began to spit up blood after fits of coughing. The regimental surgeon feared tuberculosis, assumed his case terminal, and handed him his discharge papers.

The doctor was wrong. Ramsden's condition was serious but not fatal. His cough and other symptoms began to subside after he returned to Philadelphia. By the summer, he was well enough to sign up for duty in the emergency militia. He enlisted in Dana Troop, a cavalry outfit composed of 104 officers and men commanded by Capt. Richard Hammell,[147] who, like Ramsden, had

served with the Fifteenth and been discharged early because of disability. Formed under the auspices of Philadelphia's Union League, an organization created to neutralize the city's growing Democratic Party, Dana Troop mustered in on July 2, as Union and Confederate forces battled at Gettsyburg. The repulse of the rebel juggernaut the next day ended the invasion, and Dana Troop was sent to nearby Schuylkill County, probably to protect draft officials sent to the area to carry out conscription laws that were unpopular with the public. The unit was mustered out of emergency service in September.[148]

Ramsden returned to Philadelphia, completed his recovery, and married in 1865. His family grew to include five children: three girls and two boys. He lived until 1896.

Caught in a Deadly Crossfire

ON JULY 1, 1863, the 134th New York Infantry was sent to help stop the rapid rebel advance at Gettysburg, Pennsylvania. The regiment positioned itself along a fence just beyond a brickyard on the outskirts of town. Soon afterward, three North Carolina regiments attacked and battled their way around the 134th's unprotected right flank, catching the regiment off guard with a deadly crossfire. The next twenty minutes were hell for the New Yorkers — on average, a man fell every five seconds — leaving more than 250 killed and wounded.

Cpl. James Brownlee was on the hard-hit right flank. One musket ball smashed into his breastbone, shattering ribs and perforating his right lung before blowing a hole out his back. Another bullet slammed into and fractured his right thigh. A spent bullet entered near the base of his spine and stopped just below the skin's surface at the right hip. He removed this bullet himself. Three buckshot were embedded in his left side, one piercing his bladder. His right shoulder was deeply bruised. His doctors, writing him off, made him comfortable for his expected final days.

Brownlee, a twenty-four-year-old farmhand born in Ireland, beat the odds. "Strange to say he recovered from his wounds,"[149] one surgeon reported. His bladder injury leaked urine for ten days, probably saving his life — the urine may have prevented fatal infections from occurring.[150] His weight dropped to eighty-seven pounds. After two years convalescing in three hospitals, he returned home, weakened, but generally healthy. His doctor recommended living in the country and handling cattle and meat as a health-improving occupation.

He married Mary Jane Stryker in the winter of 1865 and settled in Cobleskill, New York, where they began a family that grew to

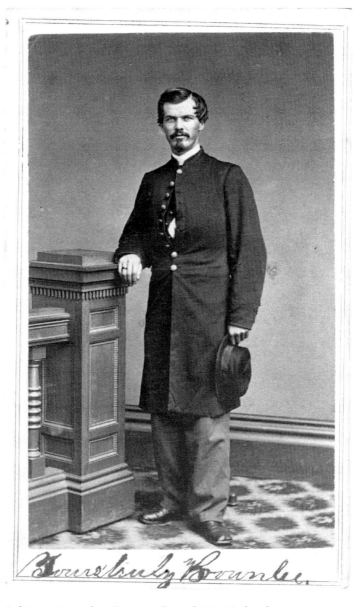

Cpl. James Brownlee, Company G, 134th New York Infantry

Carte de visite by Haines (life dates unknown) & Wickes (life dates unknown)
of Albany, New York, 1865

include four sons. In the 1870s, he worked as a street vendor, selling meats. But exposure to the elements slowed him down: On damp, cold days, he would "cling to the side of his meat wagon for several minutes"[151] to catch his breath. In the 1880s, he and his wife opened a men's clothing store, which they operated for nineteen years. He wore padded clothing to compensate for the great concavity of his chest caused by the wound to his lung, but nothing could hide the marked incline to his affected side.

After Brownlee died of a stroke in 1904, his wife moved in with her son Eugene. He lived in Tryon, North Carolina, the home state of the Confederate soldiers who had wounded her late husband. She lived until 1923.[152]

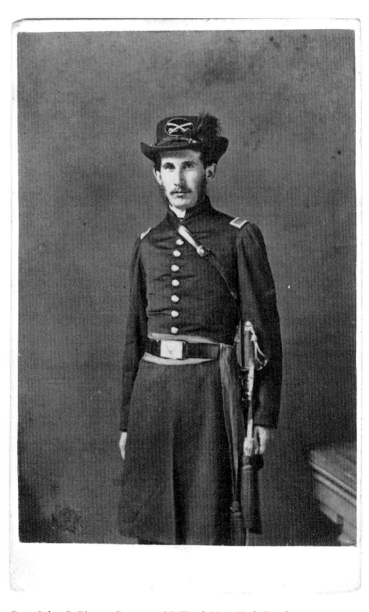

Capt. John G. Pierce, Company M, Tenth New York Cavalry

Carte de visite by unidentified photographer, 1862

Burning Ambition

LATE IN THE AFTERNOON of July 2, 1863, about two miles east of Gettysburg, Pennsylvania, two battalions of the Tenth New York Cavalry dismounted and deployed on the Union right flank along Brinkerhoff's Ridge, relieving two infantry units on the skirmish line. Enemy sharpshooters were hidden on a hill and in woods ahead, and brigade command asked for volunteers to find out what the rebels were up to. Fifty men stepped forward,[153] led by Capt. John Pierce of Truxton, New York, a man driven from youth by "a burning ambition to distinguish himself in life," according to the regimental history.[154]

Before the war, Pierce was a young, popular lawyer, "possessed of noble impulses and high aspirations after excellence,"[155] who had been admitted to the New York bar and was working in the prestigious law office of Horatio Ballard, later New York's secretary of state. He rarely lost a case; one biographer described him as "thorough, penetrating, and masterly."[156] After the war started, he helped organize a cavalry company, which mustered into the Tenth in the fall of 1861. Pierce was elected second lieutenant, made captain a year later, and occasionally ran the regiment when its commander was away. The army was impressed with his keen legal mind and sat him in the judge advocate's chair for many courts-martial. But he preferred active campaigning to deskwork, and he had plenty of it, including the June 1863 Battle of Brandy Station, Virginia, the largest cavalry combat of the war.

A month later, at Gettysburg, Capt. Pierce's battalion was initially held in reserve. But after snipers disrupted the skirmish line, he and his volunteers went in. They advanced to a narrow stretch of woods behind the skirmishers, halted, and waited for further orders from regimental command. One private recalled, "Pierce

told us to sit down and remain quiet while he went to find the major."[157] Shortly after he left, rebel musket fire intensified — the whizzing bullets made his men restless and anxious. Leaderless, they moved forward and joined the skirmish line moments before a rebel charge. Pierce's battalion, with the help of other units, checked and drove back the Confederates.[158] The Tenth rested on the third and final day at Gettysburg.

The fatigue of the campaign compromised Pierce's health. He contracted pneumonia and spent the next five months in and out of the hospital. In December 1863, he was diagnosed with tuberculosis, which had claimed the lives of his mother and two sisters. Unwilling to quit the army but no longer able to endure the rigors of life in the field, he petitioned Maj. Gen. George Stoneman[159] for a desk job in his cavalry bureau. Stoneman's office denied his request, and Pierce had no choice but to resign. He returned to his Truxton home, where he succumbed to tuberculosis in 1868 at age twenty-six. A biographer eulogized him: "His death is a loss to the world. Young men of ability superior to his are exceedingly rare, and their services can ill be spared."[160]

Slightly Favored at First

EIGHTEEN-YEAR-OLD Samuel Noyes, a high school student in Tilton, New Hampshire, was regarded as a good scholar. During the second year of the Civil War, motivated by "a sense of duty,"[161] he dropped out of school and enlisted as a private in the state's Twelfth Infantry. The "New Hampshire Mountaineers," as they were nicknamed, were noted for their height—many topped six feet. Noyes, at five-foot-seven, "fragile in looks,"[162] and in delicate health, was "slightly favored at first"[163] by the Twelfth's commanders, who detailed him to light duty as the regiment's mail carrier. About a year later, just before the Battle of Gettysburg, his company commander assigned him to a combat role.

The Twelfth, part of the Army of the Potomac's Third Corps, arrived at Gettysburg on July 2, 1863. Corps commander Maj. Gen. Daniel Sickles[164] violated orders when he marched his men ahead of their assigned place in the Union line, creating a half-mile gap between his force and the rest of the federal army. At 4 o'clock in the afternoon, Confederate attacks smashed the exposed troops, and they were forced back, with great loss. The Twelfth's ninety-two casualties included Noyes, who suffered a gunshot wound in the shoulder. He was out of action for four months.

In the spring of 1864, Noyes resigned to become second lieutenant in the First U.S. Volunteers. In July, he made captain and commander of Company B. The regiment went west to guard against Indian uprisings, and his company was sent to garrison Fort Rice, Dakota Territory. On November 28, 1864, Indians attacked Noyes and a small party on their return from a trip to a nearby river, where they had gone to supply cattle herders with rations. Noyes was wounded in the fight, but the nature of his injury was not reported.

After mustering out of the army in 1865, Noyes went to Chicago and started a grocery business. Poor health forced his return to New Hampshire, where he married and had a son. He died of tuberculosis in 1870 at age twenty-seven.

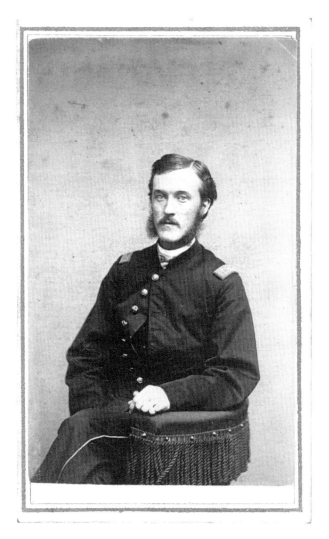

Capt. Samuel B. Noyes, Company B, First U.S. Volunteer Infantry

Carte de visite by William H. Kimball (1817–1892) & Sons of Concord, New Hampshire, about 1866

Hot Skirmish before Pickett's Charge

BEFORE NOON ON July 3, 1863, at Gettysburg, on the battle-scarred ground in front of a tall stand of oak and chestnut trees known as Ziegler's Grove, at a spot near the blasted tomb stones and broken iron fencing of Cemetery Hill, a blue skirmish line charged two hundred yards into Confederate troops entrenched along the Emmitsburg Road and drove them back, after a tough fight. The Union force, composed of four companies of the 126th New York Infantry, pushed ahead into a wheat field, where a concealed gray brigade rose up and stopped the skirmishers. Three of four captains were killed, and more than a third of the rank and file were hit, including Pvt. Edgar McQuigg, who went down after a minie ball ripped into his left forearm, plowing through his elbow and shattering the bones above the joint.

His company commander and sole surviving captain, Winfield Scott,[165] recalled, "Without exception, I think it was the hottest skirmish I was ever in. The enemy held their line at the Emmitsburg Road, and they stuck to it as though they were ordered to hold it at all hazards."[166] The regimental historian reported that the skirmish was "admitted by all to have been the severest service the Regiment was ever engaged in."[167] For McQuigg, a twenty-year-old teacher from Covert, New York, it was the high-water mark of a turbulent year of campaigning.

He had enlisted as corporal in August 1862, and, a month later, Confederates captured him at Harpers Ferry, Virginia, a disastrous affair in which members of the regiment were branded cowards for their role in surrendering a key position that caused the capture of the town and valuable military stores.[168] He was paroled a day later and returned to his unit. Two incidents tarnished his record afterwards: In October, he was busted to private after being absent

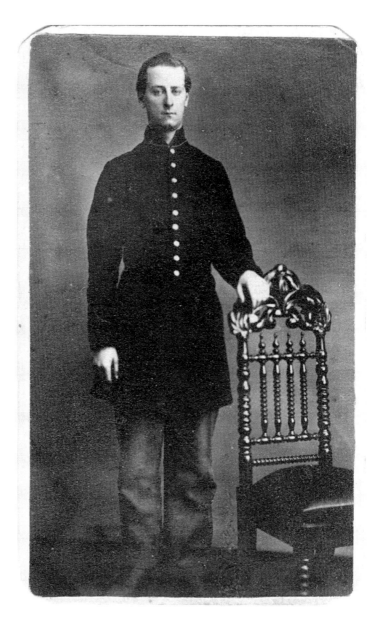

2nd Lt. Edgar Henry McQuigg, Company I, Twenty-fourth Veteran
Reserve Corps

Carte de visite by unidentified photographer, about 1862–1864

without leave, and when he fell behind during a fatiguing march in January 1863, an officer reported him for straggling. The 126th arrived at Gettysburg on July 2 and received orders to support two artillery batteries at Cemetery Ridge, near the headquarters of Army of the Potomac commander Maj. Gen. George Meade.[169] Later that day, it reinforced and successfully defended Little Round Top. Many in the regiment considered the stain of Harpers Ferry removed after the sacrifices made here. The wound that McQuigg received at the skirmish near Cemetery Hill took him out of action a few hours before Pickett's Charge, during which the 126th captured four stands of colors.

McQuigg spent the next year in a Philadelphia military hospital, regained partial use of his arm, then transferred to the Veteran Reserve Corps and served until 1867 as a clerk in the Freedmen's Bureau at Whiteville and Wilmington, North Carolina. He resigned from the VRC as a second lieutenant, and with two partners managed Excelsior, a plantation near Rocky Point, North Carolina. He withdrew from the partnership the following year, went home to New York, married, and then returned to Wilmington. In 1884 McQuigg took a clerical job with the U.S. Quartermaster Department and relocated to Washington, D.C., where he died three years later of hepatitis at age forty-five. His wife, a son, and a daughter survived him.

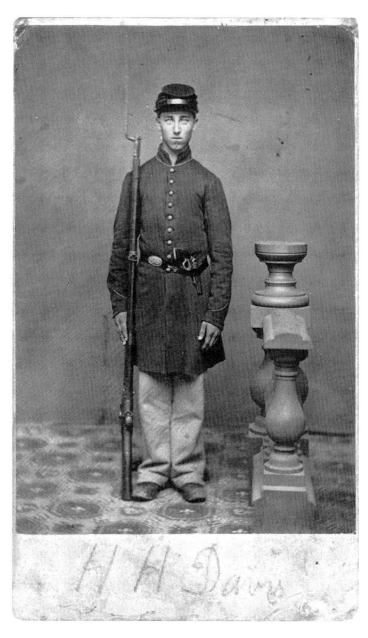

Pvt. Hiram H. Davis, Company F., Twentieth Veteran Reserve Corps

Carte de visite by I. S. Parker (life dates unknown) of St. Albans, Vermont, about 1862

Escorting Rebel Prisoners after Gettysburg

Pvt. Hiram Davis saw his first Confederate prisoner near Frederick, Maryland, in July 1863. More than a thousand sick and wounded rebels, captured in Pennsylvania with their ambulances and baggage wagons as they withdrew from Gettysburg, were sent to the Maryland camp where Davis and a detachment from his regiment, the Tenth Vermont Infantry, waited to escort them North. "Dirty looking men they were. . . . Some of them were badly wounded and in a dying condition," recalled the regimental historian.[170] By the end of his assignment Davis would be in as bad a state as the prisoners he was ordered to guard.

Davis, who was living with his widowed father and three brothers in Fairfax, Vermont, when the war began, was the first in his family to join the army, enrolling in the Tenth in July 1862, a week shy of his seventeenth birthday. His brothers signed up in 1864; two enlisted in the First Vermont Heavy Artillery and the third was rejected after failing a physical exam.[171] Davis made a favorable impression on his company's captain, who later wrote, "You have always been a good soldier ever ready to do your duty when called upon."[172] The regiment served primarily on patrols along the Potomac River in Maryland and Virginia during its first year, and Davis and his company were among the troops detailed to escort captured Confederates from Gettysburg to Union prison camps.

"It was with a sort of pleasure, although mingled with pity, that our men marched them off, such as could move, to the depot, where they put them aboard cars . . . and took them to Baltimore,"[173] wrote the regimental historian. The train ride was uneventful, but the return march, through intense July heat, proved too much for young Davis. "I was sunstroke insensible for hours,"

he recalled, "I was attended in person by the surgeon of my regiment, Almon Clark,[174] a dear, dear man, for he saved my life, and helped me along by putting me on to his own orderly's horse till we went into camp."[175] Davis never regained his health; his effective military service was over.

He spent the next two years in Washington, D.C., hospitals, suffering from a variety of ailments, including malaria, measles, and chest pains. In January 1864, he transferred to the Veteran Reserve Corps, but his illnesses prevented him from joining his new regiment and he was discharged because of disability in the summer of 1865. He enrolled in the Eastman Business College in Poughkeepsie, New York, but dropped out after a short time and drifted from job to job until 1868, when he married and settled in Fitchburg, Massachusetts. In the 1880s he owned and operated a meat and provisions market, and later he worked as a machinist. His wife died in 1909, and he succumbed to heart disease in 1930 at age seventy-five. His son, Herbert, survived him.

Cursed Twice

SGT. BOB HASTIE was given up for dead after he fell dangerously ill with diarrhea at Vicksburg, Mississippi, in the summer of 1863. "I suppose the curse was the result of continuous fighting" for three months in swamps and bayous, he recalled. During that time, he consumed "bad water and badly cooked and sometimes raw food not having time or opportunity to cook properly."[176]

"The Day after the capitulation of Vicksburg I was placed on a stretcher and carried on a steamboat and left . . . to die, as they thought I could not live till morning. I rallied however after having a drink of the River Water with Ice."[177]

The thirty-six-year-old English immigrant spent the next two months recuperating, then returned to his duties as quartermaster and principal musician in the Eleventh Wisconsin Infantry. His condition proved to be chronic, however, and he suffered repeated bouts of loose bowels. He described himself as "almost a walking skeleton" at the time of his discharge, in September 1865. However, he reported, "after getting home and good nursing and rest soon began to recuperate. But the next summer the Old Diarrhea came on again and every summer afterwards. I never had treatment from a Physician. Always doctored myself."[178] His attacks usually lasted three weeks.

When his health permitted, he worked as a master sign painter and turned his attention to his wife and four children. His second curse was alcohol, and it destroyed his family. His wife divorced him in 1869, and he drifted to St. Louis, where he found work in a grain warehouse and streetcar shop. Ten years later, he moved to Sedalia, Missouri, and turned his life around. He joined the Independent Order of Good Templars, the largest temperance organization in American history, where he met and fell in love with the

chapter treasurer, Mary Lingle. They married in 1882 and settled in Greenridge, Missouri, where Hastie returned to sign painting and served as justice of the peace. He died in 1913 of cirrhosis of the liver at age eighty-six.

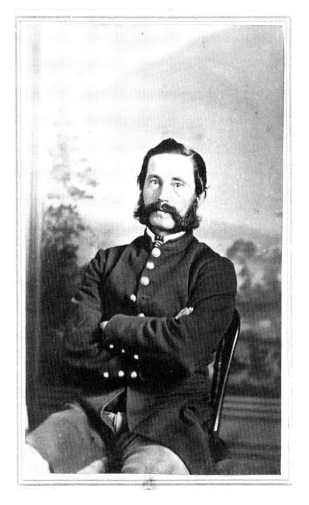

Principal Musician and Quartermaster Sgt. Robert G. Hastie, Eleventh Wisconsin Infantry

Carte de visite by unidentified photographer, about 1861–1863

Learning from Experience

THE TWELFTH INDIANA Infantry's Company E despised its second lieutenant, Andy Milice. It was the way he talked to his men. He had a "style about him that repelled rather than won, and yielded a reluctant obedience to his orders," reported the company historian.[179] He became aware of his shortcomings as an officer, and, after his regiment's one-year term of enlistment ended in 1862, he brushed up on his interpersonal skills as he helped recruit volunteers from his hometown of Warsaw, Indiana. The men became Company A of the state's Seventy-fourth Infantry, and they elected him first lieutenant. The regiment was dispatched to Tennessee, where he developed into an efficient and popular officer and made captain. But his tenure as company commander was short-lived.

At Chickamauga, Georgia, in the afternoon of September 19, 1863, the Seventy-fourth formed a single line of battle on the left flank of a three-regiment assault force. At 2 P.M., it advanced through dense woods, engaged the enemy, and drove them back for over a half-mile, suffering few casualties. Then all hell broke loose when Confederate reinforcements overwhelmed the little blue line, pounding it with devastating musket and canon fire.[180] In the Seventy-fourth, men went down all over, and eleven of twenty-four officers were hit, including Milice, who was incapacitated by a bullet that slammed into his left shoulder and left a gaping wound after it exited his back.

The injury caused severe muscle damage to his left arm, and field surgeons sent him to a hospital to convalesce. But he came down with hepatitis and symptoms that suggested typhoid. His face, hands, and feet started to swell, and he was unable to urinate for long periods. His condition went from bad to worse, and some

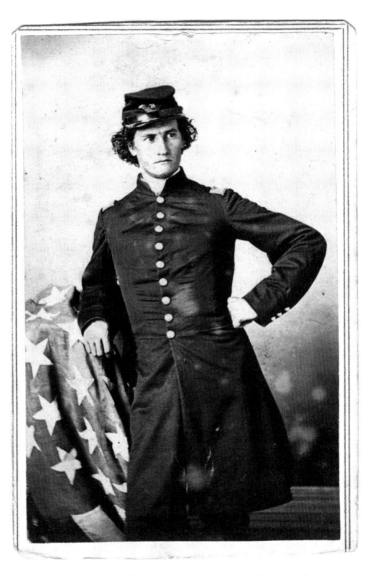

Capt. Andrew Staley Milice, Company A, Seventy-fourth Indiana
Infantry

Carte de visite attributed to J. H. Van Stavoren (life dates unknown) of Nashville,
Tennessee, about 1863

believed his case fatal. His doctors sent him home to die, but he pulled through after two touch-and-go months. He ultimately made a full recovery from his illness but was permanently disabled by his shoulder wound and was discharged from the army.

Back in Indiana, Milice returned to civilian life as a bookseller and stationer. He married in the spring of 1864 and raised a family that grew to include two boys and a girl. After his wife died in 1879, he remarried and relocated to Riverside, California, where he invested in an orange grove. Senility came upon him in the 1910s, and he died in 1919 at age eighty.[181]

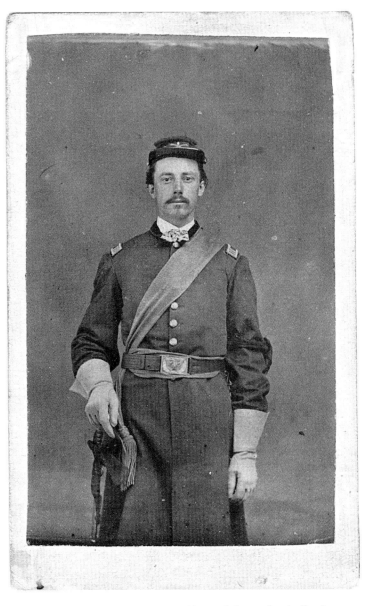

Capt. Lester D. Phelps, Company K, Sixteenth Pennsylvania Cavalry

Carte de visite by unidentified photographer, 1865

Rear-Guard Action

Gen. Robert E. Lee's Confederates were on the offensive in Virginia, and retreating Union forces were fighting a rear-guard action along the Rappahannock River to slow the gray advance. On October 12, 1863, a federal pioneer corps destroyed the bridge crossing the river at Sulphur Springs, and two squadrons from the Eighth Pennsylvania Cavalry were ordered to hold a nearby ford. The Sixth Squadron, commanded by 2nd Lt. Lester Phelps, arrived on the scene, dismounted, and took up defensive positions. About 5 p.m., heavy fire from rebel artillery rained down on the Pennsylvania cavalrymen, and a large force of enemy troops waded the ford. Phelps's men, armed with the latest carbine rifles, fired until their ammunition was exhausted, and the rebels kept coming. They reached for their pistols, but it was too late — the Confederates cut them off, and the better part of both squadrons, about seventy men, were captured, including Phelps, who would spend the next year-and-a-half in Southern prison camps.

Phelps was marched to Richmond and incarcerated in Libby Prison. He remained there through the winter, suffering rheumatism from the cold, dank conditions. In the spring of 1864, he was moved to Camp Oglethorpe in Macon, Georgia. After Union forces led by Maj. Gen. William T. Sherman[182] invaded the state and Yankee cavalry raids threatened prison security, Phelps and other captives were hustled to South Carolina. He spent the fall of 1864 in Charleston, and Christmas in Columbia. He was finally paroled in March 1865. In May he returned to his regiment on provost duty at Appomattox Court House, Virginia, where Gen. Lee had surrendered his command three weeks earlier. He was promoted to captain, transferred to the Sixteenth Pennsylvania

Cavalry by consolidation of the units in July, and mustered out in August 1865.

After the war, Phelps settled in Rockville, Connecticut, a suburb of Hartford. A law clerk before the war, he secured a clerical position in the county court system and over the next thirty-five years worked his way to probate court judge. He died in 1910 at seventy-one of heart disease. His wife of 42 years and a daughter survived him.

Injured at Rappahannock Bridge

At daybreak on November 7, 1863, Capt. A. Boyd Hutchison's Company C and two other companies from the Forty-ninth Pennsylvania Infantry formed a skirmish line along the front and flanks of a Union column commanded by Brig. Gen. David Russell.[183] The skirmishers soon encountered enemy pickets near Rappahannock Station, Virginia, where Confederate forces guarded a key bridge to be used by Gen. Robert E. Lee's army in the event that a withdrawal from its current campaign became necessary. The rebels were firmly entrenched in two forts and rifle pits along the Rappahannock River.

Brig. Gen. Russell replaced the skirmishers from the Forty-ninth with men from the Sixth Maine and ordered the column to form a line of battle. According to a member of the Forty-ninth, "General Russell gave us orders to charge, and in less than two minutes he gave us orders to not double-quick, but to run — that they were driving the Sixth Maine. We see them, and obey his orders. Now the Sixth Maine advances again. We did our best to assist them, but received plenty of grape and canister from the rebel batteries. We soon were up to their works, and using our bayonets and butts of our guns. The rebels were very stubborn. The Sixth Maine had a regular hand-to-hand conflict. It is getting dark, but we have their works. Some of the rebels tried to get away across the river on a pontoon bridge, but we had command of it, the river not being over fifty yards from us. Squads of them would start to run across the bridge and we would give them a volley. Many of those who got hit fell into the river, which was very deep. We had everything under our control."[184] Seven enemy flags and 1,800 prisoners were captured.

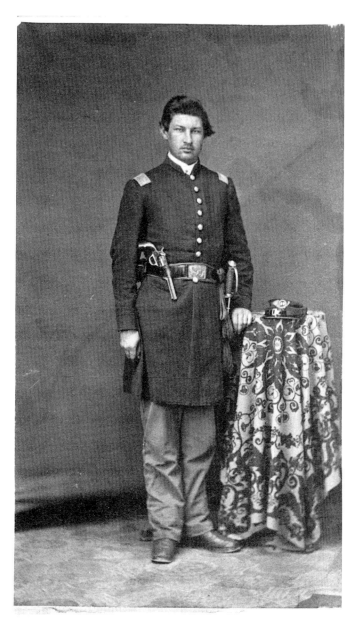

Capt. A. Boyd Hutchison, Company C, Forty-ninth Pennsylvania Infantry

Carte de visite by unidentified photographer, about 1861

Hutchison survived with a superficial face wound. The fight was praised as one of the most brilliant smaller battles of the war.[185] Hutchison served another year with the Forty-ninth and was slightly wounded at Cold Harbor, Virginia, in June 1864. In December, declining to reenlist, he mustered out. He settled in New Waverly, Kansas, and lived until 1889.

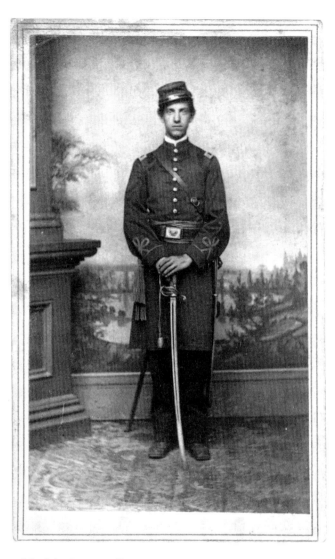

2nd Lt. John James Toffey, Company E, Twentieth Veteran Reserve Corps

Carte de visite by Henry E. Insley (1811–1894) of Jersey City, New Jersey, about 1863

On November 23, 1863, the Union Army of the Cumberland prepared to assault key rebel positions at Chattanooga, Tennessee. Battle-hardened but weary from a long siege, the Cumberland had recently been augmented by the Thirty-third New Jersey Infantry and troops from the Army of the Potomac in Virginia. The rookie Jersey men, decked out in uniforms designed in the Zouave tradition, must have made an odd pairing with the rugged western men of the Cumberland, who nicknamed them "the red tape men," a reference to the red trimming on their fancy jackets.[186]

Late that autumn afternoon, the Thirty-third and its brigade lined up in a field five hundred yards in front of Fort Wood. Ahead, rebel pickets lay beyond Citico Creek, protected by dense woods and a railroad. The regiment advanced ten paces before enemy fire peppered its two-company skirmish line. The shooting was not intense—some considered it light[187]—but it was destructive. In minutes, all the officers were hit, and the enlisted men became demoralized. They buckled and wavered, endangering the attack. Col. George Mindil,[188] desperate to rally his green troops, ordered 1st Lt. John Toffey to assume command of the shaken skirmishers. He could not have made a better choice.

Nineteen-year-old Toffey, a student from Jersey City, was eager to fight. Unlike his older brother, Daniel,[189] who joined the Navy and served on the USS *Monitor,* John joined the army, as a private with the state's Twenty-first Infantry in 1862, then reenlisted the following year as an officer in the Thirty-third. He joined Company E, where he performed his duties "cheerfully and zealously."[190] At Chattanooga, he fell sick several days before the attack. "The night before the battle the surgeon of the regiment ordered me into hospital, telling me that I was not able to take part

in the engagement that we were expecting. I was determined not to be deprived of my share of the excitement, so I tore up the permit he had given me and marched with the regiment."[191]

Col. Mindil sent Toffey in at a critical moment. "I ran across the open field and reached the advance line in time to prevent it from breaking. I reformed the line and we again charged. . . . Just as we were carrying the position I received a severe wound." Two bullets hit him. One musket ball ripped into his right thigh at the pelvis, fracturing that bone and his leg. A second shot caused a flesh wound to his left leg. He was hospitalized for two months and then sent home to recuperate, but the damage to his thigh was permanent and his combat duty was over. He transferred to the Veteran Reserve Corps in June 1864, spent the next two years commanding the guard at a Washington, D.C., military hospital, and mustered out of the army in 1866.

Toffey went home to New Jersey, married in 1870; he and his wife raised three boys. In the 1890s he served as county sheriff. He was awarded the Medal of Honor for his service at Chattanooga in 1897. Toffey's "superlatively brave conduct," wrote Col. Mindil, "saved the position, and enabled us on the following morning to press forward the entire line, and to unite the lines of the Army of the Cumberland, with those of General Sherman's Army."[192]

When Toffey died in 1911 of kidney failure he was sixty-six.

Tent Fire

THE WINTER OF 1863–1864 was a physical disaster for thirty-five-year-old Edward Marshall, a jeweler and watchmaker in civilian life who had recently been promoted to first lieutenant and quartermaster of the Fortieth New York Infantry. By season's end, he would be confined to a hospital in Washington, D.C., suffering from a severe case of pneumonia that aggravated existing kidney and bladder troubles. Health problems like these were serious enough to put almost any man down, but his condition was complicated by burns received in a fire in camp earlier that winter.

During the night of December 7, 1863, according to Lt. Augustus Keene[193] of the regiment, "the Quarter Masters tent took fire from a candle burning down to the desk, igniting paper on the desk and the tent."[194] Marshall, "in endeavoring to save the tent and contents, burned his hands and arms in a most shocking manner."[195] Another eyewitness remembered how "the Regtl. Quartermaster burned his hands terribly."[196] Marshall explained the next day that the tent "was nearly full of stores for which I am responsible to the Government. In extinguishing the fire, both my hands were seriously burned. I can neither feed nor dress myself and am perfectly helpless."[197] The Fortieth's surgeon sent him home to Milford, Massachusetts, accompanied by a servant, to recover from his injuries. Marshall was away from his duties for the next three months. Soon after his return, still suffering pain from his burns, he fell ill with pneumonia. After three months in a Washington hospital, he showed no signs of improvement. In his doctor's opinion, his recovery was "distant and quite uncertain,"[198] so Marshall resigned.

He went back to his Milford home, eventually recovered and, in 1866, relocated to Minneapolis, Minnesota. He returned to Massachusetts six years later, married, and settled in Natick, a town near Boston. He died of heart disease in 1894 at age sixty-six.

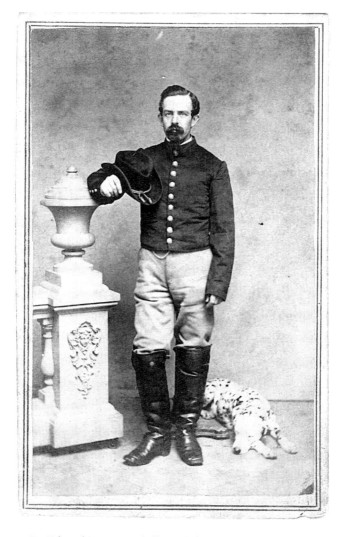

1st Lt. Edward Macy Marshall, Fortieth New York Infantry

Carte de visite by Judson (life dates unknown) of Milford, Massachusetts, about 1861–1863

IN THE WINTER OF 1863, forty-three-year-old Capt. Joseph Copeland of the Twenty-eighth Pennsylvania Infantry became frightened and deeply concerned after he began to experience trouble seeing at dusk and during evening hours. He went to see the divisional surgeon-in-chief, who examined Copeland and found him "suffering from Nyctalopia, which prevents him from seeing at night, causing him much annoyance in his official duties, and much personal alarm for his sight."[199] Nyctalopia, or night blindness, is a condition in which vision is normal in daytime but extremely weak or entirely absent in dim light or at night. It can be hereditary or a result of disease or a vitamin A deficiency. The surgeon declared him "unfit for the service . . . unless relieved from his present duties."[200] In his resignation letter, Copeland remarked, "I regret the necessity compelling me to leave the service, being identified with the Regiment since its organization."[201] For the record, he stated his medical condition was "the only cause that induces me to resign."[202]

He returned to his home near Pittsburgh. About a year later, in August 1864, Copeland rejoined the army in a role better suited to an individual with his physical limitations. He enlisted as recruiting officer, with the rank of second lieutenant, for the 212th Pennsylvania Volunteers, later designated the Sixth Pennsylvania Heavy Artillery. Within a month after mustering in, he was promoted to lieutenant colonel. In January 1865, the regiment garrisoned Fort Ethan Allen, a part of the defensive perimeter protecting Washington, D.C., and stayed on duty there until the end of the war.

After mustering out, Copeland rejoined his family, which eventually included seven children, and later settled in Wellsville, Missouri, where they worked a farm with eighty acres of improved

land and more than 150 acres of timber and brush. He died in March 1889 after a long and painful battle with lung disease. He was "surrounded for over a week by all his children and grand-children, who labored untiringly to alleviate his sufferings."[203]

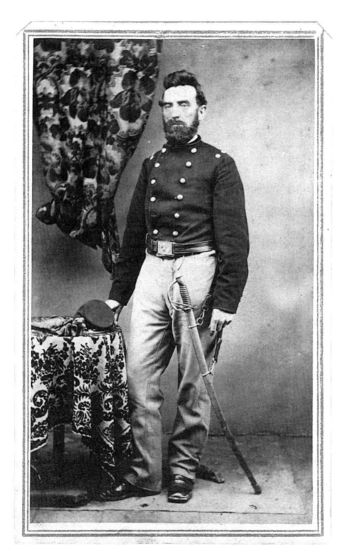

Lt. Col. Joseph B. Copeland, Sixth Pennsylvania Heavy Artillery

Carte de visite by unidentified photographer, about 1864

ON FEBRUARY 20, 1864, skirmishers from the Seventh Connecticut Infantry—the vanguard of a 5,500-man Union strike force sent to occupy northern Florida[204]—spread out and slogged through swamplands towards Olustee Station, a stop along the Atlantic and Gulf Railroad. Confederate muskets began to crackle. The shooting intensified and the rest of the Seventh went in. Soon the left flank became mired in a swamp and was hit by a galling fire. The right flank advanced another twenty yards,[205] blasting away with seven-shot Spencer rifles, but the enemy fire was too hot and the men were ordered to lie down. Then a series of well-directed volleys were pumped into the Seventh and it bent back, forming a semicircle. The men were caught in a crossfire as rebel lead poured in from three sides. Critically low on ammunition, they withdrew, leaving eighty casualties on the field, including one of their most patriotic officers, 1st Lt. Robert Dempsey.

Twenty-eight-year-old Dempsey, an Irish immigrant, was working as a clockmaker in Winsted, Connecticut. Two weeks after the war began he joined the Seventh as second lieutenant of Company E. He shipped out with the regiment to South Carolina and participated in actions along the Atlantic coast, including the June 1862 Battle of James Island, where he suffered a gunshot wound in the left shoulder. He reluctantly left for a month to recover, promising to come back and fight to insure, in his words, "many days of happiness and prosperity when *rebels* and *rebellion* are no more."[206] Dempsey spoke eloquently about his love of country—he was one of three officers, along with the colonel and another lieutenant, who delivered patriotic speeches in June 1863 to celebrate the eighty-eighth anniversary of the Battle of Bunker Hill.

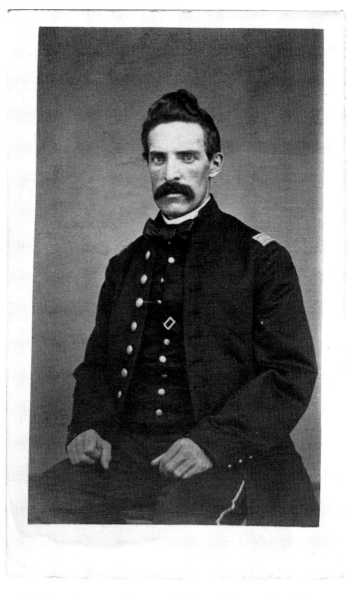

1st Lt. Robert Dempsey, Company E, Seventh Connecticut Infantry

Carte de visite by Thomas M. V. Doughty (d. 1911) of Winsted, Connecticut, about 1862–1864

At Olustee, Dempsey led thirty men at the extreme end of the right flank and was likely caught in the crossfire. A musket ball fired from the rebel front about one hundred yards away ripped into his chest and a second ball slammed into his head. He fell to the ground and lay on his back. According to a private who was at his side, "Dempsey merely said, 'I am killed. I shall die here,' and immediately expired."[207] But the Seventh's colonel reported, "he spoke but once, merely asking to be laid on his side instead of his back."[208] His body was buried on the battlefield. The Confederates who interred him had no idea of his frequently repeated desire, "that wherever he fall he might be buried."[209] His wife, Carrie, whom he married while on leave in the autumn of 1862, survived him.

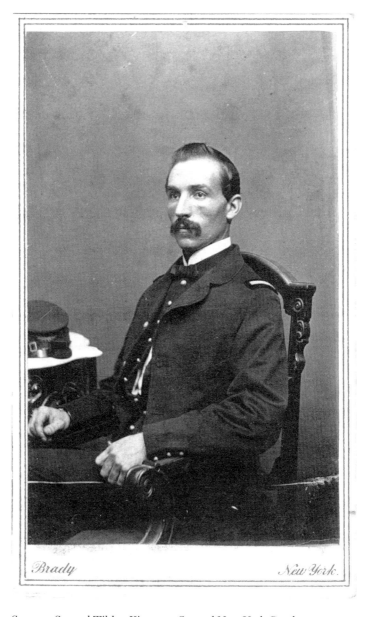

Surgeon Samuel Tilden Kingston, Second New York Cavalry

Carte de visite by Mathew B. Brady (b. ca. 1823, d. 1896) of New York City and Washington, D.C., about 1863

Captured during Dahlgren's Raid

On February 28, 1864, Union Col. Ulric Dahlgren[210] and 500 cavalrymen left Stevensburg, Virginia, on a daring raid. They planned to ride into Richmond and unite with 3,600 troops led by Gen. Hugh Judson Kilpatrick,[211] liberate prisoners, and destroy Confederate supplies. The raid went wrong two days later, after Kilpatrick ran into stiff resistance and withdrew, leaving Dahlgren isolated. Lt. Reuben Bartley,[212] Dahlgren's staff officer, recalled driving the rebels inside Richmond's defensive line of works, but "it soon got too hot, and he sounded the retreat, leaving forty men on the field."[213] Assistant Surgeon Samuel Kingston of the Second New York Cavalry stayed with the injured and was captured. The raid failed a few days later, costing Dahlgren his life. Papers ordering the assassination of President Jefferson Davis and his Cabinet were found on his body and caused indignation throughout the Confederacy. Kingston and the other prisoners were viewed with suspicion, and their treatment was harsh.

Kingston was interred in Richmond's Libby Prison, where he joined five officers, including Lt. Bartley, who was captured the night after Kingston was taken. Bartley remembered that the group were "put into a Dungeon in the cellar of the prison and informed that we had been condemned to death as Felons. This news appeared to have a very depressing effect on Dr. Kingston."[214] Lt. Col. Allyne Litchfield[215] of the Seventh Michigan Cavalry, another inmate, recalled being thrust into a "damp dungeon in the cellar of the prison, and during the day four colored soldiers were added to our number, making ten in one dungeon measuring about 7 ft. x 11 ft."[216] Food was scant and "the only sanitary accommodations . . . an open bucket in one corner."[217] Conditions worsened after they were moved to an unheated, drafty cell the next

week. Kingston caught a severe cold and cough and lost his appetite. Two weeks later, his health badly deteriorated, he was released on parole and sent north. He eventually returned to his regiment and in June 1865 mustered out as a full surgeon.

Dr. Kingston went home to Oswego, New York, and established a medical practice and drugstore. His business was successful despite his personality, which was described as being, at times, odd, peculiar and secretive, especially with regard to financial matters. In 1875, he married Anne Tozer, a "proud and spirited woman"[218] sixteen years his junior. After a cerebral hemorrhage ended his life at fifty-three in 1889, leaving her a widow at thirty-seven with two young daughters, she managed the drugstore, enlarged it, and later sold it for a substantial profit. She lived until 1910.

Injured near Sabine Cross Roads

As the sun dipped below the horizon and twilight spread across eastern Kansas, Sid Breese stood on the porch of his farmhouse and watched a wild fire ablaze on the distant prairie. Standing at his side was Dan Farren,[219] an old army pal from his company, who was always ready with a story about his adventures in the late Civil War.

"That line of prairie fire looks exactly like a line of battle," said Breese. "It certainly does," Farren replied, then launched into one of his narratives.[220] Which story he told went unrecorded, but he might have spoken about the time he and Breese charged rebel cavalry near Sabine Cross Roads, Louisiana.

In the pre-dawn hours of April 8, 1864, Union infantry marched towards Moss Plantation, in Louisiana's Red River country. Reinforcements were requested after the federal troops encountered Confederate horsemen, and Capt. Breese received orders to lead the advance with his command, the Sixth Missouri Cavalry. About sunrise, Breese's troops launched a bold charge on the enemy, met with stubborn resistance, but soon overpowered them. The Confederates fled, and the Sixth advanced slowly but steadily against the enemy, who "disputed our progress at every favorable position."[221] The casualty list grew as each side battled from cover of pine trees — a Union lieutenant colonel lost his life, and other officers were hit, including Breese, who suffered a gunshot to the elbow that shattered the bones in his arm, taking the Sixth's favorite officer out of action.

Breese was a restless young man. In 1858, at age twenty-one, he had quit after three years as a carpenter's apprentice in his hometown of Mt. Gilead, Ohio, and moved to Lawrence, Kansas, to live with his uncle, Stephen Wood, a local lawyer. He left Lawrence

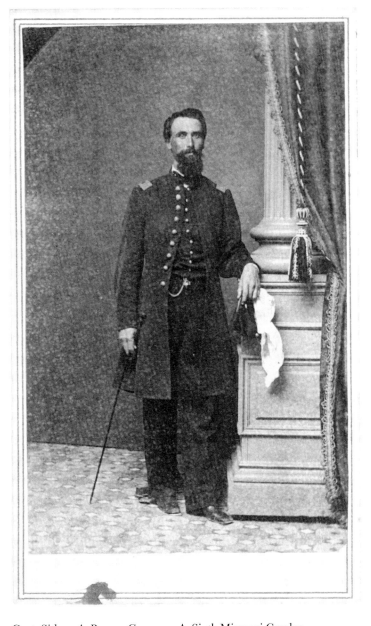

Capt. Sidney A. Breese, Company A, Sixth Missouri Cavalry

Carte de visite by N. Brown (life dates unknown) of St. Louis, Missouri, about 1862–1864

a few months later and founded the town of Cottonwood Falls. The local government was established in his cabin, the first built in the fledgling village. He was appointed postmaster and, in 1860, elected tax assessor, perhaps in recognition of his "exceptional good business talents."[222] After the war started, Uncle Stephen formed the Kansas Rangers, an independent cavalry company, and Sid joined as a corporal. When the Rangers were incorporated into the Sixth Missouri, his uncle became lieutenant colonel, and Breese's company elected him captain.

He was discharged because of disability four months after his wounding at Sabine Cross Roads, and returned to Cottonwood Falls, where he married his longtime fiancé. She died of tuberculosis in 1873, leaving behind a young daughter. Three years later, he married Theresa Young, "a woman of strong Christian character, great strength of mind, and much charm," according to a county historian. They raised two sons and his daughter. Breese kept active in real estate, local politics, and the Presbyterian Church until the turn of the century, when he was sidelined by a series of depressive episodes. Doctors attributed it to his hemorrhoids, as he had no family history of mental illness. He spoke of "a cloud over his brain that would not let him think,"[223] and fretted that he was a burden to his wife. On a September day in 1903, the telltale signs of another episode came upon him, and he told a friend he would not stand another attack. He went into his office, put a pistol in his mouth, and pulled the trigger. He was sixty-six.

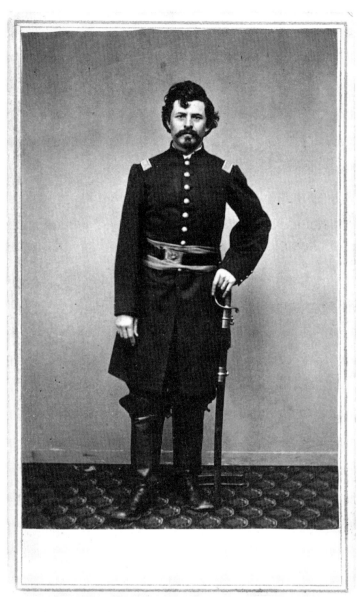

Capt. Thomas F. Burke, Company A, Sixteenth Connecticut Infantry

Carte de visite by Nelson Augustus Moore (1824–1902) and Roswell A. Moore (life dates unknown) of Hartford, Connecticut, about 1862

Under the Protection of the Star-Spangled Banner

ON APRIL 19, 1864, the 2,800-man federal garrison at Plymouth, North Carolina, was under siege and hopelessly outnumbered by rebel land and sea forces. The Confederate commander, Brig. Gen. Robert Hoke,[224] threatened, "I will fill your citadel full of iron; I will compel your surrender, if I have to fight to the last man."[225] The next day, he made good on his word. Among the prisoners was Capt. Tom Burke, commander of the Sixteenth Connecticut Infantry's Company A, who was wounded by a gunshot to his right shoulder. He was marched off to confinement in a series of prisons in Virginia, Georgia, and South Carolina. Seven months later, he attempted an escape from Camp Sorghum in Columbia, South Carolina.

On the evening of Nov. 3, Burke and two fellow officers slipped across the guard line and disappeared into the night. "We traveled through the fields and woods, until we struck a road which ran parallel with the Congaree River,"[226] a major tributary some 100 miles from the Atlantic Ocean. The next day, they met and joined forces with five other escapees, who had obtained supplies and two boats from area slaves. The prisoners paddled the Congaree at night and hid during the day, meeting helpful slaves from time to time over the next week. One day, while the escapees were in hiding, "our attention was attracted by loud talking; and soon we discovered a boat below us, upon the river, being poled up the river by negroes."[227] One prisoner showed himself and asked the head slave for provisions. The slave said he had no time to stop and continued on his way. Desperate, the escapee revealed his identity. "The negro no sooner learned his true character than he immediately landed, secured his boat, staid with us all day, cooking rations, and giving very valuable information."[228] On another

day, slaves "told us we were but five miles from a battery, mounting two pieces, upon the right bank of the river, guarded by rebel soldiers. After receiving other information and provisions, we parted with the last of our negro friends, and proceeded down the river, passed the battery in safety, and, landing, waited for the darkness of the night to finish our journey to the coast."[229]

"The light of Friday morning, November 11th, revealed to us the spars of a ship, which we soon made out to be one of the United States blockade. It was the *Canandaigua,* Captain Harrison;[230] and after sundry attempts we succeeded in getting safe on board, under the protection of the star-spangled banner."[231]

Burke made his way north and ultimately returned to the Sixteenth Infantry. He mustered out with the regiment in 1865 and returned to his family in Hartford, Connecticut. He died of pneumonia in 1885 at age fifty-one.

Three Generations of Warriors

ON JULY 25, 1814, Capt. Sullivan Burbank led a company of the Twenty-first U.S. Infantry against British troops in Canada at Lundy's Lane during the War of 1812. Fifty years later, his grandson, Capt. Sullivan Wayne "Sullie" Burbank, would lead a company against rebel troops across Saunders Field during the Battle of the Wilderness, in Virginia.

In 1861, with civil war looming, Sullie implored his father, Col. Sidney Burbank,[232] to help him get a commission in the army. Col. Burbank, an officer in the regular army and an 1829 graduate of West Point, arranged for his son a second lieutenancy in the Second U.S. Cavalry, an elite regiment whose alumni included Confederate generals Robert E. Lee and Albert Sidney Johnston.[233] When the Second Cavalry was reorganized in mid-1861, Sullie transferred to the Fourteenth U.S. Infantry. He made captain in March 1862 and fought at Second Bull Run, Antietam, Fredericksburg, and Gettysburg.

In the early afternoon of May 5, 1864, Sullie and the Fourteenth charged rebel positions at one end of Saunders Field, a small clearing in the dense forest due west of Wilderness Tavern. He was wounded, as was his grandfather fifty years earlier at Lundy's Lane. But his grandfather survived the War of 1812 and went on to retire as a lieutenant colonel after four decades of service. Sullie's wound proved mortal. He went down in the murderous fire that raked Saunders Field, and he fell into enemy hands. After a month of suffering, he succumbed to his injuries, outliving his grandfather by only two years.

Col. Sidney Burbank's adjutant delivered the news of the son's death. Recalling the effort he made to get his son a commission, the elder Burbank wrung his hands in guilt-ridden sorrow.[234] After

dismissing his orderly, Burbank buried his face in his hands. His only son was dead. Sidney Burbank retired as a general and died in 1882, the last of three generations of warriors.[235]

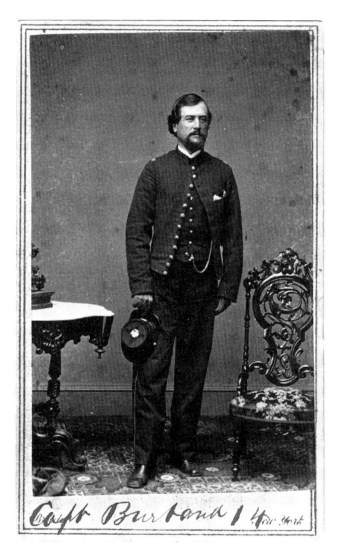

Capt. Sullivan Wayne Burbank, Company A, Fourteenth U.S. Infantry

Carte de visite by Mathew B. Brady (b. ca. 1823, d. 1896) of New York City and Washington, D.C., about 1863

In June 1863, Henry Bond concluded a nine-month enlistment with the Forty-fifth Massachusetts Infantry. The twenty-seven-year-old from West Roxbury, Massachusetts, returned to his office at the Boston publishing firm of Walker, Wise & Company, pre-occupied with thoughts "of companions still in the field, the deaths of some of them whom he greatly loved."[236] He was not content with his contribution to the war effort, and, feeling bound to serve as long as he was able, he could not decline the first lieutenant's commission offered him by the prestigious Twentieth Massachusetts Infantry in October. One month later, Bond became the regiment's adjutant. Six months after his promotion, the Twentieth was decimated at the Battle of the Wilderness in Virginia.

On the morning of May 6, 1864, the regiment formed battle lines, after an attack led by Confederate Gen. James "Pete" Longstreet[237] drove back advanced parts of the Union line. Brig. Gen. James S. Wadsworth,[238] commanding this part of the federal front, rode out and ordered the Twentieth forward. It was "met by a volley of musketry from the enemy only a few yards away."[239] A musket ball struck Wadsworth in the head almost immediately after he gave the order. Another bullet slammed into the Twentieth's commander, Lt. Col. George Macy.[240] Maj. Henry Abbott[241] took charge of the regiment, and soon afterward he went down with an injury that untimately ended his life. Rebel lead ripped into Bond's head, fracturing his jaw. So many officers were hit in the Battle of the Wilderness that the Twentieth was unable to make proper reports to account for its actions.

After his wounding, Bond left for the landing at Belle Plain, a temporary base for federal operations about twenty-five miles from

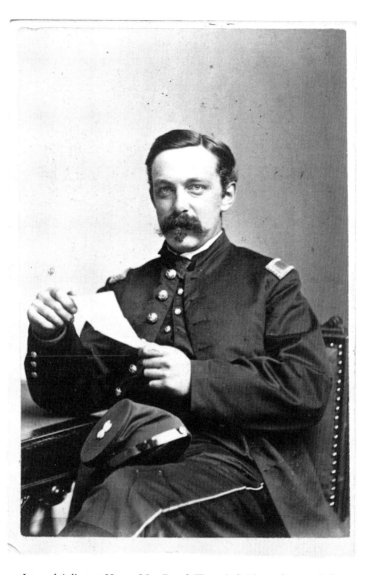

1st Lt. and Adjutant Henry May Bond, Twentieth Massachusetts Infantry

Carte de visite by John Adams Whipple (1822–1891) of Boston, Massachusetts, about 1863–1864

the Wilderness battlefield, along Potomac Creek near its junction with the Potomac River. The country between battlefield and base was flooded with soldiers. Union troops and supplies were shuttled to and from the front lines. About 7,500 Confederate prisoners were being marched to a makeshift camp for processing. Rebel guerrillas led by Col. John Singleton Mosby[242] preyed upon bands of Union men. This forced Union soldiers to take alternate, roundabout routes to the base.

On May 14, somewhere along the trail leading to Belle Plain, Mosby's men came upon Bond and shot him to death. He was remembered by one newspaper correspondent as a young man "of a loving nature, . . . beloved by all who knew him. Sincere and true, warm-hearted, single-minded." He "left a memory without a shadow resting upon its goodness."[243]

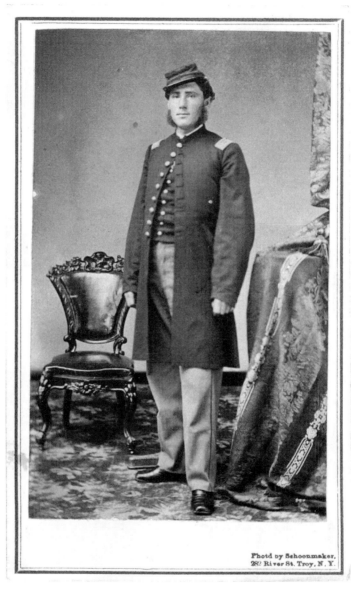

Capt. Waters Whipple Braman, Company H, Ninety-third New York
Infantry

Carte de visite by Christopher C. Schoonmaker (life dates unknown) of Troy, New
York, about 1862–1864

"P.S. The Fighting Today Was Terrible"

"I AM NOT WOUNDED, but have three bullet holes and one shell through my clothing, and one bullet struck my sword and bended it pretty bad, so I have five marks about me to remember the Rebs by,"[244] wrote Capt. Waters Braman of his three days on the front lines in the Battle of the Wilderness in Virginia. A highly respected officer who impressed many with "his executive ability and dignified military bearing,"[245] he was lucky to be alive.

Braman, a twenty-one-year-old lumber dealer from Troy, New York, set about recruiting soldiers during the first summer of the war, and, with two others, formed a company which joined the state's Ninety-third Infantry. The rank and file elected him first lieutenant, and his administrative abilities attracted the attention of the regiment's top brass. After stints as adjutant, quartermaster, and recruiting officer, he received his captain's bars and in April 1864 became commander of Company H.

A month later, he led his 47 men into the Battle of the Wilderness. The three bullet holes in his clothing and the shot that bent his sword happened the first day "in less than a half hour. The next morning at daylight we charged and drove the Rebels about a mile & a half and on that charge I got the shell, which struck me right on the ankle between my feet, and although it stung a little did not bleed me at all and in fact only damaged my trousers, which on my right leg are in rags. Two of the bullet shots, one on my leg, and one on my arm, just started the skin and that was all, so I am all right," he wrote to his uncle after the third day's fight, noting in a postscript, "the fighting today was terrible."[246] Not everyone in the Ninety-third was as fortunate as Braman—fifteen men in his company were killed or wounded, and the regiment lost about 250 soldiers, a third of its fighting strength.

Two days later, he received orders from division headquarters transferring him to the staff of Maj. Gen. David Birney,[247] who, according to Braman, "thinks the 93d are *the* regiment."[248] Surprised to receive the appointment, he wrote, "I knew nothing of being detailed until the order came, and I think myself in luck. Not that I feared to do my duty in the regt, for I consider that it was because I did so well [at the Battle of the Wilderness] that I was detailed here," and added, "I now have a horse to ride and much easier times."[249] He served the final six months of his enlistment as provost marshall and aide-de-camp to Birney and, after Birney's death from disease, to his successor, Brig. Gen. Gershom Mott.[250] He left the army in early 1865 with a major's brevet for meritorious conduct and a reputation as a brave and efficient officer who "stood forth as an example to all with whom he has been associated."[251]

He went home to New York, settled in West Troy, and married a few months later. He returned to the lucrative lumber business, and, in the 1870s, launched a successful political career, serving four terms as state representative and two terms as state senator. In 1891, Braman and his family relocated to Canada, where he reentered the lumber industry as a company manager in the province of Quebec. He died two years later at age fifty-three and was buried in Troy. He was survived by his wife and a son.

Tragedy Times Three

THE EATON FAMILY of Hartford, Connecticut, was struck by tragedy in May 1851 when William Eaton died, leaving behind a young widow, Elisabeth, and four children — two sons and two daughters. Generous friends helped support the family, but their assistance was not enough to make ends meet; so the sons, Edward and Horatio, left school and found jobs. The Eatons suffered tragedy again in 1859, when the elder son died, leaving Horatio, then twenty years old, as the family's sole wage earner. Horatio contributed about half his clerk's salary to support his mother and two sisters, one of whom had become an invalid. He continued to provide financial support after he enlisted in the Union army in April 1861. After serving a three-month term as a private in the First Connecticut Infantry, he received a commission as first lieutenant in the state's Sixth Infantry.

Eaton enjoyed life in the Sixth, where he "possessed the esteem of the regiment."[252] In an 1862 letter from Beaufort, South Carolina, he explained to a friend that the "life that I have lived the past year has worked me down to a mere nothing, but I never felt better in my life than at present."[253] He took great pride in his regiment. After a news report downplayed the Sixth's participation in an expedition to Pocotaligo, South Carolina, where he was hit in the leg with a spent ball, he wrote that he and his men were fighters, not members of some "newspaper regiment"[254] who craved exposure in the press. In the winter of 1864, he accepted a promotion to captain and company commander. He continued, as in peacetime, to lay aside half his salary for his family. But the money would stop coming home after a third tragedy devastated the family.

On May 16, 1864, at the Battle of Drewry's Bluff, Virginia, the Sixth received orders to attack. As Capt. Eaton encouraged his

company forward, rebel fire struck him, and he fell dead. His body and personal effects were sent home to Hartford, where his death was mourned by a large circle of family and friends. He was twenty-four.

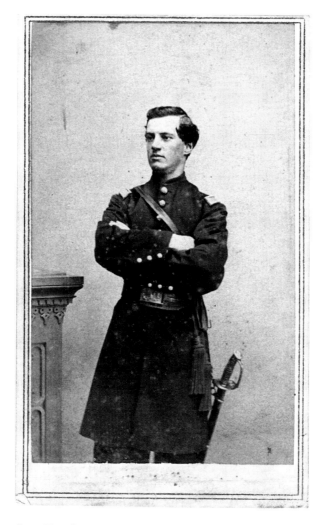

Capt. Horatio D. Eaton, Company E, Sixth Connecticut Infantry

Carte de visite by Edwin P. Kellogg (life dates unknown) and Julius A. Kellogg (life dates unknown) of Hartford, Connecticut, about 1861–1864

The Hero of Drewry's Bluff

The Reverend Thomas Brown, a War of 1812 enlistee and son of a Revolutionary War veteran, joined the Twenty-first Connecticut Infantry as chaplain in May 1863. The sixty-four-year-old minister—father of three sons and father-in-law to another, all fighting for the Union—was a quiet, unassuming man with a cheerful smile. Though unselfish and mindful of all the men, Brown's age was an issue for many, who voiced their doubts: "Why is so old a man sent to us?" "What good can he do?"[255] Brown answered these questions and others on May 16, 1864, at Drewry's Bluff, Virginia.

That day, according to the regimental historian, the Twenty-first was "engaged in battle against fearful odds, and Chaplain Brown was with us, not in the rear, but on the front line where shot and shell were flying, ministering to the wounded and dying, wounded himself but staying at what he thought was his post of duty."[256] Anxious to render practical aid, he "armed himself with an axe and found a short method of opening ammunition boxes, from which he distributed cartridges to all the empty handed."[257] "Death was thinning our ranks and anon the good chaplain, having supplied munitions of war to those in need, was beckoned to the side of a dying soldier. "Are you badly hurt, my boy?" "Oh, yes sir, I expect I've got to die." "Are you a Christian?" "Yes, sir, I hope I am." "Well, then, thank God, let us pray." "And down on bended knees by the dying man's side sank the fearless minister, and with bared head, looking up to heaven, lifted his soul in prayer that God would receive the departing spirit. Meanwhile, the air was active with leaden hail, and the roar at times drowned the firmly spoken words of him that prayed. But God could hear. Those of us

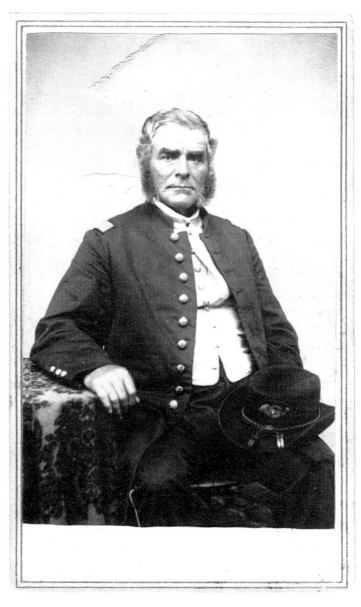

Chaplain Thomas Gibson Brown, Twenty-first Connecticut Infantry

Carte de visite by Nelson Augustus Moore (1824–1902) and Roswell A. Moore (life dates unknown) of Hartford, Connecticut, about 1863

who witnessed the scene will never forget it, nor will they ever cease to honor the fighting old chaplain."[258]

The next day, the regimental historian saw Brown, noticed he was injured, and said to him, "'Why, Chaplain, are you wounded?' 'Oh! That is nothing, just a scratch,' was his reply. Then we found that the old man, our chaplain, was a hero, and he had the love of every one of us. No one dared say a slighting word of Chaplain Brown in the presence of a member of the Twenty-first, after that."

When the war was over, "he enjoyed attending the regiment's reunions and was always present. On one occasion he was presented with a cane, and in his reply to the presentation speech . . . he said, 'I don't see what I have ever done that you boys should love me so.'"

Brown died in March 1885. "On Good Friday of that year, many of his comrades of the regiment gathered at his funeral, and with the sorrow and sincere affection followed his body to the tomb. His memory is still with us, and his benign countenance, his sturdy form, his pleasant words, his cheerful smile, as he met with us at our yearly reunions, are a recollection always with us, and the influence of his service and life is a heritage which will always be ours."[259]

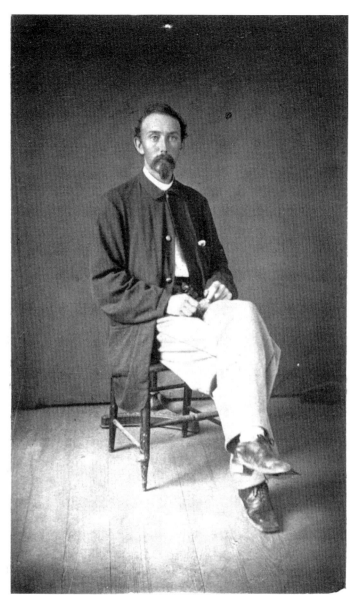

1st Lt. Aaron Hunt Ingraham, Company C, Forty-eighth New York
Infantry

Carte de visite by unidentified photographer, about 1861

On July 18, 1863, the Forty-eighth New York Infantry lost more than half its men in an ill-fated assault on Fort Wagner, a rebel stronghold guarding Charleston Harbor, South Carolina. Its total casualties were second only to the Fifty-fourth Massachusetts Infantry, and among the killed was 1st Lt. Robert Edwards[260] of Company C. Acting regimental quartermaster Aaron Ingraham filled his position. This was Ingraham's first field assignment since joining the regiment almost two years earlier.

Aaron Ingraham had lived a life of borderline poverty before the war. The twenty-two-year-old bachelor had eked out a living on a fifty-acre farm with his parents and three siblings in Amenia,[261] New York, a small village near the northwestern corner of Connecticut. The family could not make ends meet by farming alone, and Aaron, the eldest child, worked other jobs to supplement the meager monies derived from the farm. One winter, he taught school to get the family through the cold months. He kept some money for clothes and turned over the rest to his father. In August 1861, he started a new job — as corporal in the Forty-eighth Infantry — and sent his pay home regularly. So well was he performing as acting regimental quartermaster that, when he was promoted and slated for field duty, six months passed before his superiors released him from his administrative duties.

On June 1, 1864, at Cold Harbor, Virginia, the quartermaster-turned-combat officer led his company into battle for the first time. The Forty-eighth arrived late in the afternoon and was directed into nearby woods — the soldiers assumed they were to make camp. But a half-hour later, the regiment was ordered, with its brigade, to attack. The Forty-eighth fixed bayonets, charged across a field into woods — and into abandoned rebel rifle pits.

"Here the men stopped, and commenced firing; but a lull in the fire of the enemy enforced the order to move forward, and in little more time than it takes to write it we had captured and occupied a section of the main line of Confederate works."[262] Ingraham never made it to the main line — he was shot dead at the rifle pits, in the "very moment of victory."[263] His career as a combat officer lasted a few minutes. His comrades buried his body on the battlefield.

"Courageous to the Last"

ABOUT A HUNDRED MEN from the Twenty-second Massachusetts Infantry hunkered down in their breastworks on the oppressively hot morning of June 3, 1864, at Bethesda Church, Virginia, near Cold Harbor, waiting to attack. The enemy target, a heavily entrenched Confederate division, lay six hundred yards ahead. To get there, the Massachusetts men would have to charge across open land with little protection. High casualties were expected in the regiment's nine companies. In Company H, the death toll would be catastrophic.

Company H was ably led by twenty-seven-year-old Capt. Joseph Baxter, a cigar maker with an energetic spirit and "restless nature"[264] from the Boston suburb of Cambridgeport. He joined the Twenty-second in 1861 as a sergeant and earned a reputation as "an honest man and faithful soldier."[265] He rose from the ranks to line officer and led his company at the battles of Fredericksburg, Chancellorsville, and Gettysburg. On May 10, 1864, at Spotsylvania Court House, Company H was positioned in advance of the main line, and "Baxter took a prominent part, silencing a battery by the fire of his company."[266]

Less than a month later at Bethesda Church, the hundred effectives of the Twenty-second jumped the breastworks and, with eighty men from the Fourth Michigan, formed a running skirmish line ahead of the rest of the brigade. They charged across fields into a galling musketry fire. Company H was hit fast and hard. Cpl. Edward Walton,[267] a regimental favorite, died instantly after a bullet struck him in the head. Pvt. George Steele,[268] just returned from a furlough, fell dead after a rebel ball pierced his heart. A second corporal and another private went down with grisly gunshot wounds. A musket ball fired low ripped into Baxter's bowels, and

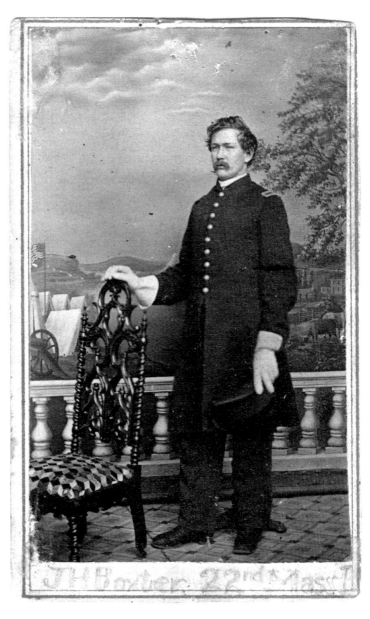

Capt. Joseph H. Baxter, Company H, Twenty-second Massachusetts Infantry

Carte de visite by John Holyland (1841–1931) of Washington, D.C., about 1863–1864

he toppled to the ground. The Twenty-second lost one-quarter of its troops, and Company H, with five men down, suffered the most casualties. The mission was accomplished—the Confederate troops were forced back to a secondary line of defense and their batteries were silenced—but the cost in men was high. Soldiers carried Baxter off the field; "he died heroically in the hospital courageous to the last."[269] The survivors held on to their advanced positions and were relieved shortly after dark.

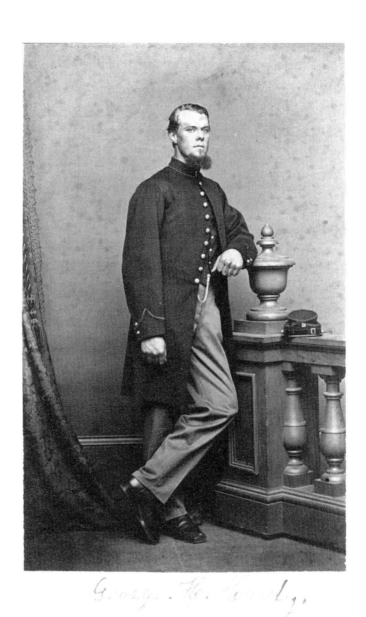

George. H. Hardy,

Cpl. George H. Hardy, Company D, Twenty-first Massachusetts Infantry

Carte de visite by Fisher Bros. (life dates unknown) of Boston, Massachusetts, about 1861

On June 23, 1864, a rebel sharpshooter at Petersburg, Virginia, took aim, fired and hit Pvt. George Hardy of the Twenty-first Massachusetts Infantry. The bullet entered the left side of his lower back and fractured some vertebrae before exiting the right side of his back. This was Hardy's second wounding of the war. The first, a gunshot to his left leg at Roanoke Island, North Carolina, in early 1862, had ended on a positive note — he had fully recovered, then married while on furlough at home in Harvard, Massachusetts. His story after the second wounding ended in an unsolved mystery.

After his shooting, surgeons ordered Hardy to a hospital in Alexandria, Virginia. According to one doctor, "if the ball had varied a hair's breadth either way it would have killed him instantly."[270] His wound discharged pus and bone fragments for seven months, finally closing in January 1865. Hardy mustered out of the army in June, went home, and found work as a station agent with a railroad company. He was plagued by spells of severe back pain. His wife recalled, "The pain seemed to move more toward the head after a while, and he had very bad distressed turns, his pain being between the shoulders and through to the breast, causing great difficulty in breathing."[271] The episodes often came on at night. "The veins on his temple would enlarge as though ready to burst. He would hold on to his head and walk the floor."[272] Two local doctors treated him with injections of morphine.

On Sunday night, September 6, 1868, Hardy had another bad spell. Pained and exhausted in the morning, he kissed his wife goodbye and told her he was going to the depot. He boarded a train bound for Nashua, New Hampshire, and was never seen again. All efforts to find him failed. Some attributed his disappear-

ance to his wound, but family and friends whispered of gambling debts and misappropriation of railroad funds. Morphine addiction may have played a role. Hardy's wife, pregnant with their second son, worked as a housekeeper and took in borders to support her children. She died in 1925 at age seventy-nine.

On July 8, 1864, at Petersburg, Virginia, thirty-nine-year-old Quartermaster Sgt. Andrew Marlatt of the Eighty-sixth New York Infantry was foraging with the regiment's quartermaster over a swampy, bramble-covered stretch of ground, in search of materials with which to build a bunk. Somewhere in the dense undergrowth, Marlatt extended his hand into a patch of green briar common to the swamps of Virginia and pricked the joint of the middle finger of his left hand with a thorn. His body had a most uncommon reaction.

His finger became inflamed, and the swelling spread to his palm and gradually his whole arm. Those who saw the swelling described it as "violent," "extensive," "enormous," and "great."[273] Ten days later, his condition unchanged, he was admitted to the hospital, where his inflamed hand began to discharge large amounts of pus. This "profuse suppuration"[274] was followed by "a tremor and twitching of the muscles of said arm with great loss of power in said hand,"[275] according to one surgeon. Doctors then sent him to a general hospital in Alexandria, Virginia, for treatment. Four months later, Marlatt wrote, "The hand is still very bad and the Surgeon tells me that I will not be able to use it inside of 8 months or a year."[276] He was transferred to a hospital in Elmira, New York, about thirty miles east of his home in Woodhull. In February 1865, he described how the thorn "poisoned the nerves, that has caused me to lose the use of my hand entirely."[277] The hand "is somewhat atrophied and stiff,"[278] and the forearm was paralyzed. A few months later, having received a medical discharge, he returned home to his wife, Maria, and daughter.

His hand and arm remained paralyzed for the rest of his life. Unable to return to his prewar occupation as a joiner, he at-

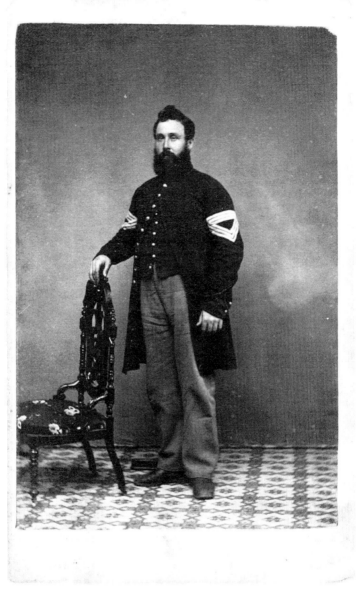

Quartermaster Sgt. Andrew Jackson Marlatt, Company C, Eighty-sixth
New York Infantry

Carte de visite by Seeley (life dates unknown) & Mitchell (life dates unknown) of
Elmira, New York, about 1862–1864

tempted a career as a cabinetmaker and carpenter, but gave up after ten years. The Marlatts stayed in New York until about 1881, then moved to Larned, Kansas. Ten years later, he suffered a stroke and spent the rest of his life in the Kansas State Soldiers Home in nearby Dodge City. He died in 1893.

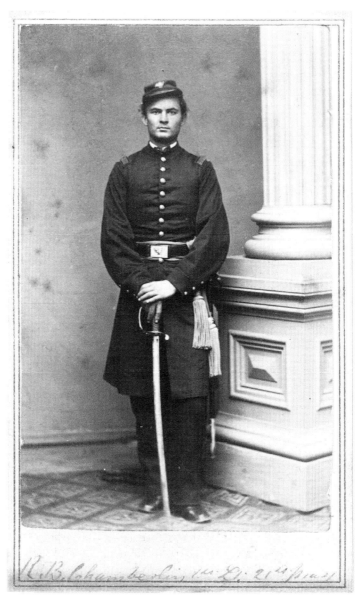

1st Lt. and Aide-de-Camp Robert Bruce Chamberlin, Company I,
Twenty-first Massachusetts Infantry

Carte de visite by E. W. Buell (life dates unknown) of Pittsfield, Massachusetts,
about 1864

Wounded after the Mine Explosion

"That crater during that day I shall never forget,"[279] wrote Union Brig. Gen. Frank Bartlett[280] of the massive mine explosion that blew a hole in the ground 170 feet long, 60 to 80 feet wide, and 30 feet deep along the center of the Confederate front line entrenchments at Petersburg, Virginia, on July 30, 1864. Despite this breach, in the federal attack that followed, Bartlett and most of his staff were wounded and captured, and his brigade was badly cut up.

One of the few staffers to escape was 1st Lt. Robert Chamberlin of the Twenty-first Massachusetts Infantry, who served as Bartlett's ordnance officer and an aide-de-camp. He and Bartlett shared a common birth year, 1840, and hometown, Pittsfield, Massachusetts. Both enlisted in the army as privates at the outbreak of war. Chamberlin had joined the Fourth New Jersey Infantry for a three-month term of enlistment then enrolled in the Twenty-first Massachusetts for three years. In March 1862, his right ear was shot off, at New Bern, North Carolina, and he was captured at Chantilly, Virginia, in September. Harvard-educated Bartlett had lost a leg at Yorktown, Virginia, in 1862. Remaining in the army, he had then helped organize the Forty-ninth Massachusetts Infantry and been elected its colonel. He had received his general's stars and a promotion to brigade command only weeks before the mine explosion.

At the crater, Chamberlin advanced to the enemy's fortifications, where a shell fragment crashed into his head, fracturing his skull. He made it back to the Union line and to the corps hospital, where he underwent surgery to remove splintered bone. Bartlett became trapped in the crater after "a shell knocked down a bowl-

der of clay on to my wood leg and crushed it to pieces."[281] He was forced to surrender, as were others in his command.

Bartlett spent a couple of months in a Confederate prison. After his release, he rose to division command. He died in 1876 at age thirty-six. Chamberlin left the army less than a month after the Battle of the Crater, his term of enlistment having expired. He married twice — his first wife died, and his second marriage to a much younger woman ended in divorce. He had two children by his second wife, in the late 1890s, but both died young. He suffered a stroke in December 1918 and died the next month at age seventy-eight.

Shot at the Crater

ON JULY 30, 1864, at Petersburg, Virginia, the Fourth New Hampshire Infantry advanced with its brigade into a mob of panic-stricken Union soldiers fleeing a devastating rebel counterattack at the Battle of the Crater. Pvt. Daniel Sullivan, an Irish immigrant and farmer in Wilton, New Hampshire, marched with the regiment as it moved around the right of the crater. Their mission was originally in support of the main Union attack, but it had become an exercise in damage control.

The Fourth came under severe enemy fire that enfiladed its ranks. Col. Louis Bell,[282] commanding the regiment and its brigade, reported Union troops "dashing through my men with arms at a trail and bayonets fixed. The officers and men of my command tried to resist the dash of those retreating but to no avail. Quite a number of my men were wounded by the bayonets of the retreating troops, and the brigade was disorganized by the large number of fugitives passing through it."[283] Over in Company D, Sullivan was loading his musket. He placed a paper cartridge between his teeth and, as he tore it open, a bullet ripped through his right hand, the ball entering just below the webbing between his thumb and index finger, shattering several bones. When the regiment fell back, he received medical treatment at nearby City Point, Virginia, and was evacuated to a Philadelphia hospital. He rejoined the Fourth in October, but his hand was permanently damaged. He could flex it only partially and he could not fully extend it.

Sullivan mustered out as a corporal after the war ended and returned to New Hampshire. In 1870, he moved to Burlington, Kansas, and found work on the Holt Ranch, renamed the Holt and Sullivan Ranch after he invested in the business. There he met Sarah Stout, a West Virginian seventeen years his junior. The

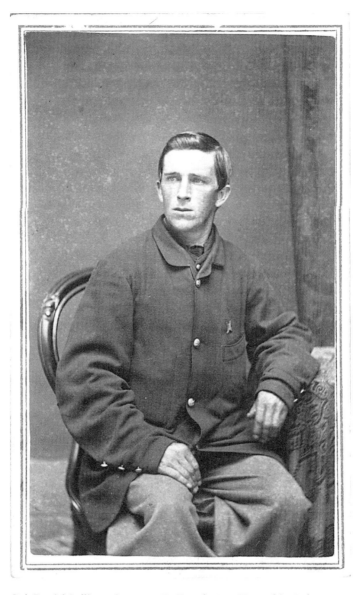

Cpl. Daniel Sullivan, Company D, Fourth New Hampshire Infantry

Carte de visite by J. Morgan (life dates unknown) of Concord, New Hampshire, about 1864

couple married in 1875 and raised three children. In 1905, the Sullivans moved to the West Coast and lived five years in Washington State before moving to Modesto, California, where their farm supplied community businesses with fruit, vegetables, and chickens. He lived until 1917, dying of heart disease at age seventy-seven.

He Followed the Sea

By 1863, the U.S. Navy's operations had expanded faster than its manpower, and it needed thousands of sailors to serve at stations along the Atlantic coast and the Mississippi River. To help recruit seamen, the U.S. War Department issued General Order 91, which encouraged Union soldiers with maritime experience to transfer to the navy. Pvt. Albert Johnson of the First Maine Cavalry applied for a transfer. When it came through, he resigned from the army, after having served in two regiments.

Johnson, a twenty-six-year-old sailor from Westbrook, Maine, had mustered into the state's Tenth Infantry as sergeant in May 1861. On September 17, 1862, at the Battle of Antietam, he was promoted to first lieutenant and slightly wounded in the head. He mustered out and went home the following May, but his return to civilian life was short-lived, as the First Maine Cavalry recruited him six months later. He enlisted as a private and had served three months when, in April 1864, his transfer to the navy was approved and he joined the crew of the *North Carolina,* a New York–based receiving ship mounting six guns.

One month later, he transferred to the *Brooklyn,* a twenty-four-gun battle cruiser with a crew of 381. In August 1864, he was on board the *Brooklyn* when it led Adm. David Farragut's[284] fleet to victory in Alabama's Mobile Bay—where Farragut famously shouted, "Damn the torpedoes, full speed ahead," at the captain of the *Brooklyn* when the ship stopped under heavy fire to clear mines. Two months later, when they were docked in Boston, Johnson inexplicably deserted. He never fully accounted for that act, but he later wrote that he had "followed the sea until 1870."[285]

His travels brought him to Northern California, where he married and settled into the life of a farmer in Sacramento County.

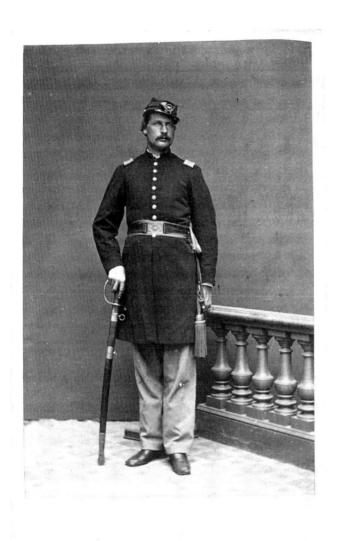

Seaman Albert H. Johnson, USS *Brooklyn*

Carte de visite by Benjamin F. Smith Jr. (1830–1927) & Son of Portland, Maine, about 1861–1863

Johnson had one daughter before his wife died in 1883. A wagon accident in 1895 left him unable to work the farm. The last time his name appeared on a government record was 1903.

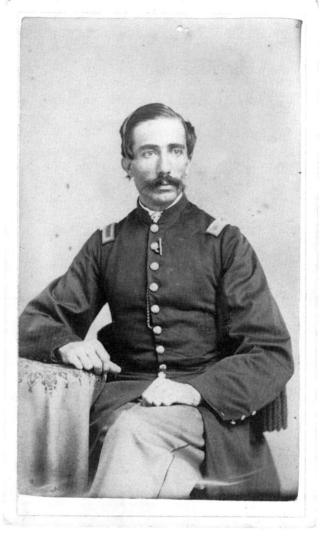

1st Lt. Martial Eugene Imbert, Company A, Ninety-sixth United States Colored Infantry

Carte de visite by James A. Sheldon (1824–1886) of New Orleans, Louisiana, October 1865

Lt. Col. Henry Merriam[286] had a personnel problem. The commander of the Seventy-third U.S. Colored Infantry repeatedly ordered 1st Lt. Martial Imbert back to the regiment's camp along the Mississippi River at Morganza, Louisiana. Imbert had been on recruiting duty in New Orleans for the past four months, had displayed no interest in returning, and had ignored several summonses issued by the colonel.

There can be little doubt that Imbert enjoyed his assignment in New Orleans, where he was in charge of the draft center and commissary department for black troops. Compared to his regular assignment as a line officer with the Seventy-third, his current job increased his responsibilities, and he must have been drawn to the Creole culture of the city, which descended from that of his homeland.

Imbert had emigrated from France, probably in the 1850s, and settled in New York City. A soldier by occupation, he reinvented himself as a French teacher after he arrived in America. In December 1861, at age thirty-three, he returned to soldiering, as an orderly sergeant with the Ninetieth New York Infantry, and departed for duty in Key West, Florida. The regiment shipped out to Louisiana in 1863. It participated in the siege of Port Hudson, where Imbert became aware of the First Louisiana Native Guards, a black regiment originally formed as a Confederate organization. After the surrender of New Orleans in 1862, the Guards reformed and became the first black regiment mustered into the Union army. Also known as the First Corps d'Afrique, it was formally designated the Seventy-third U.S. Colored Infantry in February 1864, shortly after Imbert joined Company A with a second lieutenant's commission. He served less than six months with the regi-

ment before being sent to New Orleans on recruiting duty. Lt. Col. Merriam, reduced to only six line officers, was anxious to get Imbert back, but the lieutenant did not return until July 1865. He mustered out of the army in January 1866, a few months after the Seventy-third was consolidated with the Ninety-sixth U.S. Colored Infantry.

Imbert made New Orleans his permanent home after the war. The death in 1864 of his wife, Henriete, back in New York, may have been a contributing factor in his decision to change his place of residence. He found work as a laborer and was active in the Grand Army of the Republic. He lived until 1900.

A Fortuitous Meeting

IN LATE AUGUST 1864, near Nicholasville, Kentucky, Sgt. Russell Babcock's horse gave out; and his regiment, the Eleventh Michigan Cavalry, went on without him. Babcock made his way to nearby Camp Nelson, a bustling federal army supply hub. The camp's dusty roads were crowded with wagons packed with supplies destined for troops in Kentucky, eastern Tennessee, and western Virginia. The wagons rolled passed a hodgepodge of some 300 buildings, mostly temporary structures, which included a hospital, facilities for thousands of refugees fleeing slavery, and the Union's third largest recruiting and training station for black regiments. Babcock found his old captain, Adna Bowen,[287] who had recently left the Eleventh to help recruit troopers for the Fifth and Sixth U.S. Colored Cavalry. Their meeting was fortuitous for the young quartermaster sergeant.

Capt. Bowen was looking for officers to lead the two new regiments, and he offered nineteen-year-old Babcock a second lieutenancy in the Sixth Cavalry. He accepted, was assigned to Company D, and joined his new command in late October. He had missed the Sixth's first battle, at Saltville, Virginia, where it fought with other units in a failed attempt to destroy the town's salt works.[288] In December, he led his company on Maj. Gen. George Stoneman's[289] raid into southwestern Virginia. A few days before Christmas, 1864, the Sixth and its fellow raiders had a second chance to capture the salt works, and this time they succeeded. The regiment spent the following year in Kentucky, and Babcock mustered out in September 1865.

He returned to his Hudson, Michigan, home, where he married, fathered a daughter, and worked as a real estate agent and for

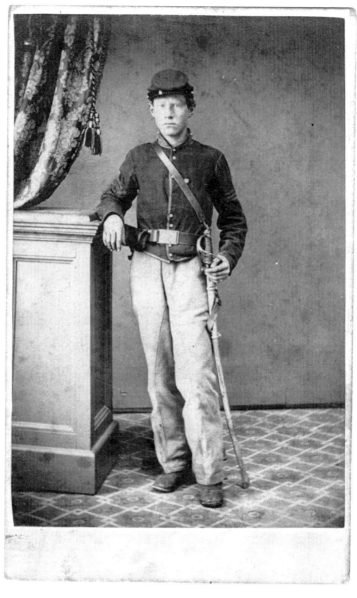

2nd Lt. Russell Dailey Babcock, Company D, Sixth United States Colored Cavalry

Carte de visite by the Elrod Brothers (life dates unknown) of Lexington, Kentucky, about 1864

a railroad company. In 1871, the Babcock family moved west. They first stopped in Hastings, Nebraska, where they lived until 1889, then in Denver until about 1907, and finally in San Francisco. Babcock's eyesight and mental faculties went into decline about 1922, and he died of colon cancer in 1928 at age eighty-three.

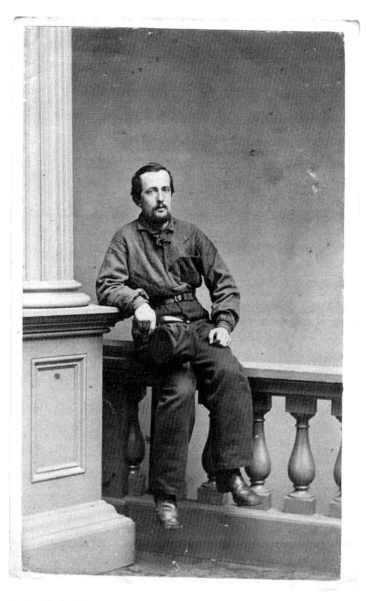

Sgt. Isaiah Goddard Hacker, Company E, Thirty-eighth Massachusetts
Infantry

Carte de visite by unidentified photographer, about 1862

"Dangerously Hurt Internally"

IN THE AUTUMN OF the third year of the war, Lottie Webb read-
ied herself for the coming home of the love of her life, Sgt. God-
dard Hacker. She faced a delicate task—nursing him back to
health after he had been seriously injured at the Battle of Winches-
ter, in Virginia.

Hacker, a dedicated journal keeper, had recorded his own
wounding on September 19, 1864: "We were ordered forward un-
der a heavy fire of grape and musketry, our lines advanced in good
order for about 3 or 400 yards when the enemy opened a masked
battery on us and a cross fire of musketry which broke our lines
and compelled them to fall back, just as we turned to go back a
piece of shell knocked me over and broke my ribs on the right side
and I had a narrow escape from being taken by the Rebs."[290] The
shell fragment left no open wound, but he began "bleeding freely
at the mouth."[291] He made his way with other wounded soldiers
to the front yard of a house-turned-field hospital in Winchester.
A friend passed by the next day, and found him "very low and
thought his recovery very doubtful as it was said he was danger-
ously hurt internally."[292] In fact, he had two broken ribs and lung
damage.

Hacker, a clerk from Readville, Massachusetts, had a hard time
finding an infantry regiment that would accept him. After failing a
physical with the Nineteenth Massachusetts Infantry in 1861, he
and his brother-in-law joined the regiment as sutlers. Later, after
another failed physical with the state's Second Infantry, he suc-
cessfully enrolled as a private in the Thirty-eighth. Possessed with
"a wonderful attitude and great spirit,"[293] he established himself as
"one who always did his duty, and could be relied on at all
times."[294] After his Winchester wounding, he went to a hospital in

York, Pennsylvania, and then on to his sweetheart at home. Lottie helped him convalesce, and he rejoined the Thirty-eighth two months later.

He mustered out of the army after the war ended, returned home, and married Lottie. They raised three children together, including a set of twins. His lung caused him some trouble. In 1868, his physician, fearing consumption, advised him to go west. The family moved to a farm in Kansas, but Hacker discovered that the agricultural life was not for him, and he became the shoe department manager for a trading store in Manhattan, Kansas. He lived to age eighty-six, dying in 1925.

The Fighting Fifer

"FALL IN, EIGHTH VERMONT!" shouted the regiment's major minutes before waves of rebel infantrymen cut through the gray dawn and crashed into the New Englanders at Cedar Creek, Virginia, on October 19, 1864.[295] The Confederates swarmed over them and demanded surrender in hoarse shouts, but the Vermont volunteers rallied around their flag and hollered back in defiant tones "Never! Never!"[296] Enemy bullets dropped the corporal guarding the colors, and the standard was passed to others, amidst hand-to-hand combat with bayonets and clubbed muskets. Then the brigade flag became in imminent danger of capture, and a half-dozen men rushed to save it. Close by, 1st Lt. Nathan Cheney of Company K, who may have been moving in support of the colors,[297] fell after a musket ball ripped into his back.[298]

Thirty-five-year-old Cheney, a Lunenburg, Vermont, farmer, had enrolled in the state's Eighth Infantry as a fifer in the winter of 1861. His leadership abilities attracted the attention of the regiment's top command; he rose steadily through the ranks and joined the officer's corps as second lieutenant in the summer of 1863. A year later, the Eighth left Louisiana, where it had served the majority of its enlistment, for Virginia's Shenandoah Valley to pursue Lt. Gen. Jubal Early's[299] Confederate army, which was menacing the region. At Cedar Creek, in the northern part of the valley near Winchester, Early's force caught the Union army off guard, and most of it fled before the oncoming raiders. The Eighth was one of the few units not broken by the shock of the initial assault. With two other regiments in its brigade, it quickly filed into a forest through which Confederate soldiers were advancing, to slow the enemy juggernaut. The rebels overpowered the little

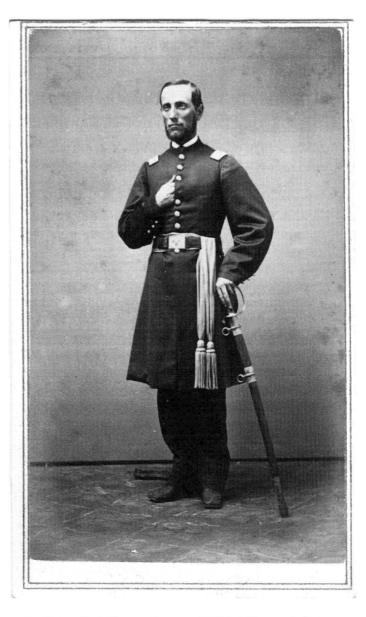

1st Lt. Nathan Cluff Cheney, Company K, Eighth Vermont Infantry

Carte de visite by George Harper Houghton (d. 1870) of Brattleboro, Vermont, 1864

brigade and forced it to retire, leaving more than half of its number behind.

As Cheney lay desperately wounded in the woods, the tide of battle turned; Maj. Gen. Philip Sheridan[300] rallied his demoralized command, went on the offensive, and destroyed the rebel raiders. The ground lost in the morning was retaken, and federal soldiers rescued Cheney that night, taking him to nearby Newtown for treatment.[301] But his wound proved mortal, and he succumbed to his injury two days later. The regiment remembered him as a brave and capable officer who rose from the ranks by faithful and efficient service. His wife and three young children survived him.

Horse Thief

To ANY PASSERSBY, the sight of Pvt. Jack Andrews with a mule and two horses on a road outside Kansas City, Missouri, might not have been out of the ordinary. But there were problems with this picture: Andrews had left his company without authorization, taken the animals without permission from the Eleventh Kansas Cavalry, and was leading them away from his regiment.

This was not the first time Andrews had ventured down the wrong path during his volunteer military service. In April 1863, about six months after joining the Eleventh, he had failed to return from his first furlough home, and military authorities declared him a deserter. He had remained at his farm and blacksmith shop in Emporia, Kansas, with his wife and son until July, when a special order was published offering leniency to all deserters who voluntarily returned to the regiment. He turned himself in and was eventually restored to duty. He stayed out of trouble for barely a year. In mid-1864, he had gone absent without leave and been confined at Fort Humboldt, Kansas. In October he disappeared a third time, taking the mule and horses left by the regiment on its march from Kansas City to Coldwater, Kansas.

Andrews led the animals to his home county and left them with an acquaintance at an undisclosed location, presumably to collect them at a later date. His plans were foiled after his absence was discovered. Charges were filed against him for stealing and for leaving his company without permission, and his case was referred to the judge advocate at Fort Riley, Kansas, where Andrews was confined until he mustered out in August 1865.

After the war, he moved his family from Emporia to nearby Neosho Rapids and continued to work as a blacksmith and farm-

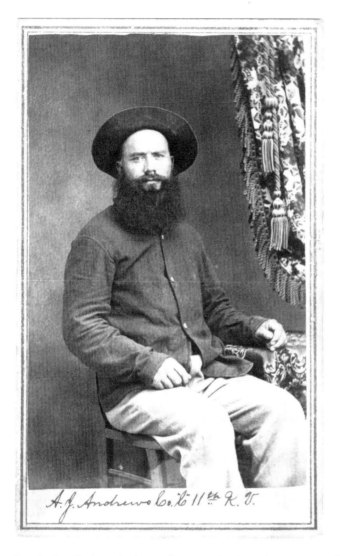

Pvt. Andrew Jackson Andrews, Company C, Eleventh Kansas Cavalry

Carte de visite by unidentified photographer, about 1862–1863

er. In later life, he was bothered by stomach problems; he attributed them to his war service and received a disability pension until his death in 1897 at age seventy-one.

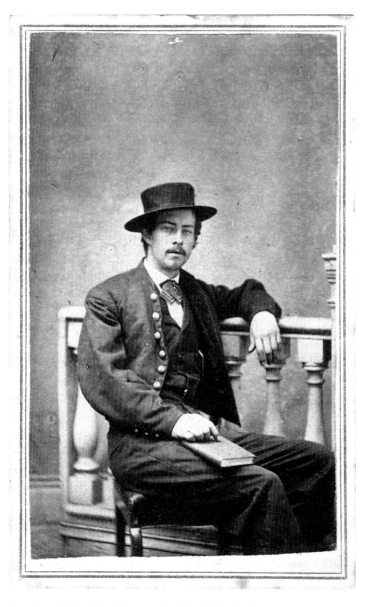

Pvt. John H. Madden, Twenty-first New York Cavalry

Carte de visite by unidentified photographer, about 1864

The Order That Never Came

JOHN MADDEN'S Civil War service began and ended in New York. The twenty-one-year-old clerk from Troy was recruited for the state's Twenty-first Cavalry in September 1864, about six months before the war ended. The regiment desperately needed replacements after campaigns up and down Virginia's Shenandoah Valley had sapped its strength. In late August, the regiment withdrew to Cumberland, Maryland, where it reported to the Department of West Virginia remount camp, a place to rest, reequip, and receive new recruits. Madden expected to join the Twenty-first after basic training, but the war ended before that order came.[302]

To learn the cavalryman's art, Pvt. Madden traveled to Hart Island in New York Harbor, where facilities had been established a year earlier to educate recruits. Up to 3,000 men at a time were housed there; a total of 50,000 soldiers ultimately received training on Hart Island. After his arrival, Madden remembered, he was "detailed in what was called 'Co. C Procurement Party' and there served until discharged May 7, 1865."[303]

Madden returned to Troy and married Emma Louise Hopkins six months later. They moved to Plainwell, Michigan, the following year and started a family that grew to include nine children. He lived until October 1, 1910, dying at age sixty-six.

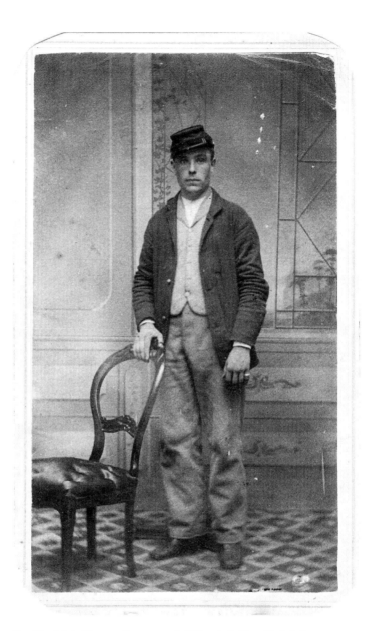

Pvt. Daniel A. Masten, Company A, Fifty-sixth New York Infantry

Carte de visite by Harry Hunt (life dates unknown) of New York City, 1864

Answering the Call

In early August 1864, as headlines from newspapers across the North heralded the battles around Atlanta by Maj. Gen. William T. Sherman's Union forces, an officer from the Fifty-sixth New York Infantry sought recruits in Newburgh, a town situated along the banks of the Hudson River about 125 miles north of New York City. He needed to replenish the regiment's depleted ranks, originally filled by volunteers raised in the village and surrounding hamlets three summers earlier. Twenty-four-year-old resident Daniel Masten, who had elected not to go to war in 1861, made a different decision in response to this new call for troops.

Life had not been easy for Masten. In 1857, when he was seventeen, a serious illness had crippled his father and left him and his mother without financial support. Daniel went to work at a local foundry, and his pay kept the family afloat. He became his mother's sole source of income after his father died in 1859. When the Fifty-sixth came to town on a recruiting mission in 1864, he decided to enlist. He may have been attracted by the $350 bounty — almost two years' wages — or perhaps had become bored after six years at the foundry. A chance to get into the war before it ended may have been a factor. Whatever the reason, he turned over the initial installment of his bounty to his mother and joined the regiment at Morris Island, South Carolina, from where the Fifty-sixth would soon be departing to support Sherman's plan to march across Georgia.

At the end of November 1864, as Sherman's Army approached Savannah, the Fifty-sixth and other units moved to secure the Charleston and Savannah Railroad and prevent enemy troops from sending reinforcements to battle Sherman's soldiers. On December 6, the Fifty-sixth boarded a steamer, landed at Deveaux

Neck, South Carolina, and immediately engaged rebel troops. The regimental historian recorded, "Our brigade advanced under a heavy fire and seized a position about one mile from the landing after a severe fight, in which we lost many in killed and wounded, many of whom were new recruits,"[304] including Masten. He "was shot by a Ball from the Enemy, said Ball taking effect in his side and passing through his body, from which wound he died about three quarters of an hour thereafter."[305] His body was buried a short time later, and his pay for four month's service was delivered to his mother.

Faithful and Meritorious Service

IN THE WINTER OF 1864–65, Union Maj. Gen. Alfred Terry[306] worked up plans for an expedition to take Fort Fisher, a Confederate stronghold protecting the port city of Wilmington, North Carolina. In assembling his support staff, he selected as his assistant quartermaster Charles Sampson, and he could not have made a better choice.

Sampson, a nineteen-year-old clerk from Quincy Point, Massachusetts, had mustered into the state's First Infantry as a private in May 1861. He had been detached to clerk in the quartermaster department, made sergeant, and had resigned from the regiment in 1863 to accept a captaincy in the U.S. Quartermaster Department, where he served on the brigade and division level in the Army of the Potomac. In February 1864, he traveled to Norfolk, Virginia, to join the Department of Virginia and North Carolina. He transferred to the Army of the James in October and served with the Tenth and Twenty-fourth Corps.

On January 15, 1865, after a two-day bombardment, Terry's force moved in and took the fortress and rebel garrison at Wilmington after a bloody assault — the mission was a complete success, and the last remaining major port along the Atlantic coast was closed to the Confederacy. Terry — a highly regarded officer who later was George Armstrong Custer's superior when Custer and his Seventh Cavalry were killed on June 25, 1876, at the Battle of the Little Big Horn — earned a Thanks of Congress resolution, and Sampson was awarded the brevet rank of major for faithful and meritorious service during the war. He spent the final months of his army service in Richmond.

After the war he moved to Chicago and married Henrietta Hatch, a recent divorcée. They had two children, a daughter who

died young and a son who lived to maturity. In 1878, the family relocated to Conejos, Colorado, a town near the New Mexico border. He died of heart disease at age seventy-six on January 30, 1919. His wife passed away exactly one year later.

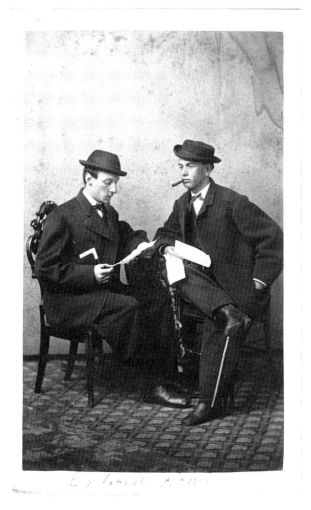

Capt. and Assistant Quartermaster Charles Monreau Sampson, Quartermaster Department, U.S. Volunteers (*left*) and friend

Carte de visite by Vannerson (life dates unknown) and Jones (life dates unknown) of Richmond, Virginia, 1865

A Man to Be Counted On

THE FINAL WEEKS of the Civil War were action-packed for the Seventeenth Massachusetts Infantry, and Cpl. Albert Cook of Company A didn't miss a minute of it. On March 8, 1865, he and the veteran volunteers of his regiment were ordered into action at Wise's Forks, a strategic crossroads a few miles from Kinston, North Carolina. One week later, the Seventeenth occupied Kinston, and it entered nearby Goldsboro on March 21. On April 9, as Robert E. Lee was surrendering his army at Appomattox Court House, Virginia, the Massachusetts men were advancing on North Carolina's capital, Raleigh. They took possession of the city the day President Abraham Lincoln was assassinated. Cook was in the ranks with his regiment every day. His perfect attendance during this hectic time was not unusual for him; he was present at every battle, skirmish, raid, and all the marches in which his company and regiment took part during its four years as an organized unit. He was a modest man who was always on the job, and his brother soldiers could count on him to be there.

When the war started, Cook, a nineteen-year-old bachelor, was working as a clerk in his hometown of Newburyport, Massachusetts. A month later, he enlisted as a private in the local military corps, the City Grays, which became Company A of the Seventeenth Infantry when it formed in the summer of 1861. The regiment was sent to Baltimore and remained there until the following spring, when it received orders and shipped out to eastern North Carolina, where it served the rest of the war. Cook remained on duty continuously for the next three years, with the exception of a single furlough granted him after he reenlisted as a veteran volunteer in 1864. Perhaps his single greatest honor came in the spring of that year, when he was promoted to corporal and given charge

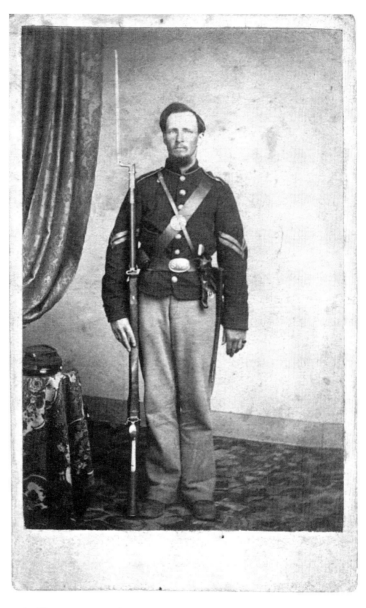

Cpl. Albert James Cook, Company A, Seventeenth Massachusetts
Infantry

Carte de visite by unidentified photographer, about 1864–1865

of the colors. He mustered out with the regiment in July 1865 and returned to Newburyport.

In 1869, he married Sarah Perkins and started a family. Two of his five children — a son and a daughter — lived to maturity. Cook participated in regimental reunions until a cerebral hemorrhage in the 1910s left him paralyzed. Senility came upon him, and he died in 1921 at age seventy-nine.

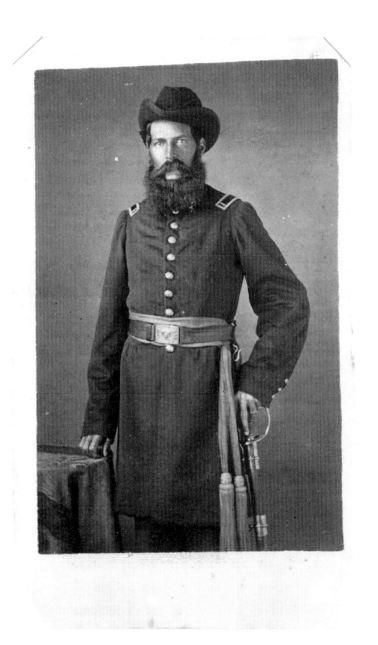

1st Lt. James Matthews Cooper, Company A, Thirty-third Iowa Infantry

Carte de visite by unidentified photographer, about 1864

"A Better Man Never Lived"

1ST LT. JAMES COOPER was beside himself with excitement when the news came in to Union headquarters at Mobile, Alabama, on the morning of May 27, 1865, that Confederate Lt. Gen. E. Kirby Smith[307] had surrendered his forces in Texas. The last gray army in the field was no more and the rebellion was over. Now his regiment's plans to go to the Lone Star State to bring down Kirby Smith's army could be cancelled. He and his men were going home. Cooper jumped on his horse and rode off to tell the rank and file. At 11 A.M., he was galloping along the line of the brigade, announcing the surrender. The relieved men exploded with lusty cheers and began firing their weapons in celebration.[308]

Cooper served with the Thirty-third Iowa Infantry for most of his enlistment, joining as a sergeant and working his way to first lieutenant of Company A, whose members regarded him as "a first class soldier." "He was our best officer—always ready for duty," remembered a corporal, "he used to be around on duty when he shouldn't have been—boys tried to get him to go to hospital but he wouldn't."[309] In March 1865, he was detached from the Thirty-third to serve as an aide-de-camp to Col. Conrad Krez,[310] a brigade commander gearing up his men to fight in the upcoming campaign against the port city of Mobile.

On March 27, 1865, Krez's troops moved in with other federal units to assault Spanish Fort, Alabama. During the fight, Cooper rode off to the brigade's right flank with instructions to move one regiment forward. He delivered the order and watched as the intended movement was executed. An enemy artillery shell burst close by, his horse recoiled and wheeled, and Cooper crashed to the ground, left shoulder first, severely injuring his left arm. He went to the regimental hospital but not much could be done, so he

returned to duty, his arm practically useless. He mustered out with the regiment in July 1865 and returned to his farm and family in Marion County, Iowa.

His life after the war was difficult. His left arm remained paralyzed. His marriage dissolved in the 1870s, and he moved into the home of a daughter, where he died in 1915 at eighty-seven. The Rev. Michael Harned,[311] who had been a private in Cooper's company, presided at the funeral. Cooper's daughter notified the pension office of her father's passing. In her letter she wrote, "a better man never lived."[312]

"Ever Afterwards My Enemy"

HENRY PEARCE'S MARRIAGE disintegrated after he returned home to Emporia, Kansas, from three years' service in the Union army. In 1867, he left his wife and children. Devastated and homeless, he drifted for the next five years; he worked at a variety of jobs in several states, including as a clerk in Kansas and an insurance agent and contractor in Illinois. His wife sued him for gross negligence and was granted a divorce in 1869. Looking back, army life may have been simpler, though still difficult.

When the war broke out, twenty-three-year-old Pearce, a mountain of a man at six-foot-five, was a struggling father of four eking out a living on his small Kansas farm. In the spring of 1861, he joined the Second Kansas Infantry, a three-months' regiment, and made a fine soldier, rising from private to sergeant over the course of his one-year enlistment. After mustering out, he rejoined the army as first lieutenant of Company H in the Eleventh Kansas Infantry, which was reorganized as a cavalry unit in April 1863.

Later that year, Pearce and 2nd Lt. William Philips[313] were candidates for the company's captaincy. Pearce won the appointment, but lost a comrade. He remembered that Philips "was ever afterwards my enemy up to the time we mustered out of company. We messed separately and had no unofficial intercourse whatever."[314]

The Eleventh guarded against Confederate attacks in Kansas and Missouri and against potential Indian uprisings in Colorado, Nebraska, and Dakota territories. Company H spent the winter of 1864 stationed at Fort Dodge, Kansas. The soldiers there had little protection from the cold, winter weather. Pearce and his bunkmate recalled taking refuge "in holes dug in the banks of the Arkansas

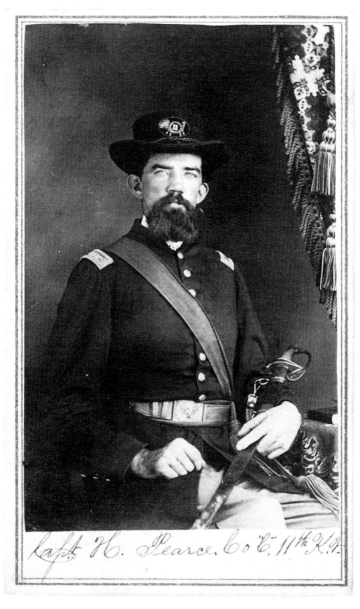

Capt. Henry Pearce, Company H, Eleventh Kansas Cavalry

Carte de visite by unidentified photographer, about 1862–1863

River, which were imperfectly heated with dried buffalo chips (manure) our only fuel."[315]

At war's end, Pearce considered staying in the army but decided against it, even though Brevet Brig. Gen. James Ford,[316] commanding the District of Upper Arkansas, praised him as "a very valuable officer to me at the present time."

Pearce's drifting ended in 1872, after former army buddies helped secure him a job as a police officer in St. Louis. His life began to turn around, and he remarried in 1874. Ten years later, kidney and heart disease confined him to bed. He succumbed to his afflictions in 1888 at age fifty-one.

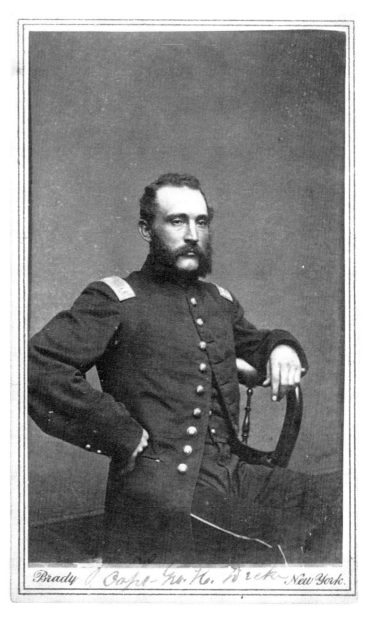

Capt. George H. Decker, Company H, 143rd New York Infantry

Carte de visite by Mathew B. Brady (b. ca. 1823, d. 1896) of New York City and Washington, D.C., about 1862–1864

"He Was Determined to Die"

CELIA DECKER FELT the cold muzzle of a revolver press against the back of her head, and, before she could react, a single bullet was fired, which entered just behind the left ear and lodged in her neck. She stumbled from her house and staggered to a neighbor's home, leaving behind a trail of bloody footprints in the December snow. In a bedroom of her Liberty, New York, home stood Celia's husband, George. He turned the pistol to his own head and pulled the trigger.

George Decker, an intelligent, enterprising and industrious young businessman, had moved from his home in Orange County, New York, to Liberty and entered the booming tanning business as a partner in the firm of Dutcher and Decker. Through hard work and savvy dealings, he became popular and prosperous. When the war started, he left his tannery in the care of his partner and raised Company H of the state's 143rd Infantry. He earned the universal esteem of his men for his gallant conduct and served them "with great credit."[317] He led his command in fourteen engagements, including the battles for Atlanta and Bentonville, North Carolina, where, according to a sergeant in his company, "Capt. Decker opened cartridges for me while I loaded and fired."[318] The war brought out the best in him—and also the worst. He began to drink during his enlistment, and while it did not appear to affect his duties, it destroyed his life and family.

After the war, Decker returned to New York and formed a new and lucrative business partnership with his brother Demmon, a veteran who had served with the Fifty-sixth Infantry. In 1866, he married Celia Wells, the daughter of the town sheriff, and started a family that grew to include two sons. His life began to unravel after financial reverses ruined his business, and he turned to rum for

comfort. He became trapped in a cycle of drunkenness and despondency followed by sobriety and bitter regret. His wife and sons were caught in the crossfire, and they suffered repeated abuses. In early 1874, the Deckers separated, but they reunited after he convinced her with a solemn pledge to reform his alcoholic ways. He broke his word soon after, however, and Celia Decker insisted on another separation. He regretted the action, "but acquiesced in it as for the best."[319]

On Tuesday afternoon, December 21, 1875, she packed and prepared to leave the house with the help of her brother and sister-in-law. George Decker called his wife into a bedroom as she and her children were on the way out. He closed the door, began to talk, and raised his pistol to her head. She begged for her life, and he lowered the weapon. He lifted the gun to her head two more times between her pleas for mercy—the last time, he pulled the trigger. After she fled, he attempted to shoot himself; "three caps were snapped without discharging the pistol," according to a news report.[320] Then he picked up a razor and slit his throat from ear-to-ear, severing the windpipe. Stunned neighbors crowded around and tried to help. Decker "could speak a little with great difficulty; and protested against having any surgical aid. He was determined to die"[321] and suffocated three hours later. Celia Decker's injury was at first believed fatal, but she survived the shooting and lived until 1928.

NOTES

Biographical information on enlisted men and officers was obtained from the National Archives and Record Service, Washington, D.C., and from Boatner's *The Civil War Dictionary* (New York: *David McKay Company, 1962*).

Abbreviations

NARS: National Archives and Record Service, Washington, D.C.

OR: U.S. Government, *The War of the Rebellion: A Compilation of the Official Records of the Union and Confederate Armies*, 128 vols. Washington, D.C., 1880–1901. The *Official Records*, established by federal law in 1864, contain reports written and filed by commanders within days, weeks, or sometimes months of the events. The volumes are arranged in four series: Volumes 1–111 make up Series 1 and consist of official battle reports for the Union and Confederate armies. The remaining three series contain correspondence relating to prisoners of war, conscription, blockade running, and other communications. Each citation of this source includes four numbers — series, volume, part, and page — and names the author of the cited report.

1. According to Fox's *Regimental Losses* (1889), the average age of a Civil War soldier was 25.8; three age groups were evaluated in an attempt to arrive at the percentage of men of prime fighting age who enlisted. Those groups were white males ages 15–19, 20–29, and 30–39. Fox also stated that the total number of men who enlisted in the Union armies was 2,236,168. Of that number, 2,080,193 were volunteers, 67,000 were categorized Regulars, and 178,975 were listed as Colored Troops. According to the Inter-University Consortium for Political and Social Research's Social Science Data and Resources for Researchers database on the Internet, the total number of white males of all ages in the United States in 1860 was 13,675,476, of which 10,875,658 belonged to states loyal to the Union. Loyal states comprised: California, Connecticut, Delaware, Illinois, Indiana, Iowa, Kansas, Kentucky, Maine, Maryland, Massachusetts, Michigan, Minnesota, Missouri, Nebraska, Nevada, New Hampshire, New Jersey, New York, Ohio, Oregon, Pennsylvania, Rhode Island, Vermont and Wisconsin. Among Union troops, 1,095,386 white males age 15–19 were reported;

1,964,385 white males age 20–29 were reported; 1,511,602 white males age 30–39 were reported. The total number of white males ages 15–39 in states loyal to the Union was 4,571,373. Since volunteer enlistments numbered 2,080,193, approximately 46 of every 100 men between the ages of 15 and 39 enlisted. That number has been rounded to 5 of every 10. When compared to the total white male population of all ages, the ratio becomes 2:10. Although the military service numbers and demographic data cited here are generally accepted, the ratios drawn from this data are estimated and, in the case of the 5:10 ratio, assume that the bulk of men who joined the armies were between the ages of 15 and 29.

Several factors that might affect the ratios may require full analysis by scholars to resolve. For example: Border states supplied regiments to both sides. As the war went on, Union regiments were raised from states deep in Confederate territory. "Colored Troops" were raised from freemen, slaves, and freed slaves from all states. Demographic and military service data for black civilians and soldiers have been excluded from the ratios because those soldiers joined the Union armies from both the Northern and Southern states. Although the contribution of black troops to the United States military effort during the Civil War was impressive, it is the author's opinion that the addition of these numbers and resolution of other auxiliary factors would not significantly change the ratios.

2. Report of Col. Edward F. Jones, Sixth Massachusetts Militia, *OR*, Series I, Volume II, Part 2: page 7.

3. Ibid.

4. Robert Williams (1825–1901) graduated from the U.S. Military Academy at West Point in New York in 1851 and, after serving on the frontier, returned to his alma mater to teach cavalry tactics. After the war started, he was appointed captain and assistant adjutant general, then was commissioned colonel of the First Massachusetts Cavalry. In 1862 he resigned from volunteer service and joined the Adjutant General's Office, where he rose to the rank of brigadier general. He retired in 1893.

5. Anna F[loyd Hillgrove] Gourley pension record, NARS.

6. Benjamin Franklin Butler (1818–1893) was one of the Union's most controversial generals. His infamous General Order No. 28, issued to the women of occupied New Orleans in 1862, is one of his actions that embarrassed the Lincoln administration: "As the officers and soldiers of the United States have been subjected to repeated insults from the women (calling themselves ladies) of New Orleans, in return for the most scrupulous non-interference and courtesy on our part, it is ordered, that hereafter, when any female shall, by word, gesture, or movement, insult or show contempt for any officer or soldier of the United States, she shall be regarded as a woman of the town plying her avocation." A politician with no military

training, it was his connections that got him appointed major general of volunteers in 1861; because of his political influence, he held several important commands until President Lincoln relieved him of duty after the election of 1864. After the war, he was elected to Congress as a Republican and played a prominent role in the impeachment of President Andrew Johnson. He was elected governor of Massachusetts in 1883 and was an unsuccessful candidate for president the following year.

7. Report of Brig. Gen. Benjamin Franklin Butler, commanding Massachusetts Volunteers, *OR*, I, LI, 1: 1,273.

8. William Buel Franklin (1823–1903) was an 1843 graduate of West Point who was breveted twice in the Mexican War. In 1861, he was named colonel of the Twelfth U.S. Infantry, where he had served as captain since 1857, and advanced to major general and corps command in short order. At Fredericksburg, Virginia, he led the Left Grand Division and was assigned the blame for the Union defeat in that battle by the Committee on the Conduct of the War. Sent to Louisiana, he was wounded at Sabine Cross Roads. Subsequently, on sick leave in Washington, D.C., he was captured on a train outside the capital city but escaped the next day. He resigned in 1866 with two brevets. He served in several public offices after the war and was general manager of the Colt's Fire Arms Manufacturing Company.

9. Report of Col. William B. Franklin, Twelfth U.S. Infantry, commanding First Brigade, Third Division, *OR*, I, II, 1: 406.

10. Ibid. In fairness to the Fifth and Eleventh Massachusetts regiments it should be said that both the Union and Confederate armies were composed largely of rookie troops, most under fire for the first time. Although the two Massachusetts regiments did not perform well, the other regiment in the brigade, the First Minnesota, was recognized by Franklin for good conduct. Franklin ends his report with this paragraph, which may have been an attempt to explain the poor performance of the Massachusetts men: "It is my firm belief that a great deal of the misfortune of the day at Bull Run is due to the fact that the troops knew very little of the principles and practice of firing. In every case I believe that the firing of the rebels was better than ours. At any rate I am sure that ours was very bad, the rear files sometimes firing into and killing the front ones. It is to be hoped that practice and instruction will have corrected this evil by the time that we have another battle." Ibid., 407. Franklin's reference to "the rear files sometimes firing into and killing the front ones" may help explain Conant's injury. Several reports in Conant's papers mention his deafness, which was total just after his wounding and partial for the rest of his life. The deafness may have been caused by a musket fired very close to his head. This is, however, conjecture by the author.

11. Julia C. Graham pension record, NARS.

12. "Gen. Prentice" is Brig. Gen. Benjamin Mayberry Prentiss, who was taken prisoner at Shiloh. He was released in October 1862 and resigned from the army a year later to resume his law practice. Boatner, *The Civil War Dictionary,* p. 668.

13. Pierson's story was first brought to my attention by his great-great-grandson, Larry Bloebaum, of Jefferson City, Missouri, who responded to a query I placed on a genealogical Web site. Bloebaum has a badly deteriorated copy of the *Oskaloosa (Iowa) Globe* published in 1886. Pierson's account is printed in full in the regimental history. Smith, *History of the Seventh Iowa Veteran Volunteer Infantry,* p. 264.

14. Ibid., 265.

15. Ibid., 266.

16. Ulysses Simpson Grant (1822–1885) was born Hiram Ulysses Grant and changed his name while at West Point, from which he graduated in 1843. He won two citations for gallantry in the Mexican War but resigned from the army in 1854 to avoid a court-martial for neglecting his duty due to drinking. At the start of the Civil War he had failed as a farmer and as a businessman and was employed in his father's store. He left to accept the command of the Twenty-first Illinois Infantry. After winning at Forts Henry and Donelson in early 1862, he won national attention. After further successes at Vicksburg and Chattanooga, he was promoted to lieutenant general and given overall command of the federal military effort. After the war, he served two terms as President of the United States and completed his widely acclaimed autobiography a week before his death of cancer.

17. Smith, *History of the Seventh Iowa Veteran Volunteer Infantry,* 267.

18. Lawyer John Albion Andrew (1818–1867) was elected governor of Massachusetts in 1860. With the threat of rebellion looming, he put the state's militia units on high alert. After the war started, President Abraham Lincoln called for volunteers to defend the capital, and Massachusetts regiments were the first to respond.

19. Howe, *Diary and Letters written during the Civil War,* p. 97.

20. Ibid.

21. Roberts, *History of the Military Company of the Massachusetts, . . . Vol. III, 1822–1865,* pp. 204, 306–307.

22. Howe, *Diary and Letters written during the Civil War,* p. 102.

23. Ibid.

24. *Middletown (New York) Daily Press,* July 7, 1900.

25. Robert Edward Lee (1807–1870) graduated from West Point in 1829 and won three brevets and a brilliant reputation in the Mexican War, where he was wounded. In 1859 he commanded Union troops sent to stop the John Brown raid on Harpers Ferry (then in Virginia). At the start of the Civil War, he declined an offer to command the U.S. armies and resigned to

take charge of Virginia troops. In 1862 he succeeded to command of the force that became known as the Army of Northern Virginia and led it through a series of decisive battles against the Union's Army of the Potomac. His streak of victories came to an end at Gettysburg, Pennsylvania. His army never recovered their former strength, but they managed to fight on for almost two more years. In April 1865, Lee surrendered his army at Appomattox Court House, Virginia. After the war, he served as president of Washington College, renamed Washington and Lee University after his death.

26. Morris J. McCornal disability pension record, NARS.

27. Thomas Jonathan "Stonewall" Jackson (1824–1863) graduated from West Point in 1846 and won two brevets in the Mexican War. In 1851, he resigned his commission to teach at the Virginia Military Institute in Lexington, Virginia. After the war started, he was commissioned colonel of Confederate Infantry and distinguished himself at the First Battle of Bull Run, where he won the nickname Stonewall. He rose to the rank of lieutenant general and was regarded as an amazingly effective independent army commander. Accidentally wounded by his own men at Chancellorsville, Virginia, in 1863, he died of pneumonia contracted after his wounding. A deeply religious man, he abstained from alcohol, tobacco, and card playing. His death was deeply mourned across the South.

28. James Shaw became lieutenant colonel of the Tenth Rhode Island Infantry in 1862 and mustered out as its colonel. He rejoined the army as lieutenant colonel of the Twelfth Rhode Island Infantry, then left to become colonel of the Seventh U.S. Colored Infantry and a brigade commander. He was breveted brigadier general of volunteers for his war service.

29. Department of Rhode Island Sons of Union Veterans of the Civil War.

30. James Ewell Brown "Jeb" Stuart (1833–1864) graduated from West Point in 1854. He fought Indians on the frontier, was wounded in the Kansas border disturbances, and served as aide-de-camp to Robert E. Lee during the John Brown raid on Harpers Ferry, Virginia, in 1859. After the Civil War started, he was commissioned lieutenant colonel of Virginia Infantry, then captain of the Confederate States Cavalry. He soon advanced to major general and command of the cavalry for the Army of Northern Virginia. Mortally wounded at Yellow Tavern, Virginia, on May 11, 1864, he died the next day.

31. Philippe Regis de Trobriand (1816–1897), the son of a French baron, was a poet and novelist who settled in the United States after visiting America on a trip. After the war started, he became colonel of the Fifty-fifth New York Infantry, a regiment that included many Frenchmen, and was transferred to the Thirty-eighth New York Infantry by consolidation in

1862. He rose to major general of volunteers and division command in the Army of the Potomac. He continued in the regular army after the war and retired in 1879. He succeeded his father as baron and wrote a well-regarded history of the Army of the Potomac.

32. Fitz-John Porter (1822–1901) graduated from West Point in 1845 and was wounded and breveted twice in the Mexican War. After the start of the Civil War, he was named colonel of the Fifteenth U.S. Infantry, soon appointed brigadier general, and given charge of a division in the Army of the Potomac. In mid-1862, he advanced to corps command and was promoted to major general of volunteers. At the Second Battle of Bull Run, Gen. John Pope relieved him, "for disobedience, disloyalty, and misconduct in the face of the enemy," and he was discharged in early 1863. He fought the charges for twenty years, and, in 1886, was restored to colonel of infantry and retired. He was breveted brigadier general U.S.A. for his service at Chickahominy. After his discharge, he served New York City as police, fire, and public works commissioners, successively.

33. Joseph Washington Fisher (died 1900) joined the Fifth Pennsylvania Reserve Infantry as lieutenant colonel in 1861, and was promoted to colonel the following year. In 1864, he became colonel of the 195th Pennsylvania Infantry and mustered out at the end of the war as a brevet brigadier general of volunteers.

34. Report of Lt. Col. Joseph W. Fisher, Fifth Pennsylvania Reserves, *OR,* I, LI, 1: 112.

35. Last Will and Testament of David McMicken, Lycoming County Genealogical Society.

36. James Miles Smith enlisted in Company A of the Fifth Pennsylvania Reserve Infantry as a musician in 1861, and mustered out with the regiment in 1864.

37. James Miles Smith to parents, July 4, 1862, Bill Jones collection. Netscher, "Away in Company A," p. 51.

38. Motier L. Norton disability pension record, NARS.

39. Motier L. Norton military service record, NARS.

40. Ibid.

41. Jane E. Norton pension record, NARS.

42. Francis Channing Barlow (1834–1896) graduated first in his class from Harvard. At the start of the Civil War, he practiced law and served on the editorial staff of the *New York Tribune.* He started his military service as a private in the Twelfth New York Militia Infantry in 1861, but soon left to accept a lieutenant colonel's commission in the Sixty-first New York Infantry. He was severely wounded at Antietam and promoted to brigadier general. By 1863 he rose to division command in the Army of the Potomac. He was dangerously wounded at Gettysburg and left for dead on the battle-

field, but he survived, was captured and exchanged, and returned to fight in the key Virginia battles of 1864. His health broke, and he took a leave of absence to recuperate. He returned to division command at the close of the war and was promoted to major general. After the war, he went back to the law and helped found the American Bar Association. Active in politics, he served as New York's attorney general.

43. Report of Col. Francis C. Barlow, Sixty-first New York Infantry, *OR*, I, XI, 2: 65–66.

44. Robert Murray, U.S. Marshall, Southern District of New York, to Brig. Gen. E. R. S. Canby, Nov. 7, 1863, NARS.

45. The friend was U.S. Marshal Robert Murray.

46. Col. D. B. DeWitt, Eleventh Regiment U.S. Invalid Corps (Veteran Reserve Corps), to Maj. J. T. Christenson, Nov. 5, 1863, NARS.

47. Albert B. Robinson disability pension record, NARS.

48. Ibid.

49. Ibid.

50. Cyrus Nathaniel Chamberlain enlisted as surgeon in the Tenth Massachusetts Infantry in 1861 and was promoted major in 1863. He resigned to accept a commission to serve in the army's Medical Staff Regiment, where he served the rest of the war and earned a lieutenant colonel's brevet.

51. Albert B. Robinson disability pension record, NARS.

52. Ibid.

53. Ibid.

54. Ibid.

55. Ibid.

56. Thomas B. Barber military service record, NARS.

57. Thomas B. Barber disability pension record, NARS.

58. Henry A. Blanchard disability pension record, NARS.

59. Ibid.

60. Ibid.

61. *Milford (Delaware) Chronicle*, Dec. 10, 1897.

62. Ibid.

63. Ibid.

64. Henry A. Blanchard disability pension record, NARS.

65. Ibid.

66. George Henry Gordon (1823–1886) graduated from West Point in 1846 and was wounded twice in the Mexican War. He left the army in 1854 to attend Harvard Law School, and after the Civil War began he became colonel of the Second Massachusetts Infantry. He rose to division command in the Army of the Potomac, then district command in Florida. After the war, his health ruined, he returned to law and authored a number of books on the Civil War.

67. Gordon, *History of the Second Mass. Regiment of Infantry,* pp. 207–208.

68. In a collection of letters written by Williams to family and friends, fourteen are signed variously "Blackstone," "W.B.W.," "William," and "W.B. Williams." Nine of the letters are signed "Blackstone." Moses Williams Papers, Massachusetts Historical Society.

69. Thompson, *Words Spoken at the Obsequies of William Blackstone Williams,* p. 7.

70. The Isthmus of Tehuantepec separates the Gulf of Mexico from the Pacific Ocean. The land area encompasses parts of the present states of Veracruz, Chiapas, Oaxaca, and Tabasco.

71. Quint, *The Record of the Second Massachusetts Infantry,* p. 488.

72. Thompson, *Words Spoken at the Obsequies of William Blackstone Williams,* pp. 8–9.

73. John Pope (1822–1892) graduated in West Point's Class of 1842 and won a brevet in the Mexican War. In 1861, he was appointed brigadier general and given department command in Missouri. In 1862, he took command of the Army of the Mississippi, where he won several engagements and was promoted major general. President Abraham Lincoln selected him to command the Army of Virginia. He was soundly defeated at the Second Battle of Bull Run, Virginia, removed from command, and ordered to the Department of the Northwest, where he served the rest of the war. He remained on active duty until 1886 and retired as major general U.S.A.

74. Joseph Bradford Carr (1828–1895) was engaged in the tobacco business in New York. At the start of the Civil War, he joined the Second New York as colonel, became a brigade commander in the Army of the Potomac, and was promoted to brigadier general in 1862. At the war's end, he was serving as a division commander and received a brevet of major general of volunteers for his war service. He returned to business and was active in New York politics and the New York State Militia.

75. Report of Col. Joseph B. Carr, Second New York Infantry, commanding Third Brigade, *OR,* I, XII, 2: 454.

76. Ibid.

77. Ibid., 455.

78. "Colonel Powell was retired from active service while on duty in the Philippines in 1899, while suffering from recurrent attacks of dysentery and stomach complaint, having been forced by the same troubles, while in Cuba in 1898, to take sick leave of absence." Angie C. Powell pension application affidavit by G. H. Powell, NARS.

79. Samuel C. Oliver disability pension record, NARS.

80. On January 1, 1862, the Fourteenth Massachusetts Infantry was designated the First Massachusetts Heavy Artillery.

81. William Batchelder Greene (1819–1878) graduated from Harvard Divinity School in 1845, became a Unitarian minister, and devoted his life to social reform and literary work. At the start of the Civil War he joined the Fourteenth Massachusetts Infantry as colonel; he resigned in 1862 after conflicts with Governor Andrew of Massachusetts and Gen. James S. Wadsworth, then military governor of the District of Columbia. He later served as a volunteer aid to Gen. Benjamin Butler.

82. Samuel C. Oliver disability pension record, NARS.

83. Edward Augustus Wild (1825–1891) graduated from Harvard and served as a medical officer in the Turkish Army during the Crimean War. At the start of the Civil War, he joined the First Massachusetts Infantry as captain and was wounded at Fair Oaks, Virginia. He then aided Massachusetts Governor Andrews to raise colored regiments, received an appointment to brigadier general, and commanded on the division level in North Carolina and Virginia. He left the army in 1866 and was afterwards active in silver mining in Nevada and South America.

84. Dexter F. Parker enlisted in the Tenth Massachusetts Infantry as a lieutenant in 1861 and was promoted to major in 1862. Mortally wounded at Spotsylvania Court House, Virginia, on May 12, 1864, he succumbed to his injuries on May 30, 1864.

85. Pierce, "The Gilded Pitcher: The Story of Captain George Pierce Jr.," p. 6.

86. Ibid.

87. Henry Lawrence Eustis (1819–1895) graduated from Harvard in 1838, then went on to West Point, where he graduated with top honors in 1842. At the start of the Civil War, he left his post as professor of engineering at Harvard to become colonel of the Tenth Massachusetts Infantry. He worked his way to brigade command in the Army of the Potomac. He resigned in 1864 because of poor health and spent the rest of his life teaching at Harvard.

88. Zachariah Medler disability pension record, NARS.

89. Report of Col. Nicholas L. Anderson, Sixth Ohio Infantry, *OR,* I, XX, 1: 570.

90. Nicholas Longworth Anderson (1830–1892) joined the Sixth Ohio Infantry as first lieutenant and regimental adjutant in 1861; he advanced to colonel before the end of the year. He mustered out with his regiment in 1864 with two brevets: brigadier general of volunteers for his service at Stone's River, Tennessee, and major general of volunteers for Chickamauga, Georgia.

91. Report of Col. Nicholas L. Anderson, Sixth Ohio Infantry, *OR,* I, XX, 1: 570.

92. Hannaford, *The Story of a Regiment,* p. 395.

93. Ibid., 396.

94. Wolf A. Nasztl, an American Civil War reenactor in Austria, suggested that Kalin's name may be Czech. E-mail to author, Jan. 5, 2001.

95. Willis, *The Fifty-third Regiment Massachusetts Volunteers,* pp. 47–48.

96. Ibid.

97. Von Deck, "Marching to the Sound of Terrible Music."

98. Silas F. Havens disability pension record, NARS.

99. Edward A. McAtee disability pension record, NARS.

100. Ibid.

101. Susan E. McAtee pension record, NARS.

102. Willis, *The Fifty-third Regiment Massachusetts Volunteers,* p. 57.

103. John H. Thomas disability pension record, NARS.

104. Ibid.

105. Ibid.

106. Joseph W. R. Stambaugh disability pension record, NARS.

107. Ibid.

108. Ibid.

109. Ibid.

110. Ibid.

111. Whitman, Walt, *The Correspondence of Walt Whitman,* vol. 1, pp. 84–85.

112. Lyman Hapgood, Letters Received, Commission Branch, Adjutant General's Office, H1353 1865, NARS.

113. Ibid.

114. Ibid.

115. Calder, Ellen M., "Personal Recollections of Walt Whitman." *Atlantic Monthly* (June 1907).

116. Ibid. Calder writes, "Visiting one sick boy in hospital led to his finding another, there or elsewhere, and soon his occupation was the daily visiting of the soldier 'Boys,' as they nearly all were to him, not only the Brooklyn boys, but any and all who needed ministrations of any kind."

117. Lyman Hapgood, Letters Received, Commission Branch, Adjutant General's Office, H1353 1865, NARS.

118. Charles Russell Codman started the war as captain of the Boston Cadets Regiment of Massachusetts, was promoted to colonel, and helped organize the Forty-fifth Massachusetts Infantry. After serving its year of enlistment in eastern North Carolina, Codman and his regiment mustered out in 1863.

119. Cpl. James H. Keating.

120. Hubbard, *The Campaign of the Forty-Fifth Regiment, Massachusetts Volunteer Militia,* p. 179.

121. Christopher Colon Auger (1821–1898) graduated from West Point in

1843 and served in the Mexican War as an aide-de-camp. At the start of the Civil War, he left his post as Commandant of Cadets at West Point to accept a brigadier general's appointment. He was wounded at Cedar Mountain, Virginia, in 1862, then was sent to Louisiana, where he commanded the left wing of the army at Port Hudson. He spent the rest of the war in Washington, D.C., without further participation in field command. He was breveted brigadier general and major general U.S.A. for his leadership at Port Hudson and for his service during the entire war and retired in 1885 as a regular army brigadier.

122. Eben Poore Stanwood, a shoemaker in West Newbury, Massachusetts, before the war, enlisted as captain in the state's Forty-eighth Infantry in 1862. He was promoted to lieutenant colonel two weeks after the death of Lt. Col. James F. O'Brien and mustered out with the regiment in 1863.

123. Plummer, *History of the Forty-Eighth Regiment,* p. 35.

124. Callahan, "A Memorial Day Remembrance: Lieutenant Colonel James O'Brien," p. 1.

125. Johns, *Life with the Forty-Ninth Massachusetts Volunteers,* pp. 252–255.

126. *Chevaux de frise* were used in a defensive structure placed in front of earthworks. According to the Petersburg National Battlefield Civil War Pictionary on the Internet, "they were logs that measured about 12 feet long and 10 inches thick, drilled through every foot at right angles for sharpened stakes which projected 3 feet" and were "most common among the Confederate fortifications."

127. Plummer, *History of the Forty-Eighth Regiment,* pp. 38–39.

128. James G. Abbott disability pension record, NARS.

129. Nathaniel Prentiss Banks (1816–1894) was governor of Massachusetts and a former member of Congress at the start of the Civil War. A career politician with no military experience, he was described as an "honest and forthright soldier" who "proved consistently unsuccessful as a tactician." He resigned in 1864 after the failed Red River Campaign in Louisiana. He returned to Congress, served until 1877, and was reelected in 1888. A mental health disorder forced his retirement from public life in 1890.

130. Willis, *The Fifty-third Regiment Massachusetts Volunteers,* pp. 170–171.

131. Ibid.

132. Ibid.

133. Ibid.

134. Halbert Eleazer Paine (1826–1905) left his law practice in 1861 to become colonel of the Fourth Wisconsin Infantry. In 1863, he was promoted to brigadier general and later advanced to brigade command. He lost his leg at Port Hudson, Louisiana, and served as commander of the Military District

of Illinois. He was breveted major general of volunteers for his service at Port Hudson and was elected to Congress as a radical Republican. Later, while serving as commissioner of patents, he instituted several changes, including the use of typewriters at the Patent Office and the acceptance of drawn plans instead of working models by applicants.

135. Willis, *The Fifty-third Regiment Massachusetts Volunteers,* p. 138.

136. Edward R. Washburn military service record, NARS.

137. Willis, *The Fifty-third Regiment Massachusetts Volunteers,* pp. 169–170.

138. Ibid.

139. Confederate soldier John A. Wyeth, who witnessed the charge, wrote about it in the June 18, 1898, issue of *Harper's Weekly* magazine. His article was reprinted in the regimental history. Sipes, *The Seventh Pennsylvania Veteran Volunteer Cavalry,* pp. 64–65.

140. Ibid.

141. William B. Sipes, commissioned lieutenant colonel of the Seventh Pennsylvania Cavalry in 1861, was promoted to colonel in 1863. He resigned in November 1864.

142. Report of Lt. Col. William B. Sipes, Seventh Pennsylvania Cavalry, *OR,* I, XXIII, 1: 565.

143. Walter C. Whitaker (1823–1887) was a criminal lawyer and Kentucky state senator who introduced the resolution that aligned his state with the Union. In December 1861, he became colonel of the Sixth Kentucky Infantry and in 1863 accepted a promotion to brigadier general. In the Army of the Cumberland, he rose to division command and was breveted major general of volunteers for his service at the Battle of Atlanta. After the war, he returned to his law practice. He developed some sort of personal difficulties that confined him to an "insane asylum" for a time, but he fully recovered his health later in life.

144. Whitaker wrote a letter marked "private" for Anna:

Nashville, Tenn.

August 11th 1863

General Robt. Granger

Dr Sir:

Mrs. Rhoads is here with the body of her husband, Lt. Rhoads of the 7th Pann. Cav.—He was killed at Shelbyville Tenn. In the late attack on that place.—He was a gallant officer. She has come from Pennsylvania to take his body home and is short of money. I gave her transportation for his body to this place believing it to be right—I send this note to you hoping in its perusal you may find it proper to give her transportation for herself and the body of her husband to Louisville Ky.

I have never from it declined and I know you will give it if you think it in the line of duty. She is well recommended and trustworthy.

Yours—
WC Whitaker Brig. Genl.
Comdg. 1st Div RC

Anna M. Rhoads pension record, NARS.

145. Andrew Gregg Curtin (1817–1894), a Republican, served two terms as Pennsylvania's governor (1860–1866) and was considered as U. S. Grant's running mate in 1868. The position went to Schuyler Colfax, but Grant selected Curtin as minister to Russia. Curtin later switched to the Democratic Party and served three terms in Congress.

146. John Reid Seitter, "Union City: Philadelphia and the Battle of Gettysburg," *Gettysburg Magazine* 21 (1999): 8.

147. Richard W. Hammell enlisted as a private in the Fifteenth Pennsylvania Cavalry in 1862 and was discharged for disability the following year. He led Dana Troop as captain during the Pennsylvania invasion crisis of 1863 then enlisted in the Twenty-first Pennsylvania Cavalry. He was discharged from the Twenty-first in late 1864.

148. From notes provided by author John Reid Seitter in September 2002.

149. James Brownlee disability pension, NARS.

150. Karl Sundstrom, "Corporal James Brownlee," *Military Images* (1996): 9.

151. Mary Jane Brownlee pension record, NARS.

152. Mary Jane Brownlee died in Tryon, North Carolina. After I learned of the place of her death, I called my mother, Carol Coddington, an office manager for a real estate company in Tryon. She said the name sounded familiar and that she was sure she had seen it recently. In fact, she remembered seeing a one-page document titled "Description of land sold Eugene Brownlee March 9, 1903." The document was in a box of papers bought at auction in early 2001 by Allan Pruette of Tryon, North Carolina. Pruette sent me the document, which is still in my possession.

153. The regimental history and the *Official Records* both state that the Tenth was moved in to replace two infantry units at Gettysburg, but they do not provide a comprehensive description of the role of Pierce's reserves. The regimental history states, "A call was made for one hundred men for special service. There was a ready response of, I think, ninety men. Captain John G. Pierce was in command." The text does not explain the nature of the "special service." Col. J. Irvin Gregg of the Sixteenth Pennsylvania Cavalry commanded the brigade that included the Tenth New York Cavalry. In the *Official Records,* he states, "I threw forward the Tenth New York Cavalry,

under command of Major Avery, and deployed skirmishers to occupy the ground vacated. During the afternoon, my vedettes were considerably annoyed by the enemy's sharpshooters from the hill and woods immediately in my front, and at 6 o'clock I ordered 50 dismounted men to clear the hill and find out what was beyond, but they were driven back by a much superior force, and followed until the enemy were checked and driven back by Colonel J.B. McIntosh's command." In this profile, the general facts and numbers from Col. Gregg's report have been used in combination with the description of Pierce's actions from the regimental history. Preston, *History of the Tenth Regiment of Cavalry, New York State Volunteers*, p. 113; *OR*, I, XXVII, 1: 977.

154. Preston, *History of the Tenth Regiment of Cavalry, New York State Volunteers*, p. 486.

155. Ibid.

156. Ibid.

157. Ibid., p. 113.

158. The assistance came in part from men of Col. John B. McIntosh's first brigade, second division of the Army of the Potomac's Cavalry Corps. *OR*, I, XXVII, 1: 977.

159. George Stoneman (1822–1894) was an 1846 graduate of West Point who had served in the Mexican War. At the start of the Civil War, he was in charge of Fort Brown, Texas. When the fort was taken, he escaped with part of his command. In May 1861, he was appointed major of the First U.S. Cavalry, then transferred to the Fourth U.S. Cavalry. Later he was promoted to major general of volunteers and given command of the Army of the Potomac's Cavalry Corps. He was relieved after the Battle of Chancellorsville, Virginia, and for the rest of the war served in the western theater, where he led numerous raids. He ended the war with three brevets (his last as major general, U.S.A.) and continued in the regular army until his retirement as colonel in 1871. A Democrat, he served as governor of California from 1883 through 1887.

160. Preston, *History of the Tenth Regiment of Cavalry, New York State Volunteers*, p. 486.

161. Bartlett, *History of the Twelfth Regiment, New Hampshire Volunteers*, p. 712.

162. Ibid.

163. Ibid.

164. Daniel Edgar Sickles (1825–1914) was a New York lawyer and Democratic politician before the Civil War; he served as a U.S. representative from 1857 through 1861. In 1859, he shot and killed Philip Barton Key, son of Francis Scott Key, in a duel after Key was caught in an affair with Sickles's wife. In the trial, Sickles pleaded temporary insanity and was ac-

quitted. He created a national sensation by taking his wife back. In 1861 he raised a brigade, was commissioned colonel of the Twentieth New York Infantry, and soon rose to major general and corps command. At Gettysburg, Pennsylvania, he violated orders by moving his corps into a vulnerable position, and in the devastating attack that ensued, was hit by an artillery shell and lost his leg. For the rest of his life he argued that his actions helped win the battle. He played a key role in preserving the battlefield as a national park. He earned a regular army brigadier general's brevet for the Battle of Fredericksburg and a major general's brevet and Medal of Honor for Gettysburg. He later served as U.S. minister to Spain and chairman of the New York State Monuments Commission but lost both positions after he was found to be involved in shady dealings.

165. Capt. Winfield Scott (1837–1910) enlisted in the 126th New York Infantry in 1862 and was captured with McQuigg at Harpers Ferry, Virginia. He was discharged in September 1864 after being wounded at Spotsylvania, Virginia; he later served as a U.S. Army chaplain.

166. Scott, *Pickett's Charge as Seen from the Front Line,* p. 5.

167. Willson, *Disaster, Struggle, Triumph: The Adventures of 1000 "Boys in Blue,"* p. 180.

168. Twelve thousand Union troops surrendered at Harpers Ferry, and the 126th was very sensitive to news reports that it had disgraced itself on the battlefield. In November 1862, nineteen line officers signed a seven-point petition that refuted the charges. Willson, *Disaster, Struggle, Triumph. The Adventures of 1000 "Boys in Blue,"* pp. 71–76.

169. Pennsylvania's George Gordon Meade (1815–1872) graduated from West Point in 1835 and served in the Mexican War. At the start of the Civil War, he was appointed brigadier general of volunteers and steadily rose in rank, achieving command of the Army of the Potomac two days before the Battle of Gettysburg. He came under intense criticism for failing to pursue Confederate forces at the end of that battle. After Lt. Gen. U. S. Grant took command of the Union armies and made his headquarters alongside the Army of the Potomac, Meade found himself in the unenviable position of having Grant directing at close quarters. Meade was the longest-serving Army of the Potomac commander and, after the war, took charge of Military District No. 3, headquartered in Atlanta, Georgia, and the Division of the Atlantic. He died of pneumonia at age fifty-seven, having never entirely recovered from his 1862 wounding at White Oak Swamp, Virginia.

170. Haynes, *A History of the Tenth Regiment, Vermont Volunteers,* p. 34.

171. Hiram Davis's older brother, Lysander, and a younger brother Willard joined the First Vermont Heavy Artillery in August 1864 and were assigned to Company K. Lysander survived the war, but Willard was killed two months after enlistment in the battle at Cedar Creek, Virginia. The

third brother, Norman, failed to meet the physical requirements and did not serve. Hiram H. Davis disability pension record, NARS.

172. Ibid.

173. Haynes, *A History of the Tenth Regiment, Vermont Volunteers*, p. 34.

174. Almon Clark was the assistant surgeon, not surgeon, of the Tenth Vermont Infantry. He later served as surgeon of the First Vermont Cavalry and survived the war.

175. Hiram H. Davis disability pension record, NARS.

176. Robert G. Hastie disability pension record, NARS.

177. Ibid.

178. Ibid.

179. Hemphill, *Journal of the Kosciusko Guards, Company E, 12th Regiment Indiana Volunteers*, p. 119.

180. Ibid.

181. Special thanks to Mark Weldon of Fort Wayne, Indiana, who positively identified my unsigned image. Weldon's *carte de visite* of Milice is almost a full standing view without the flag. The photographer's imprint is on the back. Weldon believes the two images may have been made during the same sitting.

182. William Tecumseh Sherman (1820–1891) graduated from West Point in 1840 and resigned from the military in 1853 to begin a banking career in California and, in 1857, a law career. He tried to rejoin the military after becoming tired with civilian life but was recommended instead as superintendent of a military school in Alexandria, Louisiana (now Louisiana State University). After the Civil War started, he resigned his position, accepted a commission as colonel of the Thirteenth U.S. Infantry, and soon advanced to brigadier general and commanding officer of the Department of the Cumberland. His criticism of government policy and his problems with the press, who labeled him insane, almost ended his military career. He was wounded at the Battle of Shiloh, in Tennessee, where he became influenced by the leadership of Gen. U. S. Grant. The two formed a close personal bond that was made stronger by professional respect, and they relied on each other for support and advice for the rest of the war. Sherman played a key role as corps commander at Vicksburg and joined Grant in breaking the siege at Chattanooga. After Grant was called east to take command of all the Union armies, Sherman replaced Grant as commander of the Military Division of the Mississippi and conducted major operations in the western theater of the war. He is best remembered for the Battle of Atlanta and the march across Georgia, known as the March to the Sea, which was designed to wage economic war on the South. He was promoted to lieutenant general in 1866 and succeeded Grant as commander in chief of the army in 1869. He retired in 1884 and was succeeded by Gen. Philip Sheridan.

183. David Allen Russell (1820–1864), an 1845 graduate of West Point, earned a brevet during the Mexican War. After the start of the Civil War, he became colonel of the Seventh Massachusetts Infantry and rose to brigadier general and brigade command. He was wounded in the battle at Rappahannock Bridge, Virginia, and killed in action at the Battle of Winchester, in Virginia, on September 19, 1864.

184. Westbrook, *History of the 49th Pennsylvania Volunteers,* pp. 168–169.

185. Boatner, *The Civil War Dictionary,* p. 87.

186. Cozzens, *The Battles for Chattanooga,* p. 123.

187. Most sources provide little more than a passing reference to the action along this part of the Union front, and many fail to mention the Thirty-third New Jersey at all. Cozzens's book devotes almost two pages to the action and includes a passage that describes how the Thirty-third panicked under fire. Ibid., pp. 133–134.

188. George Washington Mindil (died 1907) was a German-born officer who began his Civil War career as a second lieutenant of a Pennsylvania infantry regiment. He resigned in October 1862 to become colonel of the Twenty-seventh New Jersey Infantry. After that unit was mustered out of service, he commanded the Thirty-third New Jersey Infantry and received a brigadier general's brevet at the end of the war. He was awarded the Medal of Honor in 1893 for leading a successful charge in the 1862 battle at Williamsburg, Virginia.

189. John's brother Daniel Toffey served as captain's clerk to Commander John L. Worden on the USS *Monitor.* John also had two younger sisters. This information provided by Toffey ancestor William Finlayson of New York.

190. John J. Toffey disability pension record, NARS.

191. Beyer, *Deeds of Valor,* pp. 282–283.

192. Ibid.

193. Augustus W. Keene enlisted as a private in the Fortieth New York Infantry in 1861 and was promoted to the officers' ranks in 1863. He mustered out as the regiment's major at the end of the war.

194. Edward M. Marshall disability pension record, NARS.

195. Ibid.

196. Ibid.

197. Edward M. Marshall military service record, NARS.

198. Ibid.

199. Joseph B. Copeland military service record, NARS.

200. Ibid.

201. Ibid.

202. Ibid.

203. *Mexico (Missouri) Weekly Ledger*, March 14, 1889.

204. In a January 31, 1864, letter to Union General-in-Chief Maj. Gen. Henry Halleck, Maj. Gen. Quincy Gillmore, commander of the Department of the South, listed four reasons for going into Florida: "I beg leave to state that the objects and advantages to be secured by the occupation of that portion of Florida within my reach, viz, the richest portions between the Suwannee and the Saint John's Rivers, are: First. To procure an outlet for cotton, lumber, timber, turpentine, and the other products of that State. Second. To cut off one of the enemy's sources of commissary supplies. He now draws largely upon the herds of Florida for his beef, and is making preparations to take up a portion of the Fernandina and Saint Mark's Railroad for the purpose of connecting the road from Jacksonville to Tallahassee with Thomasville, on the Savannah, Albany and Gulf Railroad, and perhaps with Albany, on the Southwestern Railroad. Third. To obtain recruits for my colored regiments. Fourth. To inaugurate measures for the speedy restoration of Florida to her allegiance, in accordance with instructions which I have received from the President by the hands of Major John Hay, assistant adjutant-general." *OR,* I, XXXV, 1: 279.

205. According to the battle report by Capt. Charles C. Mills, the advance of the Seventh was entirely checked after four miles, "all the left of the line being thrown into a swamp and exposed to a galling fire from the enemy's right. From this position the right was advanced a few rods, the ground being more open and passable." A rod equals 5.5 yards, so "a few rods" is interpreted to measure about twenty yards. *OR,* I, XXXV, 1: 310.

206. Carrie Dempsey pension record, NARS.

207. The March 4, 1864, issue of *The Winsted (Connecticut) Herald* reported that Pvt. John Rowley was at Dempsey's side. Two privates named John Rowley served in the Seventh. Dempsey's Company E included one John G. Rowley, who enlisted in 1861 and mustered out in September 1864. Company D also had a John Rowley who was drafted in 1863 and executed at Petersburg in 1864. *The Winsted Herald*, March 4, 1864.

208. Colonel Joseph Roswell Hawley, 1826–1905, worked as a newspaperman and Republican Party organizer before the war. He enlisted as captain in the First Connecticut Infantry in 1861, then lieutenant colonel of the Seventh Connecticut, where he rose to the rank of brigadier general and command of the District of Wilmington, North Carolina. He also served as chief of staff to Gen. Alfred Terry. After the war, he served as Connecticut's governor from 1866 through 1867 and several terms in the U.S. House of Representatives as congressman and senator.

209. *The Winsted (Connecticut) Herald*, March 11, 1864.

210. Ulric Dahlgren (1842–1864) was the son of Admiral John Dahlgren.

At the start of the Civil War, he became an aide-de-camp to Gen. Franz Sigel and later served on the staffs of Army of the Potomac commanders Ambrose Burnside, Joseph Hooker, and George G. Meade. He was wounded and lost a leg at Gettysburg. He was promoted to colonel and then died in the 1864 Kilpatrick-Dahlgren raid on Richmond.

211. Hugh Judson Kilpatrick (1836–1881) graduated from West Point in 1861 and received a commission as a captain in the Fifth New York Infantry. After his wounding at Big Bethel, Virginia, in June 1861, he was promoted to lieutenant colonel of the Second New York Cavalry. He made colonel in late 1862 then rose to division command in the Army of the Potomac's Cavalry Corps. After the failed Kilpatrick-Dahlgren raid on the Confederate capital, Gen. William T. Sherman had him assigned to division command in the Army of the Cumberland. He was severely wounded at Dalton, Georgia. After his recovery, he participated in the March to the Sea. By the end of the war, he had earned five brevets and a promotion to major general of volunteers. After the war, he left the military, served as U.S. minister to Chile, and ran unsuccessfully for Congress. His nickname, "Kill Cavalry," was given for his recklessness and daring in battle.

212. Reuben Bartley enlisted as a sergeant in the 123rd Pennsylvania Infantry in 1861 and was promoted to second lieutenant in 1863. He served as aide-de-camp to Col. Ulric Dahlgren.

213. Jones, "The Kilpatrick-Dahlgren Raid Against Richmond," p. 519.

214. Anna E. Kingston pension record, NARS.

215. Allyne Litchfield enlisted in the Fifth Michigan Cavalry as captain in 1862 and transferred to the state's Seventh Cavalry with a lieutenant colonel's commission later that year. He was captured during the Kilpatrick-Dahlgren raid on March 1, 1864, and later paroled. He ended the war as colonel and brevet brigadier general of volunteers.

216. Anna E. Kingston pension record, NARS.

217. Ibid.

218. Ibid.

219. 1st Lt. Daniel J. Farren served in Company A with Breese. He died in 1893.

220. This anecdote was related by Breese's daughter Carrie. The event probably took place in the 1870s, when Carrie was a child. Chase County Historical Society, *Chase County Historical Sketches*, vol. 1, p. 157.

221. Report of Brig. Gen. A. L. Lee, Cavalry Division, Department of the Gulf, *OR*, I, XXXIV, 1: 456.

222. Theresa L. Breese pension record, NARS.

223. Ibid.

224. Confederate officer Robert F. Hoke (1837–1912) was promoted to major general for the capture of Plymouth. A graduate of the Kentucky Mili-

tary Institute, he began the war as second lieutenant in the First North Carolina Infantry. By 1863, he was a brigadier general and brigade commander. He was wounded at Chancellorsville, Virginia, and returned to active duty in the fall of 1863. After Plymouth, he fought in the Virginia battles at Bermuda Hundred, Cold Harbor, and Petersburg. His excellent war record was tarnished by his reputation as a man unable to cooperate with others.

225. Blakeslee, *History of the Sixteenth Connecticut Volunteers,* pp. 156–158.

226. Ibid.

227. Ibid.

228. Ibid.

229. Ibid.

230. "Captain Harrison" was Cdr. N. B. Harrison. The ship's captain was Gustavus H. Scott.

231. Blakeslee, *History of the Sixteenth Connecticut Volunteers,* pp. 156–158.

232. Sidney Burbank (1807–1882) was a member of the West Point Class of 1829. He fought Indians in Florida during the Seminole War and taught infantry tactics at his alma mater. In 1861 he was appointed lieutenant colonel of the Thirteenth U.S. Infantry and soon after advanced to colonel of the Second U.S. Infantry and to brigade command. He was breveted brigadier general U.S.A. for his service at Gettysburg, and he retired in 1870.

233. Albert Sidney Johnston (1803–1862) graduated from West Point in 1826 and rose to brigadier general in the Republic of Texas army. Two years after fighting in the Mexican War, he was appointed colonel of the Second U.S. Cavalry. After the Civil War started, he resigned his position as post commander of the District of the Pacific, turned down an offer to be the second-highest-ranking officer in the U.S. Army, and accepted an appointment as general from the Confederate States government. At the Battle of Shiloh, in Tennessee, in 1862, he was hit in the leg and bled to death. In the early part of the war he was widely regarded as the best soldier in either army.

234. Scott Valentine, "A Father's Lament," *The Regimental Gazette* (1995): 1.

235. Swords belonging to Gen. Sidney Burbank and Capt. Sullivan Burbank are owned today by Natalie Bates of Cary, North Carolina. Mrs. Bates's mother, Margaret Maize Boaz, was the daughter of Sully Burbank Maize. Sully was named after his uncle, Sullivan Wayne Burbank, but spelled his name "Sully" instead of adopting the spelling of his uncle's nickname, "Sullie." John Burbank of Bristol, Vermont, supplied this information from a letter written by Mrs. Boaz in the *Burbank Family News,* a family newsletter.

236. Staff, "Twentieth Massachusetts. The Late Adjutant Bond." *Dedham (Massachusetts) Gazette,* May 28, 1864, 2.

237. Georgia's James "Pete" Longstreet (1821–1904) graduated from West Point in 1842 and fought in the Mexican War, where he was wounded and won two brevets. He resigned his commission at the start of the Civil War and was appointed a brigadier general in the Confederate army, where he rose to lieutenant general and was known as Gen. Robert E. Lee's "Old War Horse." After the war, Southerners blamed him for the loss at Gettysburg, and consequently the defeat of the rebellion. He served as U.S. Minister to Turkey from 1880–1881.

238. James Samuel Wadsworth (1807–1864) read law in the office of Massachusetts senator Daniel Webster, but spent the bulk of his time managing his sprawling estate. Although a delegate to the Washington, D.C., Peace Convention during the winter before the war, after hostilities began, he became an aide-de-camp to Brig. Gen. Irvin McDowell at the First Battle of Bull Run and was then appointed brigadier general. Following a failed run for the New York governorship in 1862, he returned to the army and division command. He was breveted major general of volunteers for his service at Gettysburg and the Battle of the Wilderness.

239. Bruce, *The Twentieth Regiment of Massachusetts Volunteer Infantry, 1861–1865,* p. 165.

240. George Nelson Macy was commissioned first lieutenant in the Twentieth Massachusetts Infantry in 1861 and rose to the rank of colonel before the war's end. He was breveted twice: in 1864, as brigadier general of volunteers for the Wilderness and Deep Bottom battles in Virginia, and, in 1865, major general of volunteers for the Appomattox Campaign. He died in 1875.

241. Henry Livermore Abbott joined the Twentieth Massachusetts Infantry as second lieutenant in 1861 and rose to the rank of major before his death in action in the Battle of the Wilderness in 1864. He was breveted brigadier general of volunteers posthumously.

242. John Singleton Mosby (1833–1916) practiced law at Bristol, Virginia, before the Civil War. In 1861 he became a private in the Confederate First Virginia Cavalry and rose to the rank of first lieutenant. In 1863, he organized the Partisan Rangers and launched a guerilla war in eastern Virginia. At the end of the war, ranking as colonel, he refused to surrender and disbanded his raiders. He returned to law and later served as U.S. consul in Hong Kong.

243. Staff, "Twentieth Massachusetts. The Late Adjutant Bond." *Dedham (Massachusetts) Gazette,* May 28, 1864, 2.

244. Waters Whipple Braman to Waters Braman, May 7, 1864, Waters Whipple Braman Letters, New York State Archives.

245. King, *History of the Ninety-third Regiment, New York Volunteer Infantry, 1861–1865,* pp. 550–551.

246. Waters Whipple Braman to Waters Braman, May 7, 1864, Waters Whipple Braman Letters, New York State Archives.

247. David Bell Birney (1825–1864), a native of Alabama, son of prominent abolitionist leader James G. Birney and brother of Brig. Gen. William Birney, was practising law in Pennsylvania at the start of the Civil War. He enlisted as lieutenant colonel of the Twenty-third Pennsylvania Infantry and by mid-1863 had advanced to major general and division command. At Gettysburg, Pennsylvania, he took the lead of the Army of the Potomac's Second Corps after the wounding of its commander, Maj. Gen. Daniel Sickles. He was transferred by reorganization to the head of the Tenth Corps. While serving in this capacity he contracted malaria and died.

248. Waters Whipple Braman to Waters Braman, May 11, 1864, Waters Whipple Braman Letters, New York State Archives.

249. Ibid.

250. Gershom Mott (1822–1884) fought in the Mexican War and was commissioned lieutenant colonel of the Fifth New Jersey Infantry in 1861 and, in 1862, colonel of the Seventh New Jersey Infantry. He was wounded at the Second Battle of Bull Run and afterwards advanced to division command with a rank of major general of volunteers. He was wounded again during the Mine Run campaign and served two stints as commander of the Second Corps. Breveted major general of volunteers for war service, he later served in the New York National Guard. He held several public offices and was active in business.

251. Notation on discharge record signed by Lt. Col. B. C. Butler, New York State Volunteers, Waters Whipple Braman Letters, New York State Archives.

252. Cadwell, *The Old Sixth Regiment,* p. 168.

253. Horatio D. Eaton to Willis Asa Pomeroy, Nov. 11, 1862, Willis Asa Pomeroy Collection, Connecticut Historical Society.

254. Ibid.

255. Members of the regiment, *The Story of the Twenty-First Regiment, Connecticut Volunteer Infantry,* pp. 355–356.

256. Ibid., 355.

257. Ibid., 190.

258. Ibid., 191.

259. Ibid., 355–356.

260. Robert S. Edwards enlisted as second lieutenant in the Forty-eighth New York Infantry in 1861 and received a promotion to first lieutenant two months before his death in action at Fort Wagner, South Carolina, on July 18, 1863.

261. According to the City of Amenia, New York, Web site, the name is derived from the Latin word *amoena,* which means "pleasing to the eye." Settler Dr. Thomas Young gave the town, founded in 1788, its name.

262. Nichols, *Perry's Saints,* p. 225.

263. Ibid., p. 226.

264. Parker, *Henry Wilson's Regiment,* p. 462.

265. Ibid.

266. Report of Col. William S. Tilton, Twenty-second Massachusetts Infantry, *OR,* I, XXXVI, 1: 561.

267. Edward M. Walton, a laborer from Bradford, Massachusetts, enlisted in the state's Twenty-second Infantry as a private and was promoted to corporal. He was killed on June 3, 1864, at Bethesda Church, Virginia.

268. George A. Steele, a clerk from Haverhill, Massachusetts, enlisted as a private in the state's Twenty-second Infantry in 1861. He was wounded and captured at Gaines Mill, Virginia, in June 1862 and released a month later. He died in action on June 3, 1864, at Bethesda Church, Virginia.

269. Parker, *Henry Wilson's Regiment,* p. 462.

270. Nancy E. Hardy pension record, NARS.

271. Ibid.

272. Ibid.

273. Andrew J. Marlatt disability pension record, NARS.

274. Ibid.

275. Ibid.

276. Andrew J. Marlatt military service record, NARS.

277. Ibid.

278. Ibid.

279. Palfrey, *Memoir of William Francis Bartlett,* p. 119.

280. William Francis Bartlett (1840–1876) left Harvard to enlist as a private in the Fourth Battalion Massachusetts Volunteers after the Civil War started. In August 1861 he received a captain's commission in the Twentieth Massachusetts Infantry. At Yorktown, Virginia, in 1862 he suffered the amputation of his leg. After recuperating, he organized and was elected colonel of the Forty-ninth Massachusetts Infantry. During the Port Hudson, Louisiana, campaign he was wounded twice. Next he organized another regiment, the Fifty-seventh Massachusetts Infantry, serving as its colonel, and was wounded at the Battle of the Wilderness, in Virginia, in 1864. He received a promotion to brigadier general then advanced to brigade command. He suffered his fifth wound of the war and was captured at the Petersburg, Virginia, mine explosion. After his release, he rose to division command, finally leaving the army in 1866 as a brevet major general of volunteers. After the war, he worked as a businessman in Richmond, Virginia, and his hometown of Pittsfield, Massachusetts.

281. Palfrey, *Memoir of William Francis Bartlett,* p. 119.

282. Lawyer Louis Bell enlisted as captain of the first New Hampshire Infantry in 1861, a three-months regiment, then became lieutenant colonel of the Fourth New Hampshire Infantry and advanced to colonel in 1862. In October 1862 he was wounded at Pocotaligo, South Carolina. In January 1865, he suffered a mortal wound at Fort Fisher, North Carolina.

283. Report of Col. Louis Bell, Fourth New Hampshire Infantry, commanding Third Brigade, *OR,* I, XL, 1: 704.

284. David Glasgow Farragut (1801–1870) joined the navy as a midshipman in 1810 and traveled to various ports around the globe. He served in the Mexican War, and, after the Civil War started, he commanded an expedition to New Orleans, then was promoted rear admiral. He successfully opened the lower Mississippi River to Vicksburg and commanded naval operations against Port Hudson, Louisiana. In 1864 he led the attack on Mobile Bay, where he uttered his famous words. He was promoted to vice admiral in late 1864 and in 1866 became the first person in the American navy to hold the rank of admiral.

285. Albert H. Johnson disability pension record, NARS.

286. Lt. Col. Henry Clay Merriam was awarded the Congressional Medal of Honor for volunteering to lead the Seventy-third U.S. Colored Infantry in an assault, which proved successful, on the Confederate works at Fort Blakely, Alabama, on April 9, 1865.

287. Adna H. Bowen enrolled as a corporal in the Fourth Michigan Infantry when the war started; he transferred to the Fifteenth Michigan Infantry to accept a second lieutenant's commission in 1862. He left the regiment with a captain's rank in 1863 then joined the state's Eleventh Cavalry. He remained with this unit for a year, then left to accept a major's commission in the Sixth U.S. Colored Cavalry. He was captured in Tennessee in September 1862 and was paroled a month later.

288. Brig. Gen. Stephen Burbridge's raid into Southwest Virginia (Sept.–Oct. 1864) targeted the salt works at Saltville on October 2. He suffered almost 500 casualties in the attack, and it is said that Confederate soldiers, against orders, captured and murdered wounded black soldiers from the Fifth and Sixth U.S. Colored Infantry and left them on the battlefield. Burbridge (1831–1894), before the war a businessman in the District of Columbia and a plantation owner in Kentucky, was commissioned as colonel of the Twenty-sixth Kentucky Infantry, and rose to division command in the Thirteenth and Twenty-third Army Corps. He was breveted major general of U.S. volunteers in July 1864 for repulsing John Hunt Morgan's raid into Ohio.

289. Maj. Gen. George Stoneman's raid in southwestern Virginia (Dec. 1, 1864–Jan. 1, 1865) resulted in the capture of Saltville and the de-

struction of its prized works. Stoneman's raiders also captured Wytheville, Virginia, and drove Confederate forces out of eastern Tennessee. Stoneman (1822–1894), an 1846 West Point graduate and Mexican War veteran, commanded in several large-scale raids during his war service. He retired in 1871 as a regular army colonel and lived in Los Angeles, California, where he held several public offices, including governor.

290. September 19, 1864, entry, Isaiah Goddard Hacker diary, Goddard Family Papers.

291. Lottie R. Hacker pension record, NARS.

292. Ibid.

293. Ibid.

294. Ibid.

295. Carpenter, *History of The Eighth Regiment Vermont Volunteers, 1861–1865*, p. 209.

296. Ibid., p. 215.

297. Col. Herbert E. Hill describes the morning engagement at Cedar Creek in detail, and he focuses on the defense of the regimental and brigade flags. In the paragraph he devotes to a recounting of the fight to protect the brigade flag, he mentions the wounding of Cheney, but does not explain what he was doing when he received his injury. Ibid., pp. 217–218.

298. Marshall, *A War of the People: Vermont Civil War Letters*, p. 273.

299. Lynchburg, Virginia's Jubal Anderson Early (1816–1894), nicknamed "Old Jube" or "Jubilee," graduated from West Point in 1837. He left the military in 1838 to pursue a career in law and politics. He returned to the army to fight in the Mexican War and when the Civil War started became colonel of the Confederate Twenty-fourth Virginia Infantry. He was soon promoted to brigadier general and brigade command. He was wounded at Williamsburg, Virginia. By the time of Antietam, he had advanced to division command, and in 1863 he made major general. He fought in all the key battles of the Army of Northern Virginia. In 1864 he succeeded to corps command, led a raid on Washington, and was defeated by Gen. Philip Sheridan in the Shenandoah Valley. After the war, he fled to Mexico and then Canada, but later returned to Lynchburg and resumed legal practice. He was employed by the Louisiana Lottery for a time and also served as president of the Southern Historical Society.

300. Philip Henry Sheridan (1831–1888), who graduated from West Point in 1853, started the Civil War in an administrative capacity then in 1862 moved to a combat role, as colonel of the Second Michigan Cavalry. He soon advanced to division command and was promoted to brigadier general. He won his major general's rank at Stone's River, Tennessee, and distinguished himself at Chattanooga. His fighting ways attracted the attention of Gen. U. S. Grant, who in 1864 chose him to lead the Army of the

Potomac's Cavalry Corps, with whom he won numerous victories and played a key role in defeating the Army of Northern Virginia. Voted the Thanks of Congress for his successful campaign in the Shenandoah Valley, he was made lieutenant general in 1869 and succeeded Gen. William T. Sherman as commander in chief of the armies in 1884. A person of short physical stature, he acquired the nickname "Little Phil."

301. Cheney's exact whereabouts after his wounding are undocumented. However, Carpenter's *History of The Eighth Regiment Vermont Volunteers* (p. 226) reports that after the ground lost in the morning was retaken, "a halt of half an hour was made, for bringing in our wounded men, some of whom fell in the morning and had lain all day on the disputed field, and were shivering in the raw night air." Marshall's collection of Vermont Civil War letters (p. 275) states, "Nearly all of our wounded fell into their hands at first and were carried back to Fishers Hill but nearly all of the wounded that could not walk were retaken that evening."

302. In *Sabres in the Shenandoah: The 21st New York Cavalry, 1863–1866,* author John C. Bonnell includes an image of Madden on page 140. According to the text, "Private John E. Madden from Troy enlisted in the regiment about this date [September 30, 1864] and was probably sent to Cumberland." I could not find mention in his military service record of his getting any farther than Hart Island, New York, although the timing of his enlistment and training falls in line with the regiment's remount needs.

303. John E. Madden disability pension record, NARS.

304. Blake and Fisk, *A Condensed History of the 56th Regiment New York Veteran Volunteer Infantry,* p. 62.

305. Catherine Masten pension record, NARS.

306. Alfred Howe Terry (1827–1890) had graduated from Yale and was working as a lawyer at the start of the war. He was commissioned colonel, first of the Second Connecticut Infantry, a three-months regiment, and then of the Seventh Connecticut Infantry. Over the next three years, he rose to major general and corps command. In early 1865, he led the successful expedition to capture, Wilmington, North Carolina, for which he received the Thanks of Congress and a promotion to brigadier general U.S.A. and department command. He ended the war with two brevets, stayed in the regular army, and retired in 1888 as major general U.S.A. He was George Armstrong Custer's superior at the Battle of the Little Big Horn.

307. Edmund Kirby Smith of Florida graduated from West Point in 1845 and won two brevets in the Mexican War. He entered Confederate service in 1861 as a lieutenant colonel of cavalry and worked his way up to lieutenant general in command of the Trans-Mississippi Department. He died in 1893.

308. Sperry, *History of the 33d Iowa Infantry Volunteer Regiment 1863–6,* p. 171.

309. James M. Cooper disability pension record, NARS.

310. Col. Conrad Krez, a German lawyer and revolutionary, came to the U.S. in 1849. A gifted poet, he published volumes in Germany, France, and America. He entered the war as colonel of the Twenty-seventh Wisconsin Infantry and commanded on the brigade level. He was breveted brigadier general for service at Mobile, Alabama, and died in 1897.

311. Michael R. Harned enlisted in the Thirty-third Iowa Infantry in 1862 and was discharged for disability six months later.

312. James M. Cooper disability pension record, NARS.

313. William V. Philips joined the Eleventh Kansas Cavalry as a first lieutenant in Company C, and mustered out with the regiment in 1865 with the same rank.

314. Henry Pearce disability pension record, NARS.

315. Ibid.

316. James Hobart Ford (died 1867) enlisted as a captain in the Independent Corps of Colorado Infantry in 1861 and was promoted to major of the Second Colorado Infantry the following year. In 1863, he became colonel of the Second Colorado Cavalry. He later rose to command the District of the Upper Arkansas and Department of Kansas and left the army with a brigadier general of volunteers brevet.

317. *Monticello (New York) Republican Watchman*, December 24, 1875.

318. Henry Ward to Katey Palmer, March 29, 1865, Henry Ward Letters, collection of Elisabeth A. Stitt via Kenneth Jennings Wooster's Web site about the 143rd New York Infantry.

319. *Monticello (New York) Republican Watchman*, December 28, 1875.

320. Ibid.

321. Ibid.

REFERENCES

Books and Unpublished Manuscripts

Barrett, John Gilchrist. *North Carolina as a Civil War Battleground, 1861–1865.* Raleigh, N.C.: Division of Archives and History, North Carolina Department of Cultural Resources, 1987.

Bartlett, Asa W. *History of the Twelfth Regiment, New Hampshire Volunteers in the War of the Rebellion.* Concord, N.H.: I. C. Evans, Printer, 1897.

Beyer, William F. *Deeds of Valor: How America's Civil War Heroes Won the Congressional Medal of Honor.* Stamford, Conn.: Longmeadow Press, 1994.

Blake, H. D., and Joel C. Fisk. *A Condensed History of the 56th Regiment New York Veteran Volunteer Infantry.* Newburgh, N.Y.: Newburgh Journal Printing House and Book Bindery, 1906.

Blake, Henry N. *Three Years in the Army of the Potomac,* Boston, Mass.: Lee & Shepard, 1865.

Blakeslee, Bernard F. *History of the Sixteenth Connecticut Volunteers.* Hartford, Conn.: Case, Lockwood & Brainard Co., Printers, 1875.

Boatner, Mark. *The Civil War Dictionary.* New York: David McKay Co., 1962.

Bonnell, John C. *Sabres in the Shenandoah: The 21st New York Cavalry, 1863–1866.* Shippensburg, Pa.: Burd Street Press, 1996.

Bruce, George Anson. *The Twentieth Regiment of Massachusetts Volunteer Infantry, 1861–1865.* Boston: Houghton, Mifflin, 1906.

Cadwell, Charles K. *The Old Sixth Regiment, its War Record, 1861–5.* New Haven, Conn.: Tuttle, Morehouse & Taylor, Printers, 1875.

Callahan. "A Memorial Day Remembrance: Lieutenant Colonel James O'Brien—An Irish-American Hero." Unpublished manuscript, 2002.

Carpenter, George N. *History of The Eighth Regiment Vermont Volunteers, 1861–1865.* Boston: Press of DeLand & Barta, 1886.

Century Magazine. *The Century War Book: The Famous History of the Civil War by the People Who Actually Fought It.* New York: Arno Press, 1978.

Chase County Historical Society. *Chase County Historical Sketches, Vol. 1.* Chase County, Kan.: Chase County Historical Society, 1940.

Civil War Times Illustrated. *Great Battles of the Civil War.* New York: Gallery Books, 1984.

Commemorative Biographical Record of Tolland and Windham Counties, Connecticut; Biographical Sketches of Prominent and Representative

Citizens and of Many of the Early Settled Families. Chicago: J. H. Beers & Co., 1903.

Conklin, George W. *Under the Crescent and Star: The 134th New York Volunteer Infantry in the Civil War.* Port Reading, N.J.: Axworthy Publishing, 1999.

Cosgrove, Charles H. *A History of the 134th New York Volunteer Infantry Regiment in the American Civil War, 1862–1865: Long Night's Journey into Day.* Lewiston, N.Y.: E. Mellen Press, 1997.

Cozzens, Peter. *The Battles for Chattanooga: The Shipwreck of Their Hopes.* Urbana: University of Illinois Press, 1994.

Darrah, William C. *Cartes de Visite in Nineteenth-Century Photography.* Gettysburg, Pa.: W. C. Darrah, Publisher, 1981.

Dyer, Frederick H. *A Compendium of the War of the Rebellion, comp. and arranged from official records of the federal and confederate armies, reports of the adjutant generals of the several states, the army registers, and other reliable documents and sources.* Des Moines, Iowa: Dyer Publishing Co., 1908.

Fox, William F. *Regimental Losses in the American Civil War, 1861–1865.* Albany, N.Y., 1889.

Gordon, George H. *History of the Second Mass. Regiment of Infantry: Third Paper.* Boston: Alfred Mudge & Son, Printers, 1875.

Greiss, Thomas E. *The West Point Military History Series Atlas for the American Civil War.* Wayne, N.J.: Avery Publishing Group, 1986.

Hannaford, Ebenezer. *The Story of a Regiment: A History of the Campaigns, and Associations in the Field, of the Sixth Regiment Ohio Volunteer Infantry.* Cincinnati, Ohio: privately published, 1868.

Haynes, Edwin Mortimer. *A History of the Tenth Regiment, Vermont Volunteers.* Rutland, Vt.: Tuttle Co., Printers, 1894.

Heitman, Francis B. *Historical Register and Dictionary of the United States Army.* 2 vols. Washington, D.C., 1903.

Hemphill, William S. *Journal of the Kosciusko Guards, Company E, 12th Regiment Indiana Volunteers.* Warsaw, Ind.: Kosciusko County Historical Society, 1993.

Howe, Henry Warren. *Passages From the Life of Henry Warren Howe, Consisting of Diary and Letters written during the Civil War, 1861–1865.* Lowell, Mass.: Courier-Citizen Co., Printers, 1899.

Hubbard, Charles E. *The Campaign of the Forty-Fifth Regiment, Massachusetts Volunteer Militia.* Boston: J. S. Adams, 1892.

Johns, Henry T. *Life with the Forty-Ninth Massachusetts Volunteers.* Washington, D.C.: Ramsey & Bisbee, Printers, 1890.

Jones, J. William. *Southern Historical Society Papers.* Richmond, Va.: Richmond Historical Society, 1876–1959.

King, David H. *History of the Ninety-Third Regiment, New York Volunteer Infantry, 1861–1865.* Milwaukee, Wis.: Swain & Tate Co., Printers, 1895.

Kirwan, Thomas. *Memorial History of the Seventeenth Regiment, Massachusetts Volunteer Infantry in the Civil War from 1861–1865.* Salem, Mass.: Salem Press, 1911.

Marshall, Jeffrey D. *A War of the People: Vermont Civil War Letters.* Hanover, N.H.: University Press of New England, 1999.

Members of the regiment. *The Story of the Twenty-First Regiment, Connecticut Volunteer Infantry during the Civil War, 1861–1865.* Middletown, Conn.: Stewart Printing Co., 1900.

Netscher, C. Nat. "Away in Company A: A Civil War Soldier's Story." Unpublished manuscript, n.d.

Nichols, James M. *Perry's Saints, or the Fighting Parson's Regiment in the War of the Rebellion.* Boston: D. Lothrop and C., 1886.

Palfrey, Francis Winthrop. *Memoir of William Francis Bartlett.* Boston: Houghton, Osgood and Co., 1878.

Palmer, Abraham J. *The History of the Forty-Eighth Regiment New York State Volunteers in the War for the Union, 1861–1865.* Brooklyn, N.Y.: Veteran Association of the Regiment, 1885.

Parker, John L. *Henry Wilson's Regiment.* Boston: Press of Rand Avery Co. for the Regimental Association, 1887.

Pierce, Richard L. "The Gilded Pitcher: The Story of Captain George Pierce Jr." Unpublished manuscript, 1999.

Plummer, Albert. *History of the Forty-Eighth Regiment, M.V.M., during the Civil War.* Boston: Press of the New England Druggist Publishing Co., 1907.

Powers, George W. *The Story of the Thirty Eighth Regiment of Massachusetts Volunteers.* Cambridge, Mass.: Dakin & Metcalf, 1866.

Preston, Noble D. *History of the Tenth Regiment of Cavalry New York State Volunteers.* New York: D. Appleton & Co., 1892.

Quint, Alonzo H. *The Record of the Second Massachusetts Infantry, 1861–1865.* Boston: James P. Walker, 1867.

Reed, Thomas J. *Tibbits' Boys: A History of the 21st New York Cavalry.* Lanham, Md.: University Press of America, 1997.

Roberts, Oliver Ayer. *History of the Military Company of the Massachusetts, Now Called The Ancient and Honorable Artillery Company of Massachusetts,* Vol. 3, 1822–1865. Boston: Alfred Mudge & Son, Printers, 1898.

Scott, Winfield. *Pickett's Charge as Seen From the Front Line. A paper prepared and read before California Commandery of the Military Order of the Loyal Legion of the United States, February 8, 1888.* San Francisco, 1888.

Sipes, William B. *The Seventh Pennsylvania Veteran Volunteer Cavalry; its*

Record, Reminiscences and Roster. Pottsville, Pa.: Miners' Journal Print, 1905.

Smith, Henry I. *History of the Seventh Iowa Veteran Volunteer Infantry During the Civil War.* Mason City, Iowa: E. Hitchcock, Printer, Binder, 1903.

Sperry, A. F. *History of the 33d Iowa Infantry Volunteer Regiment 1863–6,* Edited by Gregory J. W. Urwin and Cathy Kunzinger Urwin. Fayetteville: University of Arkansas Press, 1999.

Stevens, William B. *History of the Fiftieth Regiment of Infantry, Massachusetts Volunteer Militia in the Late War of the Rebellion.* Boston: Griffith-Stillings Press, 1907.

Thompson, James W., D.D. *Words Spoken at the Obsequies of William Blackstone Williams, Late Captain in the Second Regiment of Massachusetts Infantry, Sunday, August 17, 1862,* Jamaica Plain, Mass.: Unitarian Church of Jamaica Plain, 1862.

Von Deck, Joseph F. "Marching to the Sound of Terrible Music: The History of New England in the Civil War Era, 1850–1870." Unpublished manuscript, n.d.

Walkley, Stephen. *History of the Seventh Connecticut Volunteer Infantry, Hawley's Brigade, Terry's Division, Tenth Army Corps, 1861–1865.* Hartford, Conn.: n.p., 1905.

Westbrook, Robert S. *History of the 49th Pennsylvania Volunteers.* Altoona, Pa.: Altoona Times Printer, 1898.

Whitman, Walt. *The Correspondence of Walt Whitman.* Edited by Edwin Haviland Miller. 6 vols. New York: New York University Press, 1961.

Willis, Henry A. *The Fifty-third Regiment Massachusetts Volunteers, Comprising Also a History of the Siege of Port Hudson.* Fitchburg, Mass.: Blanchard & Brown, 1889.

Willson, Arabella M. *Disaster, Struggle, Triumph. The Adventures of 1000 "Boys in Blue," from August, 1862, to June, 1865.* Albany, N.Y.: Argus Co., Printers, 1870.

Articles

Calder, Ellen M. "Personal Recollections of Walt Whitman." *Atlantic Monthly* (June 1907).

Ferry, Richard J., "The General's Tour—The Battle of Olustee (or Ocean Pond), February 20, 1864." *Blue & Gray* (February–March 1986).

Seitter, John Reid. "Union City: Philadelphia and the Battle of Gettysburg." *Gettysburg Magazine* (July 1999).

"Twentieth Massachusetts: The Late Adjutant Bond." *Dedham (Massachusetts) Gazette* (May 28, 1864).

Sundstrom, Karl. "Corporal James Brownlee." *Military Images* (1996): 9.

Valentine, Scott. "A Father's Lament." *Regimental Gazette* (1995): 1.

Manuscript Collections

Compiled Military Service Records and Pension Application Files, U.S. National Archives and Records Administration, Washington, D.C.

Waters Whipple Braman Letters, New York State Archives, Albany.

Isaiah Goddard Hacker diary, Goddard Family Papers, San Rafael, California.

Willis Asa Pomeroy Collection, Connecticut Historical Society, Hartford.

Newspapers

Boston Globe
Dedham (Massachusetts) Gazette
Mexico (Missouri) Weekly Ledger
Middletown (New York) Daily Press
Milford (Delaware) Chronicle
Monticello (New York) Republican Watchman
Oskaloosa (Iowa) Globe
Winsted (Connecticut) Herald

World Wide Web Sites

Amenia, NY 12501. "Your Guide to the Mid-Hudson Valley of NY State." 2001. www.bearsystems.com/amenia/amenia.html.

Blenderman, Walter. "53rd Massachusetts Infantry." 1996–2001. http://www.intac.com/blenderm/53rd_Mass_f/53rd_Mass.html.

The Church of Jesus Christ of Latter-Day Saints. "FamilySearch." 1999–2001. www.familysearch.org.

eHistory.com LLC. "War of the Rebellion: Official Records of the Union and Confederate Armies." www.ehistory.com. Accessed 2000–2003.

Genealogy.com. "Genforum." 1996–2002. www.genforum.com.

George Eastman House International Museum of Photography and Film. "George Eastman House Catalog." www.eastman.org. Accessed 2000–2003.

Hayes, Tom. "Letters of the Civil War: A Compilation of Letters, Stories, Diaries from the Soldiers, Sailors, Nurses, Politicians, Ministers, Journalists and Citizens During the War of the Rebellion, from the Newspapers of Massachusetts." 1997–2002. http://www.letterscivilwar.com/.

Inter-University Consortium for Political and Social Research. "Social Science Data and Resources for Researchers." http://www.icpsr.umich.edu/. Accessed 2003.

National Park Service. "Petersburg National Battlefield Pictionary." www.nps.gov/pete/mahan/pictionary.html. Accessed 2002.

Wooster, Kenneth Jennings. "143rd New York Volunteer Infantry." 2000–2002. skaneateles.org/143_inf/143_inf.html.

ACKNOWLEDGMENTS

Faces of the Civil War: An Album of Union Soldiers and Their Stories was created with the help and support of a wide circle of family, friends, and the many persons I have communicated with during the course of researching and writing these profiles.

First and foremost, I thank my wife, Anne, for her patience, understanding, encouragement, and commitment. She has given much in my pursuit to chronicle old soldiers. Her candid observations and honest critiques have made this a better book, and her keen sense of humor raised my spirits when they were low.

My parents, Carol and Ron, supported my interest in history and instilled in me an appreciation of the past through family trips and antique hunting. My brothers have always been helpful: Michael convinced me to buy my first Civil War photograph, and Gary always has his eye open for old photos as he hunts for antiques and collectibles. Louise Bodnar, my grandmother, has always been wonderfully supportive. I admire her courage, resolution, and endurance.

"To look at, hold, and compare with others these personal images mounted on cards is what maintains and sustains my interest, the appreciation and process in understanding one of our great national conflicts." This is how Henry Deeks of Acton, Massachusetts, a well-respected dealer and historian and a familiar face at most major Civil War shows, describes his passion for the *carte de visite*. His popular column in the *Civil War News* and his meticulously researched catalogs inspired me to investigate and write about the identified soldiers in my collection. For this and for his many thoughtful words over the years I am most appreciative.

Kathryn Jorgensen, managing editor of the *Civil War News,* took an early and active interest in my soldier profiles. I am in her debt for her key role in establishing *Faces of War.*

My experience with the Johns Hopkins University Press has been a thoroughly enjoyable one, due in large part to three individuals. Bob Brugger's constructive comments at many points during the development of this project helped to shape the manuscript and sharpen its focus. Melody Herr helped me stay on top of the many deadlines associated with publishing this book. Anne Whitmore copyedited the manuscript and guided me through the production process. I am indebted to them all.

Boyd Baker, the late Mike Duggan, Brennan Lukas, Chuck Myers, and

Ray Walker read the manuscript at various points and made valuable comments. They bring a wealth of editing and writing talents to the table, and I appreciate their time and effort. Author Stanice Anderson offered encouragement and advice in the earliest stage of this project, and Roger Hunt, author of *Colonels in Blue — Union Army Colonels of the Civil War,* provided helpful research information and tips.

Several individuals provided details about their ancestors, and three men deserve special recognition. Larry Bloebaum of Jefferson City, Missouri, identified the photograph of his great-great-grandfather, Pvt. John Wesley Pierson of the Seventh Iowa Infantry, and shared a terrific article written by "JWP" in the 1890s. Paul Hacker of San Rafael, California, a descendant of Sgt. I. Goddard Hacker of the Thirty-eighth Massachusetts Infantry, provided me with a copy of his forefather's journal. Richard Pierce of Dedham, Massachusetts, sent a well-researched profile of his ancestor, Capt. George Pierce Jr. of the Tenth Massachusetts Infantry.

An army of men and women at libraries, historical societies, and genealogical organizations across the country gave of their time and expertise. Don Goetz of the Beardsley and Memorial Library in Winsted, Connecticut, stands out among them—he combed through period newspapers and uncovered several articles concerning 1st Lt. Robert Dempsey of the Seventh Connecticut Infantry.

Our little pug dog Charlie, a constant companion and friend who brought so much joy to our lives, made several battlefield research trips despite his age and infirmities. He came to us the year before this manuscript was begun and left as the final paragraphs were being written.

INDEX

Page numbers in italic refer to photographs.